Designed in ORANGE COUNTY

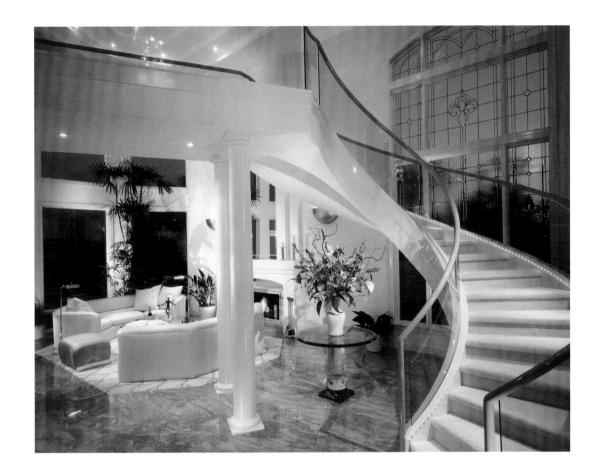

A Collection of Southern California's Finest Designers

dsa
Publishing & Design Inc.
DSA Publishing, Inc.
Dallas, Texas

Published by

Publishing & Design Inc.
2809 Sunset Ridge
McKinney, Texas 75070
972-562-6966
FAX 972-562-7218
www.dsapubs.com

Publisher: Duff Tussing

Design by Donnie Jones, The Press Group, Plano, TX

All images in this book have been reproduced with the
knowledge and prior consent of the designers concerned
and no responsibility is accepted by the producer,
publisher, or printer for any infringement of copyright or
otherwise arising from the contents of this publication.
Every effort has been made to ensure that credits
accurately comply with the information supplied.

Printed in Canada

PUBLISHER'S DATA

Designed in Orange County

Library of Congress Control Number: 2005909631

ISBN Number: 0-9774451-0-0

First Printing 2005

10 9 8 7 6 5 4 3 2 1

On the Cover: Melinda Grubbs
See page 37

Previous Page: Karen & Brooke Ziccardi
See page 149

This Page: David Rance
See page 103

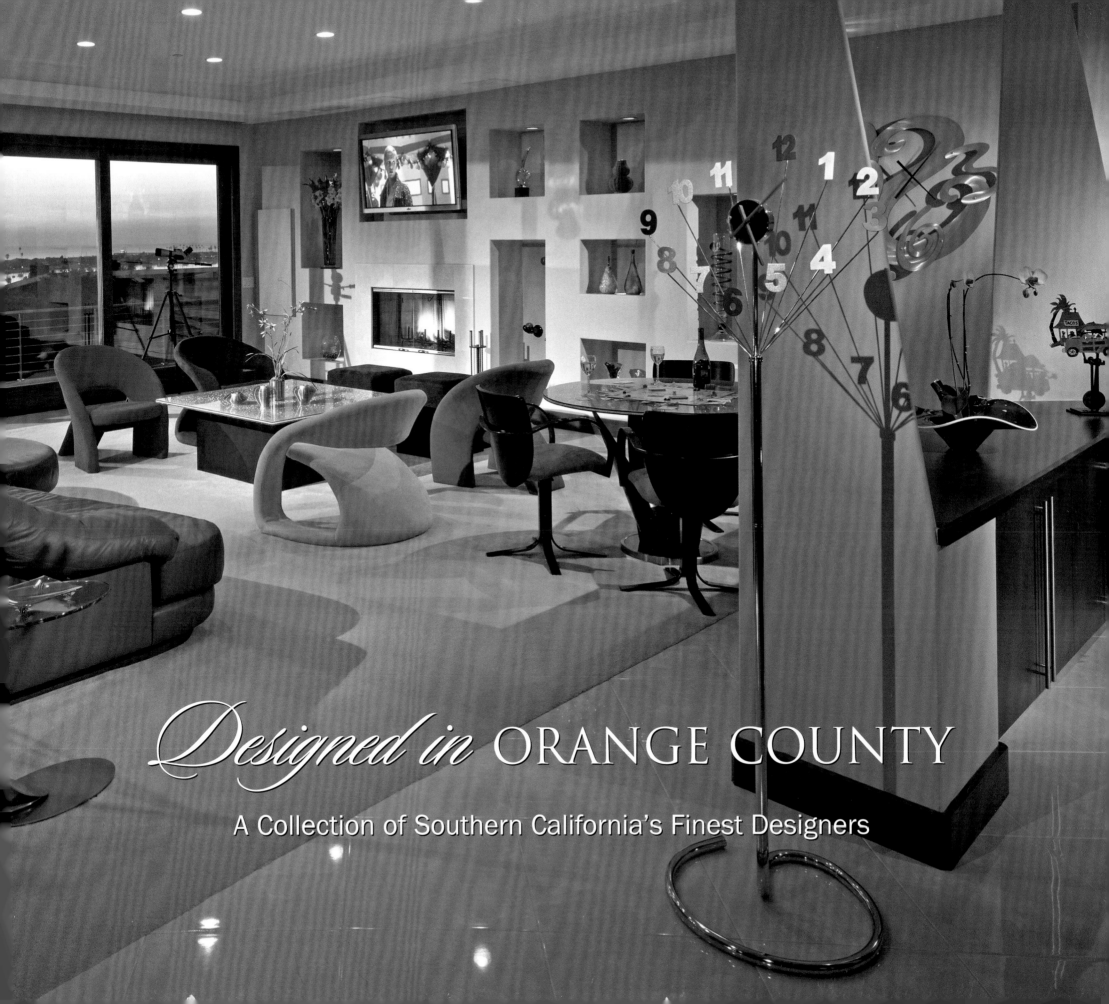

Designed in ORANGE COUNTY

A Collection of Southern California's Finest Designers

Introduction

This book represents the wonderful world of interior design in Orange County, California. The designers whose beautiful work is shown here are some of the most talented, conscientious and creative people you will find anywhere in North America.

Their designs are as varied as their individual personalities and styles. While their projects range from beach cottages to mansions to country clubs, their work shows that it is not always budget that counts, but rather a commitment to good taste and quality, always turning the homeowner's desires into reality.

All of the designers in this book are members of the American Society of Interior Designers, the largest professional association of interior designers in the U.S. and Canada. For the last 14 years, the Orange County Chapter of ASID has, in conjunction with the Philharmonic Society of Orange County, proudly produced a showcase home open to the public. This philanthropic endeavor raises funds for music education in the Orange County public schools so that more than 25,000 students each year are introduced to live, quality music and culture.

Each page is lavishly illustrated with photos that feature beautiful furniture, window treatments, art and accessories that display the wide range of ASID members' concepts and creativity. Whether it is a designer's personal home or that of a client, the photographs define extraordinary design excellence. There is something for everyone to appreciate, learn from. ..and afford. This is not simply a showcase for the affluent, but a representation of quality design and techniques that accommodate a variety of budgets.

No matter how beautiful a room, the one thing that matters is how your home reflects who you truly are. It's the canvas that allows you to share time with friends and pursue your interests, as well as to bring personal enjoyment to you on a daily basis. May this book inspire you to fulfill that desire to have the home of your dreams. As you delve into the pages that follow, hold hands with the designers and allow your imagination to soar.

Anne Dullaghan

The Designers

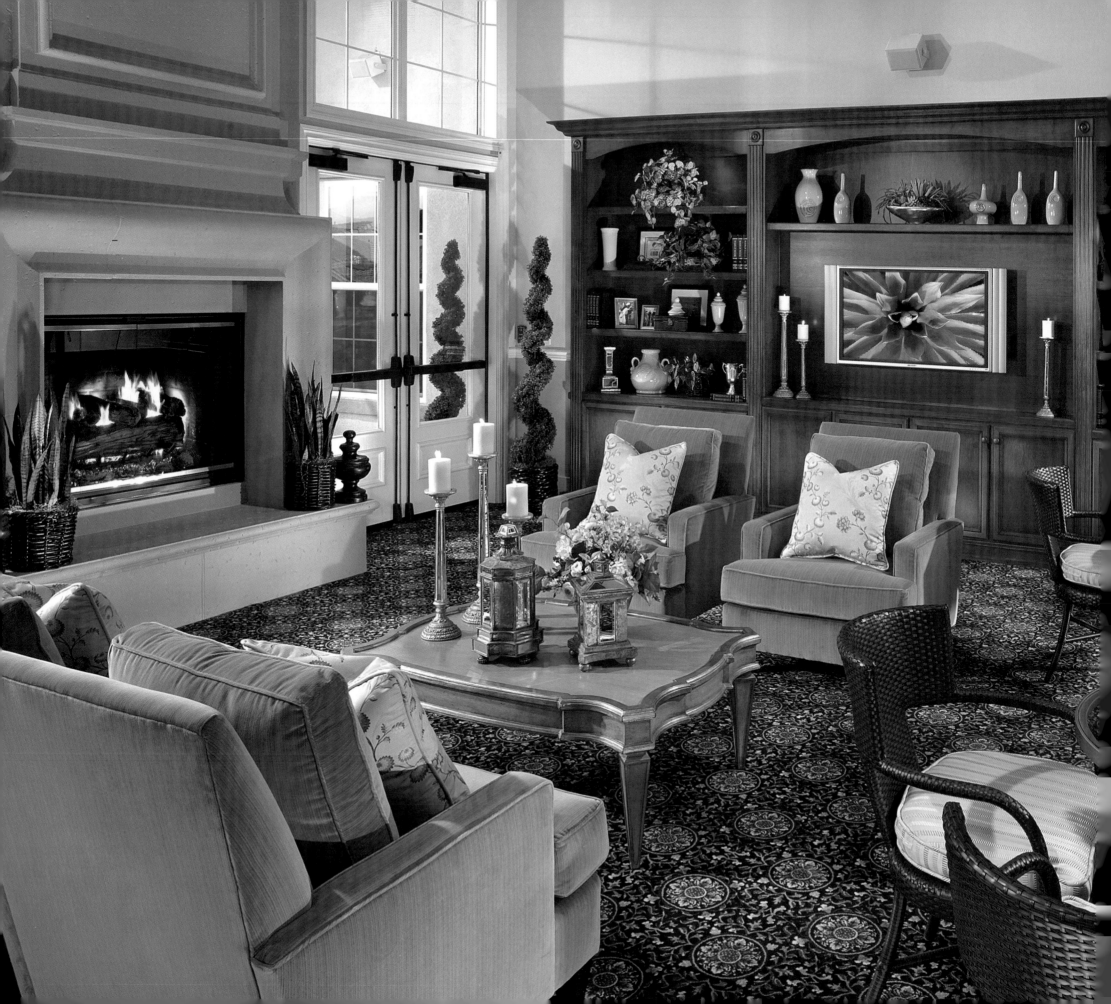

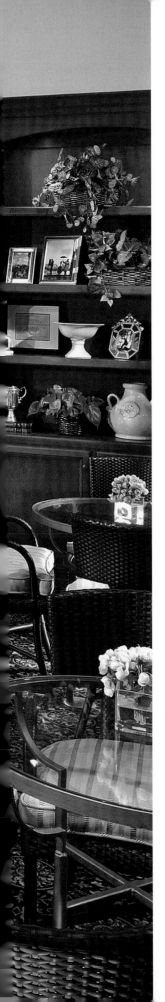

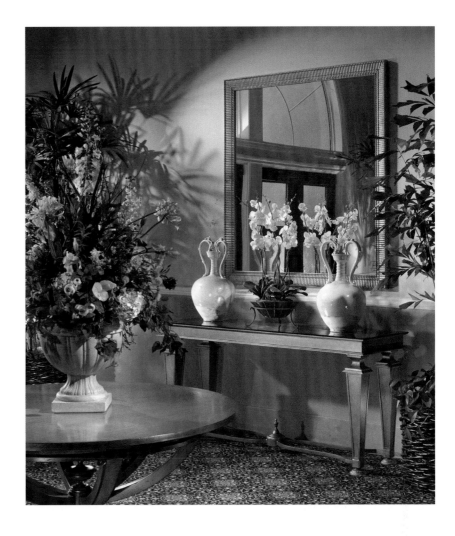

Yuri Bast, ASID
Yuri Bast Interior Design, Inc.

LEFT The neutral color scheme and contrasting textures enhance the sense of tranquility and create a warm sense of welcome.

RIGHT Colors and furnishings provide a sense of elegance and classic style.

Though she originally planned to be a fine artist, Korean-born Yuri Bast eventually majored in interior design, transforming all her creative energies onto a different set of canvases. And she's having a devil of a good time with the details.

After college, Yuri worked for both residential and commercial design firms. Since opening her own company three years ago, her clientele have ranged from commercial projects, such as golf course clubhouses, real estate development information centers and restaurants, to residential redesigns and remodels.

Though her own design sensibilities run toward the contemporary, she'll gladly blend the colors and textures in her palette to fit the tastes of her clients. Currently, Yuri is designing a country club in an elegant Mediterranean style, while another commercial project is being adorned in a timelessly enchanting Santa Barbara motif, and still a third space is being decorated in a fashion that's extremely modern. "I try to create a space where everyone can feel at home," says Yuri. "Offices don't have to be sterile, with a bunch of cubicles and florescent lights. I try to create an enjoyable, pleasant environment."

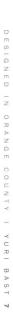

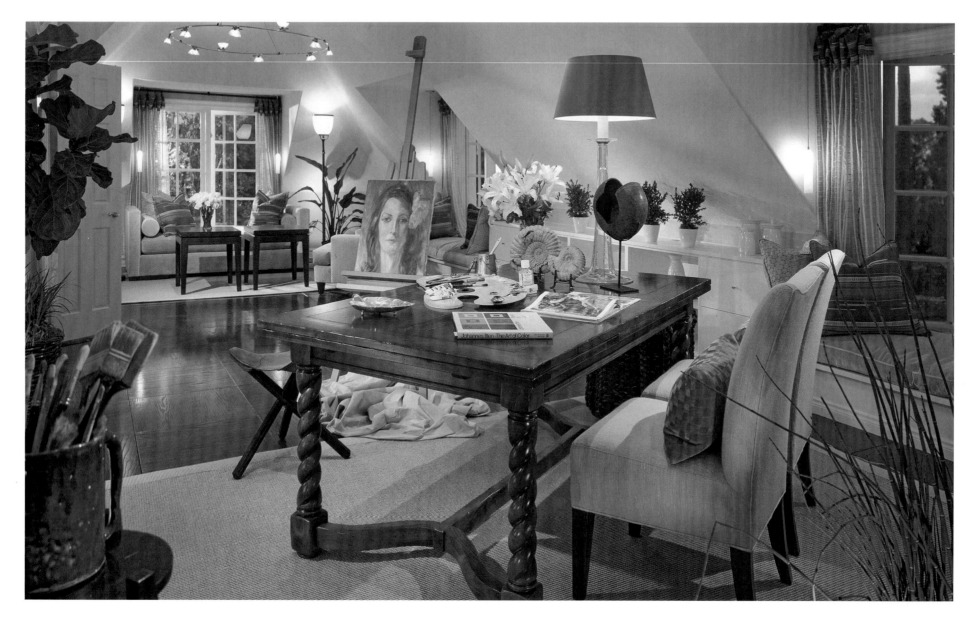

Yuri loves the opportunity to work on these larger scale projects; they tend to have a longer developmental gestation period, sometimes as long as three years. This gives her time to become more personally involved with the architect, electrical and mechanical engineers, the kitchen consultant and the construction crew. "It's a lot of work, but I love the challenges," she says. Yuri appreciates the "many details that need to be completed and maintaining the relationships with the people on the job site."

Her creative approach is one that is completely collaborative. "I think about function and get clues from architectural elements and surroundings," she says. "I like to bring the outdoors in. Lighting is also important – I want to bring in as much natural light in my designs as possible."

She loves working with new building materials, reinventing residential properties in a way that's both attractive and cost-effective. "You don't have to have a big budget to create a beautiful space," she says.

ABOVE Oversized dark wood parquet flooring and contemporary low-voltage chandeliers set the tone for this comfortable yet eclectic artist studio. *2004 Philharmonic House of Design.*

FACING PAGE LEFT As the room's focal point, the rustic fireplace separates the retail area from the lounge area of this Old World wine tasting bar and boutique.

FACING PAGE RIGHT This cavern of a retail space was converted to a smart, clean-lined, multi-functional space with oversized contemporary cabinetry, rich fabrics and colors, and organic-shaped ceiling canopies.

"Good design doesn't always have to be expensive." Yuri is keenly aware that a residential space needs to not only be gorgeous, but functional as well. From building codes to fabulous fabrics for fine furniture, she is always on top of the details.

Last year, Yuri's hard work was recognized and rewarded when she was invited to design a display room for the 2004 Philharmonic House of Design in Orange County.

Like all experienced designers, she understands that her "signature" should not smother the space. "Editing is very important to me," Yuri says. "Designers tend to add too much. At the end of a project, I take a final close look and consider the composition. As a result, my spaces tend to be elegant, but understated." And she is always confident that her finished works...from country clubs to country houses...will ultimately speak for themselves. ■

YURI BAST INTERIOR DESIGN, INC.

28 Argonaut, Suite 100

Aliso Viejo, CA 92656

949-643-6704

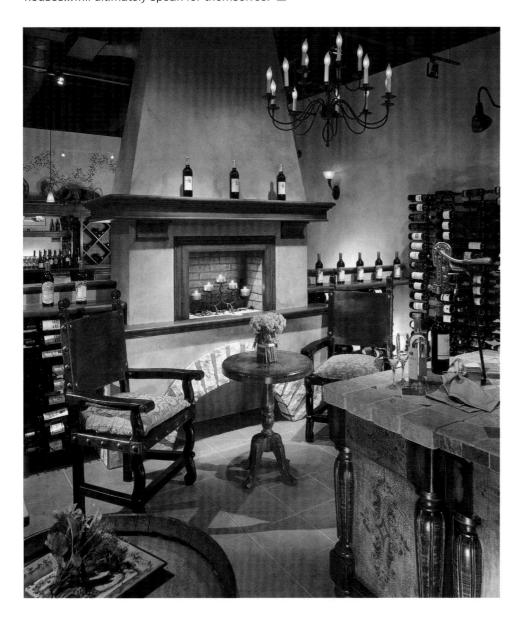

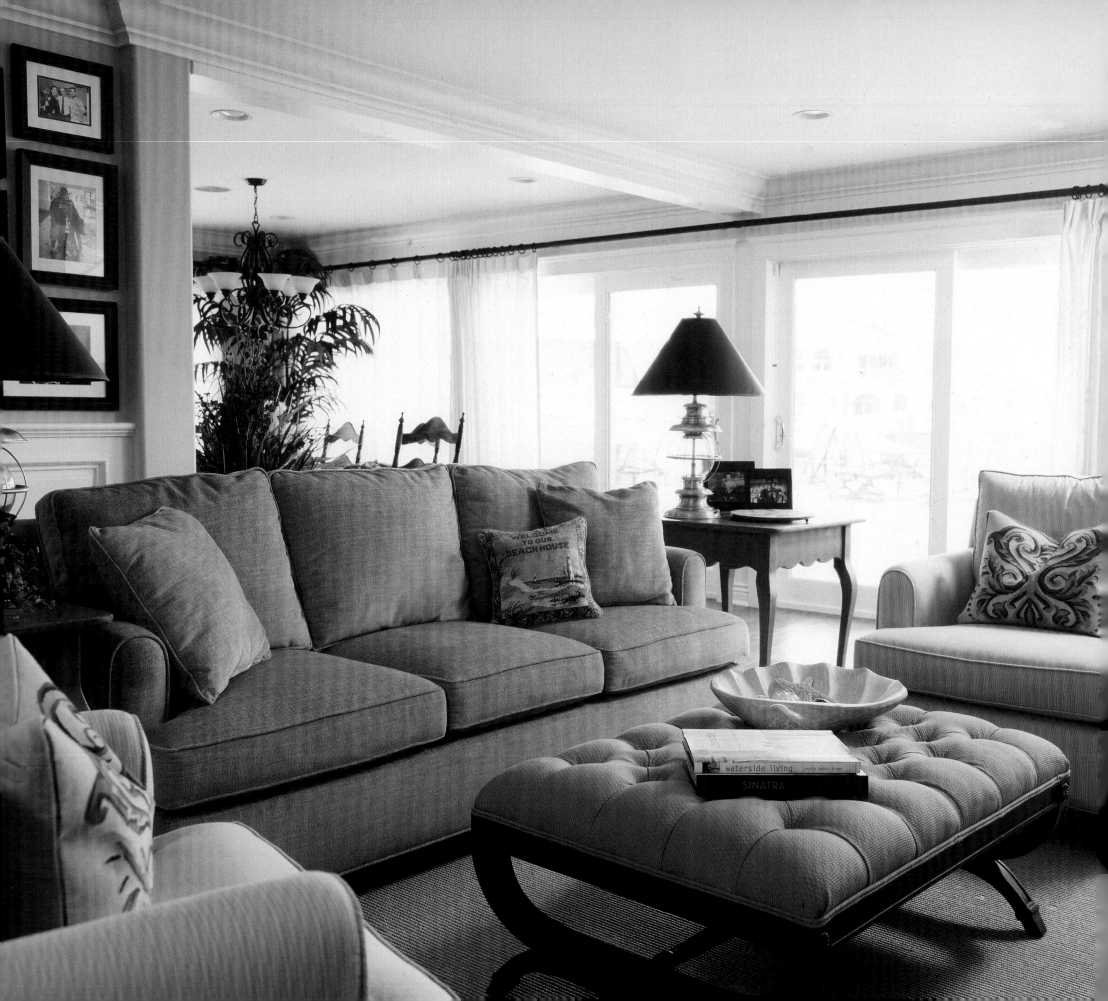

Lauréll Bertino,
Allied Member ASID
Lauréll Bertino Interiors

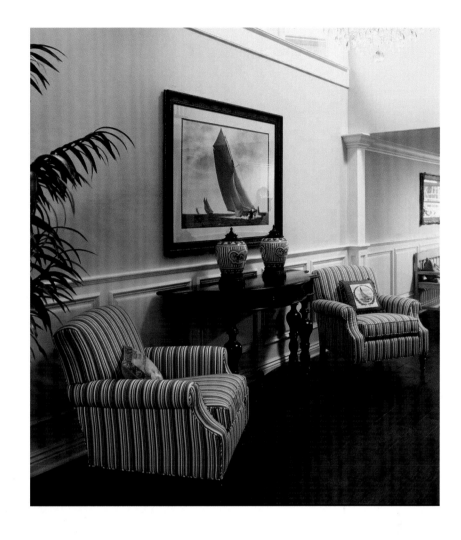

LEFT Peaceful and comfortable, the blue and aqua fabrics invite the owners to relax and put their feet up in their oceanfront vacation home.

RIGHT The dark wood on the floors and furniture are a pleasing contrast to the white wainscoat and trim. Nautical stripes welcome the homeowners to the beach.

The design process should be balanced and harmonious. This is why designer Lauréll Bertino follows the Feng Shui philosophy of harboring positive energy in a living space. "My homes feel comfortable and relaxed when you walk in," she explains. "They're formatted to produce harmony and balance."

From the wilderness of Alaska to beach homes of California, Lauréll has brought balance to homes all over the country. "It's very exciting," she says. "I never feel like I'm doing the same thing twice." This is in part because she believes interior design should reflect the intricacies of a homeowner's personality rather than reproduce the latest fad or mimic the designer's personal tastes.

Thanks to word-of-mouth referrals, Lauréll has been designing nonstop since 2001. Her hard work was recognized in the September 2003 edition of *Orange Coast Magazine*, which jump-started her career to another level. She also received the platinum award for the Living Room category in the 2004 *Orange County Home Magazine* Design Awards competition.

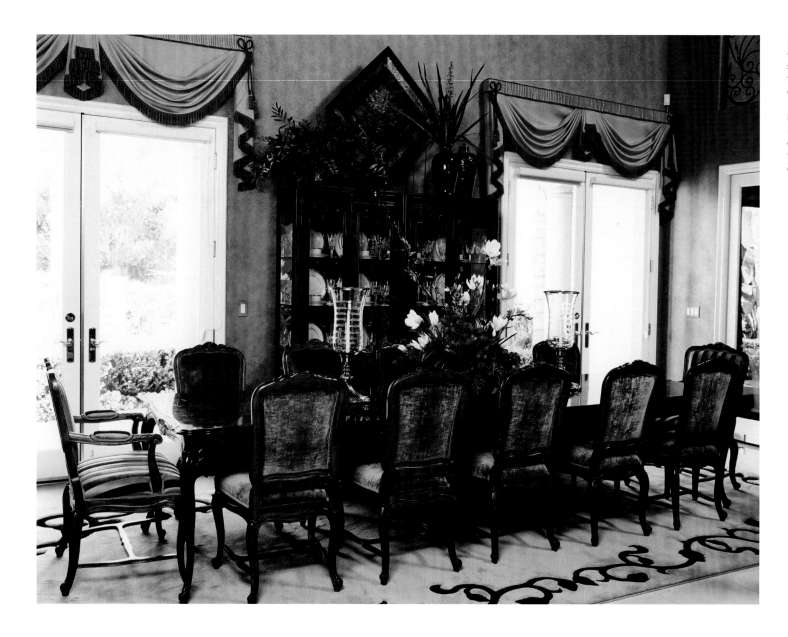

LEFT The traditional and formal dining area is made to feel like a seperate space in this great room through the use of valances and a decorative area rug.

FACING PAGE The hassock and bench provide extra storage. Soft draperies and simple yet elegant furnishings create an uncluttered easy lifetsyle.

Much of her inspiration stems from the structure of a home. "I want my design to complement the interior of the structure with how I think it was meant to be," she says. "Each house has its own bones; I help find its suitable clothing." To this end, she's constantly reading books and magazines on various periods and remains inspired by classical European design. In fact, she plans on taking a transatlantic cruise in the near future to explore England and its rich architectural history.

Having a background as a literature teacher, Lauréll excels at imagining each of her designs as a story. "I always think about what the people are going to be doing in the house, whether it be dining, relaxing, entertaining," she explains. "And I try to imagine things like what they would want to be sitting on."

She used her limitless imagination recently when designing a Colorado mountain log home. "I did a lot of research into what the pioneers would have," she says. "I had a running story in my head about how Wild Bill or a woman with hoop-skirts would have lived." Incorporating her own imaginative ideas with the client's Native American artifacts, she was able to create an authentic and inviting mountain home.

Before she starts dreaming up possibilities, Lauréll is sure to explore each client's taste. "I always ask my clients to go through magazines and bring five pictures of things they love and five pictures of things they dislike. And then I have them explain to me why," she says. "You don't want to spend a lot of time thinking you're finding something the clients will like only to find out it's not to their liking."

Lauréll understands how attached people are to their living spaces, so she goes out of her way to satisfy even the most discriminating tastes. "Design is all about psychology and emotion," she explains. "When clients are in their home, you want them to be happy and secure in their own environment." ∎

LAURÉLL BERTINO INTERIORS

65 Cloudcrest

Aliso Viejo, CA 92656

949-831-9790

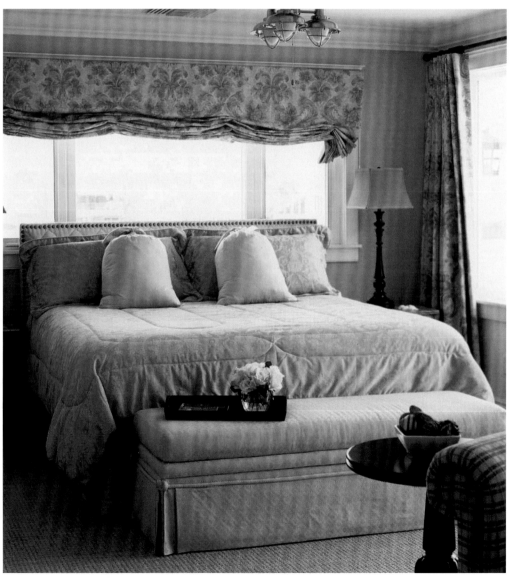

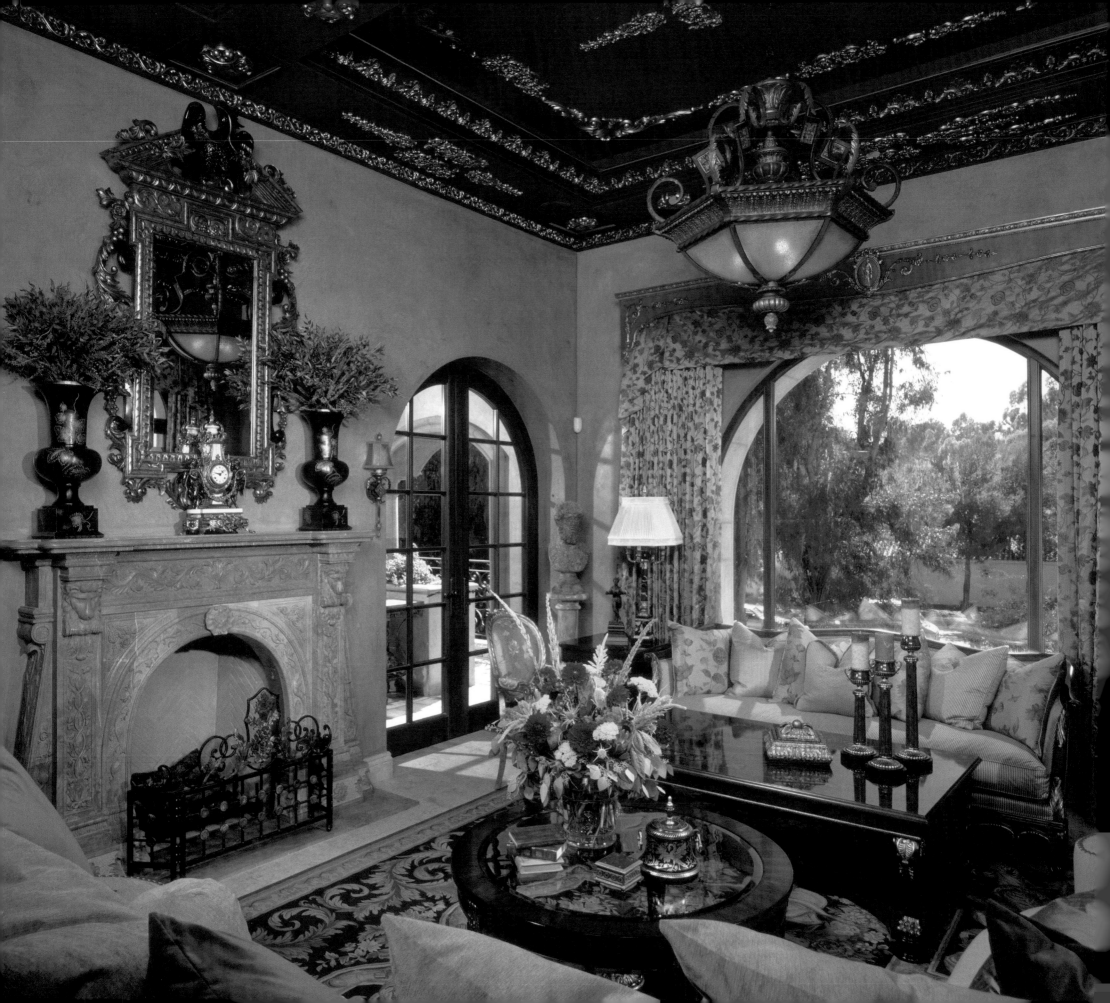

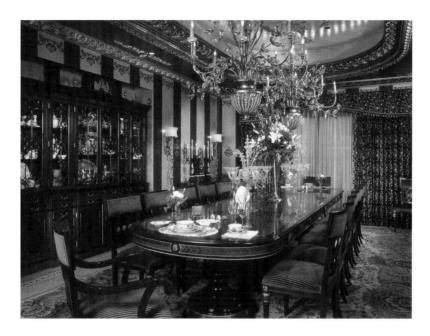

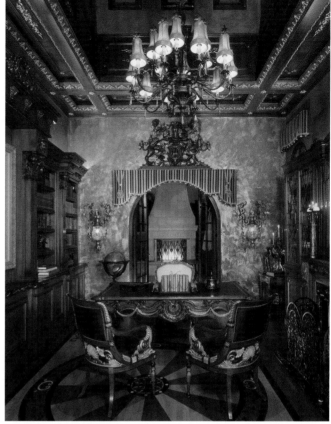

Shelley Brosé, Allied Member ASID
The Design Studio, Inc.

THE DESIGN STUDIO, INC.

27128 A Paseo Espada #1501

San Juan Capistrano, CA 92675

949-488-3700

FACING PAGE The living room incorporates Renaissance elements in the structure and in the furnishings. The most captivating feature is the ornate gilded ceiling with mahogany moldings.

TOP Inspired by Venetian Renaissance designs, the dining room seats 18 comfortably, but the room allows intimacy when dinner is just for two.

TOP RIGHT The Venetian plaster finish and the ornate details of the ceiling, furniture and accessories make this room into a "palatial" library.

Shelley Brosé recently faced the ultimate challenge in her 20 years of design experience: creating her family residence on a beautiful San Juan Capistrano country-club hillside. Although Shelley has designed homes throughout the United States and Europe, taking on her own family as a client was a completely new experience. "My husband Danny has high expectations, he loves art and architecture, and he's not an easy client to please!" she says.

Villa Rosa Rugosa, the home Shelley designed, is an 18,000-square-foot homage to the Renaissance that seamlessly blends modern technology with classic art and architecture. "It's a home that is a sanctuary, a showcase for our collected treasures, as well as a functional space that accommodates everyone – all the way down to the grandchildren – with room for lots of friends and entertaining."

The owner and sole proprietor of The Design Studio, Inc., she is supported by a talented staff of eight. In building and designing Villa Rosa Rugosa, Shelley relied on the expertise of construction guru Danny Ray Edwards, and Italian master painter Roberto Pellecchia, who supervised 16 artists working full time to complete the house's many original oil paintings and frescoes.

Her work is shaped by her extensive travels in Europe and China, as well as by classical architecture. But whether Shelley avails herself of the past, present or future in her designs, she knows an integral part of any project is the client. "The key to successful design is implementing the client's ideas and their unique personalities – not mine." ∎

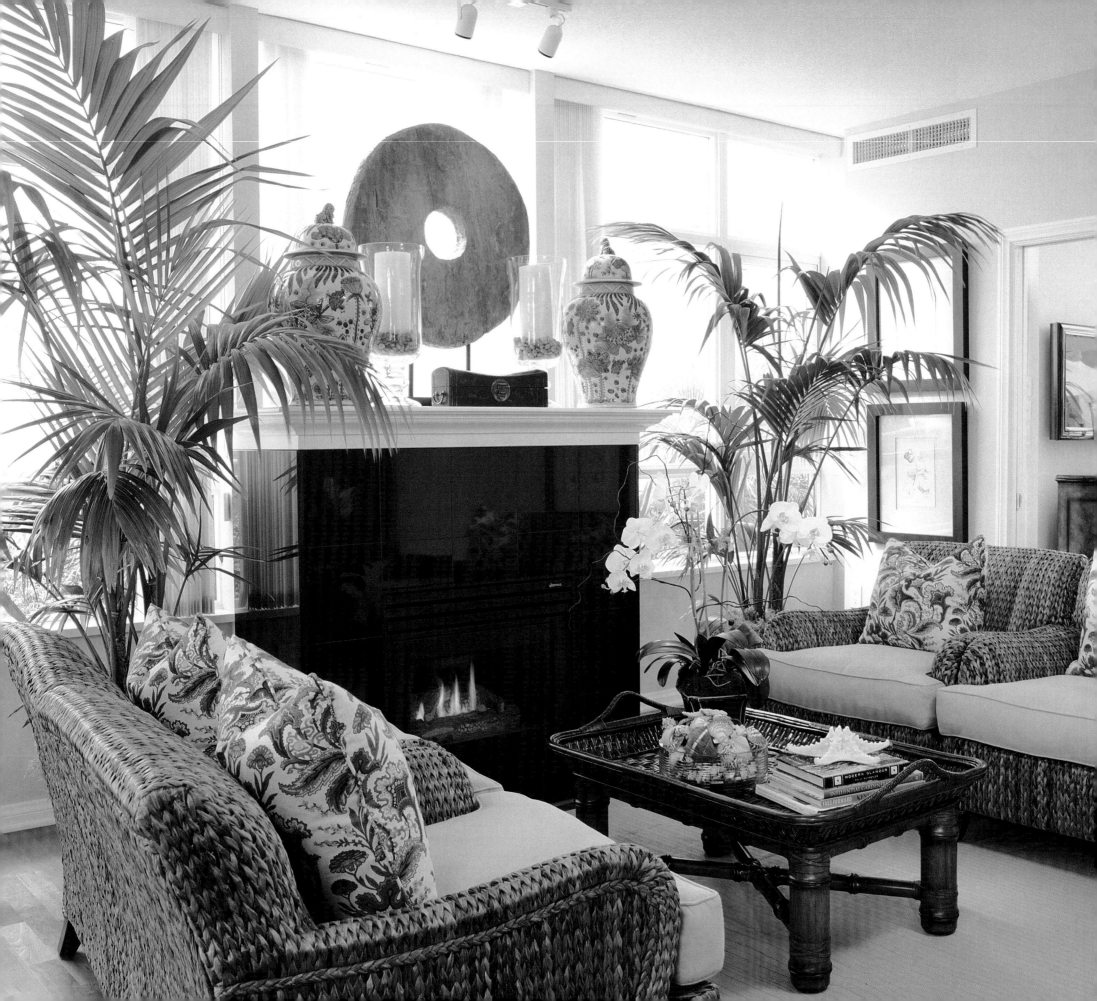

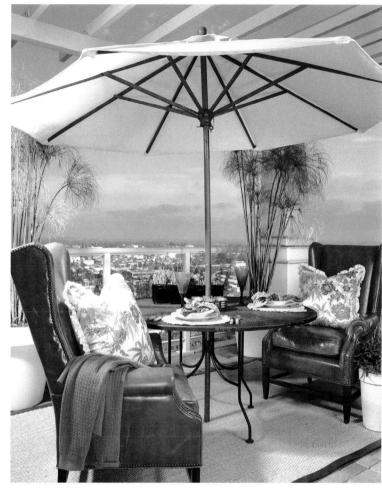

Barclay Butera,
Allied Member ASID
Barclay Butera, Inc.

LEFT Barclay designed this high-rise condo living room to capitalize on the indoor/outdoor feel. Blue and white, mix of floral textiles, rattan and Far East influences help create an other-world getaway.

RIGHT With a panoramic view of San Diego, outdoor living is a natural extension of the condo, as seen through the use of Barclay's own Grant Wing Chairs in spice-colored leather, typically used indoors.

A home is more than a house; it's a personal haven, and should exude sophistication, elegance and comfort, believes Barclay Butera, founder and owner of Barclay Butera, Inc. "It's important to create an enjoyable environment – whether it's for a single person, a family or an older couple," he says. "If my homes aren't livable, then I haven't achieved my goal."

Barclay emphasizes the importance of layering well, by combining interesting and diverse colors, textures and patterns. In his own home, leopard print and raffia pillows share the couch. He has even been known to "layer" coffee tables to reach an appropriate height, and delights in creating three-dimensional displays on bookshelves and even layering paintings on his walls. It's a technique that incorporates the many facets of Barclay's style – prominently evidenced in each product and each home his company designs.

His transitional style relies on the smooth lines of French Country and late British Colonial Empire styles, as well as Far East and American traditional influences. Recently, the Hollywood Regency style that developed during the era of Cary Grant, Bette Davis and the 1950s Rat Pack has become

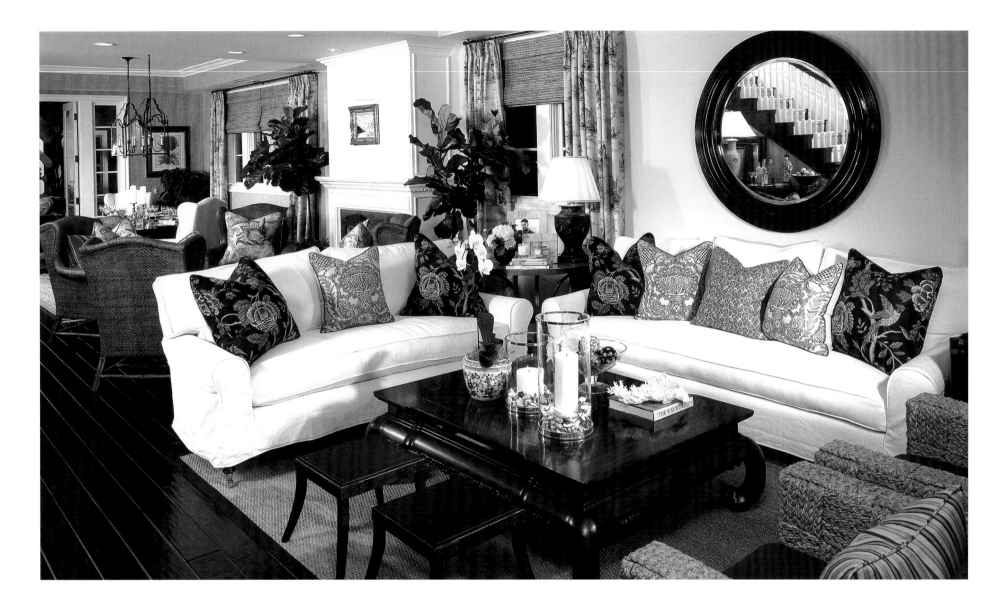

another source of inspiration, especially the emphasis on great rooms and inviting locations for social occasions. He is currently applying his fusion to two famous homes he recently purchased: "Twin Palms," the Palm Springs retreat of Frank Sinatra and Ava Gardner; and the 30-year-old, Hollywood-hillside home of Desi Arnaz, Jr. The homes will be restored to their former glory, with a little of Barclay's own modern twist. "These homes bring back feelings of a simpler time where people gathered together," he notes. "Both are mid-century in style and to me, represent entertaining, enjoying good friends and their many talents."

ABOVE The great room is a mainstay of Barclay's philosophy in creating casually elegant gathering spaces, here marked by his own slipcovered Sussex sofa, Asian accents, and lighting always all on dimmers.

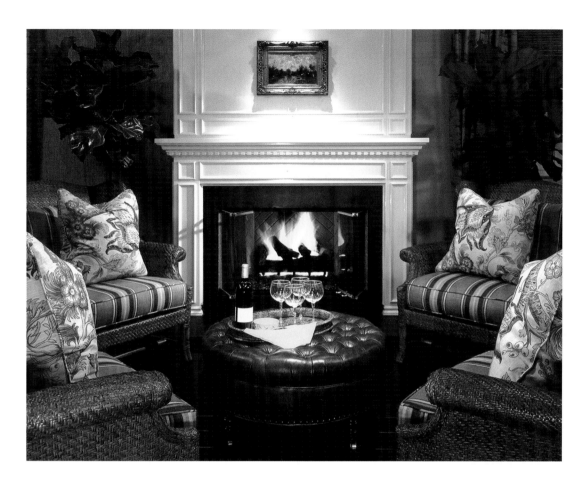

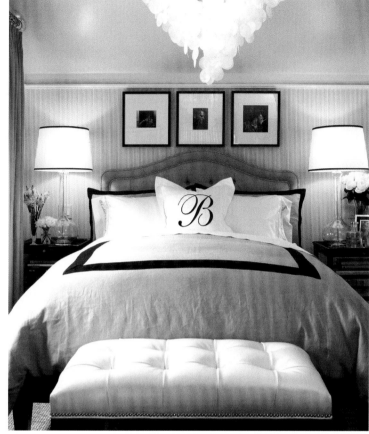

Barclay learned the importance of hard work from his family: his grandfather and parents were business owners willing to devote long hours to their careers. Barclay was first exposed to design through his mother, an independent designer with clients around the globe. Growing up, he spent summers traveling and working with her while she designed the interiors of model homes and private clients' houses. Design sparked his interest early and he developed his own palette. When he went to college, Barclay set his designing aspirations aside and earned his degree in political science and economics – even considering a career in law. It wasn't long, however, before Barclay realized where his real passion lay – at 25, he founded his own stylish pine case goods company in Los Angeles, a venture that has evolved to become the current national corporation. Today, he has five showrooms (three more are expected to open in the next 12 months), and a line of furnishings,

TOP LEFT Barclay Butera Home's Elizabeth Ottoman is used as a coffee table for this intimate gathering spot within a great room. High gloss wall paint and ebonized floors invites the use of stripes, florals and focused lighting.

TOP RIGHT Blue, white and high gloss black accents create clean, traditional look, accented by black-&-white 1950s Rat-Pack era photography and Barclay Butera Home's tufted Bel Air Ottoman and Bed.

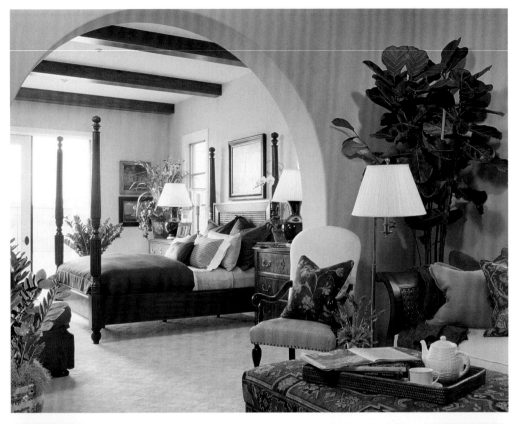

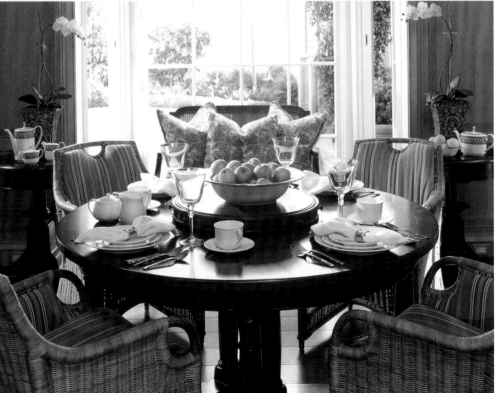

Barclay Butera Home, that is carried by 300 showrooms nationwide. "Going forward, I'm always thinking: How can I improve on what's already been done?" he says. "What's next is expanding on all aspects of the business – the upholstery line, the retail and trade showrooms and product distribution."

Additionally, Barclay has won praise for his guest bedroom/bath suite in *House Beautiful*'s 2003 Bel-Air Show House. Barclay was later invited to design the family room in the Chicago show house, and has been recognized by *The Wall Street Journal, Los Angeles Times, Western Interiors and Design, Country Home, Utah Style & Design, Estates West, California Homes, Coastal Living*, and *Southern Acccents* for his talents.

Despite the expansion and accolades, Butera retains the personal focus on which his reputation was built. When redesigning a home, Barclay's motto is "Yours, Mine, Ours," an inclusive perspective that incorporates the owner's prized heirlooms and pieces that are meaningful into a new look that is both generational and hip. Butera's furniture stands out because of the signature artisan touch: all items are handmade, hand-stuffed, and even packed and delivered by hand. All

TOP LEFT Shady Canyon master suite combines textures with antique kilim, raffia, linen and a stately four-poster bed making a grand but livable feel.

LEFT Tonal blues and white – accenting oceanfront living – mix with wicker, mahogany and a cozy bench to create a comfortable breakfast nook.

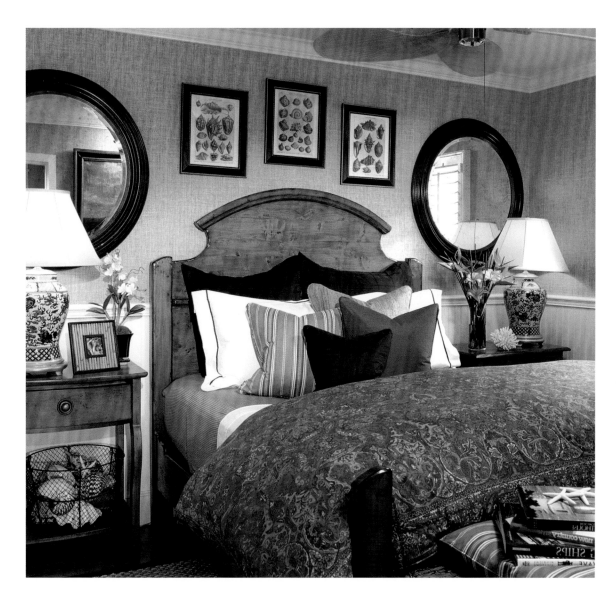

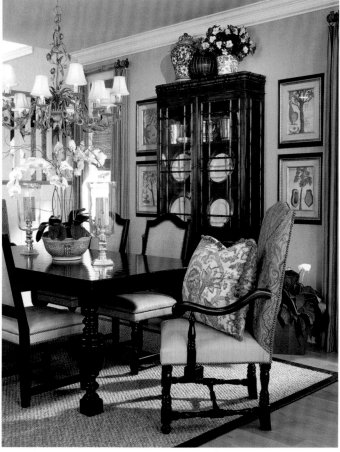

manufacturers are trained individually in the Butera technique. These modern and painstakingly shaped pieces are fully customizable, right down to Barclay's textiles, giving each home the potential to be a totally unique space. Although designers often claim that their clients' preferences take precedence over their own, Barclay's style is surprisingly adaptable to individual taste, and open to development. Barclay is always looking for new ways to add luxury and comfort to his line.

"As my customers' sophistication increases, just as mine has, they visit our showrooms again and again to be inspired by our interpretation of interiors, and thus, end up growing with me," he says. "And it's always about the customer, the quality and service." ∎

BARCLAY BUTERA, INC.

365-A Clinton Street

Costa Mesa, CA 92626

714-431-1160

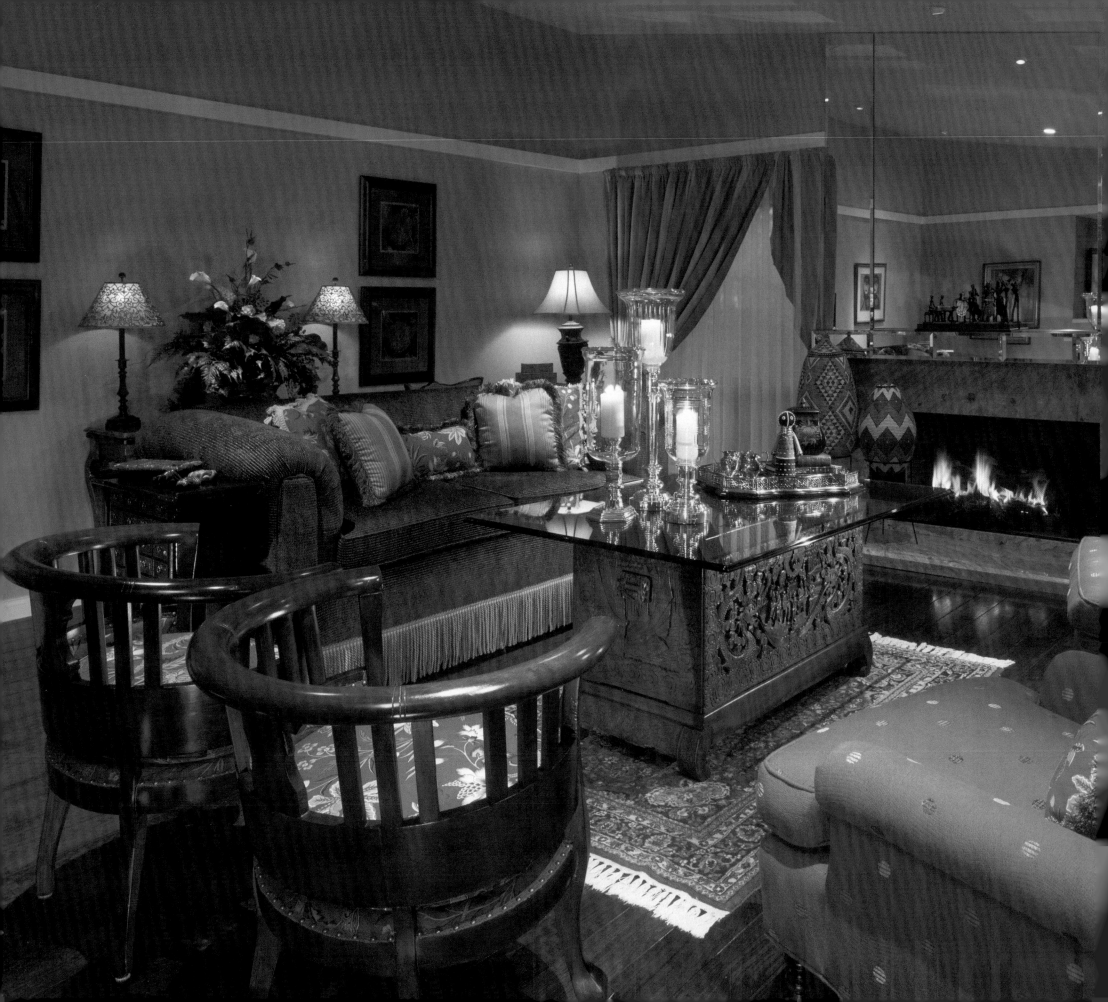

Adriel Cogdal, ASID, CID
Adriel Designs

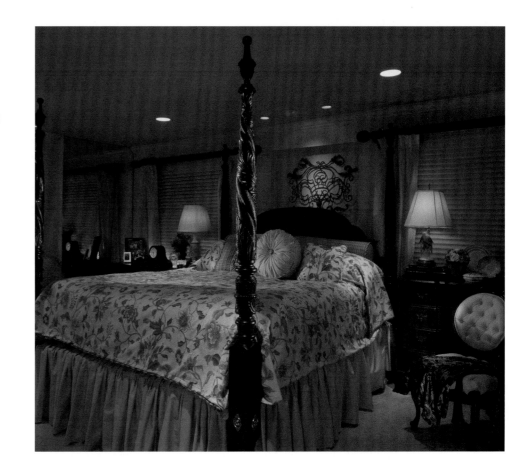

ADRIEL DESIGNS

2120 East Hill Street, #209

Signal Hill, CA 90755

562-989-8968

www.adrieldesigns.com

FACING PAGE This dark, never-used room was transformed into an inviting space by a new floor plan, a few new pieces, window treatments, paint and reupholstery.

TOP RIGHT Another dark room, used for storage was brightened with recessed lights and cheerful colors. Adding a built-in storage/TV cabinet and turning the floor plan created a spacious, comforting bedroom.

Adriel Cogdal's design philosophy is simple: "I help clients uncover how they want their spaces to look and feel, and I work with them step-by-step to create that vision," she says. For more than seven years, Adriel Designs has been designing residential interiors throughout Southern California. "My approach is very sensory and emotional. It goes beyond simply focusing on what your room looks like, because a design can always look good on paper. I want to know what's missing so I can pinpoint just the right elements to add."

Adriel is a professional member of ASID and a Certified Interior Designer. While residential design is her first love, Adriel has carved a unique niche working on yacht interiors. She heads up the interior design concepts for custom yacht fabricator Buxton Boat Works, overseeing design, construction and materials procurement. "Yachts have their own design challenges, but it's another aspect of the business that needs a professional touch," she says.

Rather than designing in a particular style, Adriel creates rooms that are accessible, "the kind that people really live in, that are enduring in style," she says. "They must reflect the style and personality of the client, not the designer." Her expertise and sharp eye are much appreciated by busy clients who don't have the time to resource materials or spend countless hours shopping. "They know they need help, but don't know where to start or how to put it all together," she says. "The best clients understand the value, experience and knowledge a designer brings to the project and are open to a designer's creativity." ■

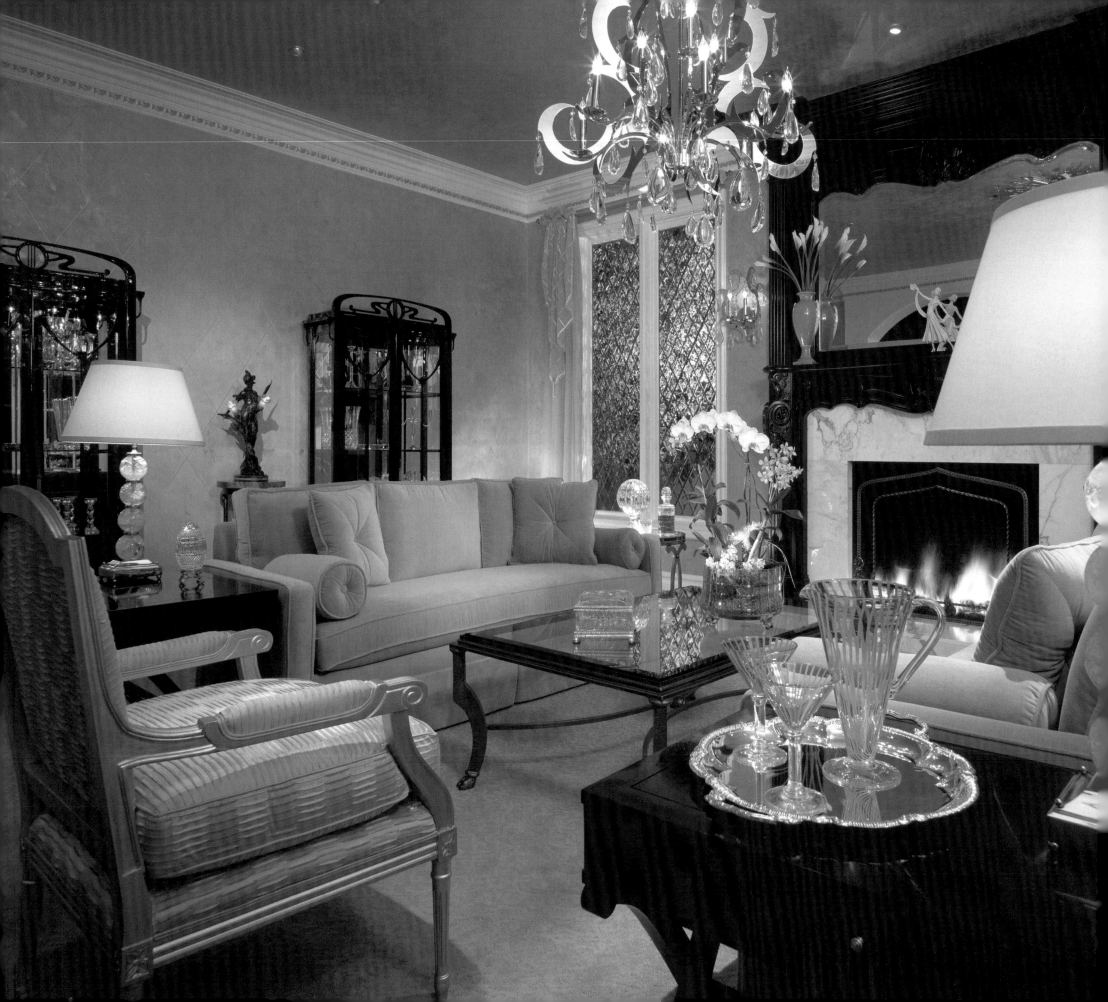

Linda Enochs,
Allied Member ASID, CID
Linda Enochs Interiors, Inc.

LEFT Linda loves a challenge in her work, and derives inspiration from her client's special treasures. This room was inspired by the homeowner's pair of Art Nouveau cabinets and the figurine shown on the mantle. Evocative of the Romantic fluid lines of Art Nouveau, juxtaposed with the geometric lines of Art Deco, this room is meant to portray a penthouse living room in Paris circa 1930. Philharmonic House of Design, 2004.

RIGHT Polished stainless steel chandelier and sconces add drama and sparkle. The polished steel ceiling medallion was custom-designed to be reminiscent of the French Sunburst pattern. The ceiling is platinum overwashed in soft opalescence. Philharmonic House of Design, 2004.

After nearly three decades as one of Orange County's premier residential interior designers, Linda Enochs still loves to blend styles and sophisticated sensibilities to create lively, compelling showplaces. Some of her superb design works have been on display at the annual Philharmonic House of Design in Orange County and the "Entertaining by Design" event at the Laguna Design Center in Laguna Niguel. Her work has also been chronicled in many local and regional publications. Linda is a long-standing board member on the Orange County chapter of the American Society of Interior Designers (ASID) and has won two ASID/*Orange County Home Magazine* awards for Design Excellence.

The result of her various exploratory trips to Europe can be seen in Linda's wide-ranging style – freely integrating Italian, Old English, Spanish, Austrian, Asian, Scandinavian, French, and German accents with contemporary, period, traditional, Montecito and Santa Barbara design styles. "I'm inspired by architecture, art, locations and vistas, by interesting antiques, and by my wonderfully diverse, fascinating and adventurous clients," she says. Linda's commitment to quality is reflected in one of her favorite quotes from Oscar Wilde: "I have the simplest tastes. I am always satisfied with the best."

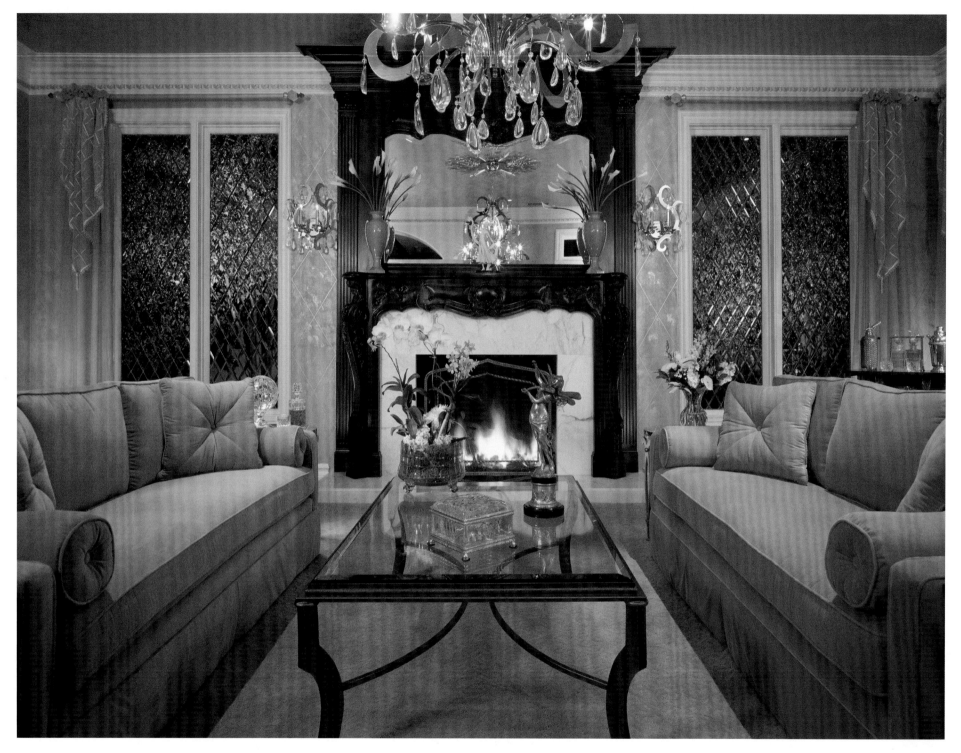

ABOVE Harlequin walls in platinum with green Lustertone overlay were designed by Linda to set off the rich mahogany furnishings. Luxurious sofas invite conversation. Philharmonic House of Design, 2004.

RIGHT Rock crystal finials, gossamer drapery, soft green pleated silk on silver Louis XVI chairs, a "campy" bar complete with vintage glasses, shaker and even an antique silver seltzer bottle set the mood. Philharmonic House of Design, 2004.

For her, the process begins with the initial consultation. "I listen...really listen... observe and question," Linda says. "I need to learn my client's lifestyle, preferences, entertaining needs, hobbies and limitations." Whether she's designing a living room or a yacht club, her creative palate is rather unique and extensive. "I love to add a touch of romance," she says. "I love color. I love to integrate maximum function into a room with fluid design. I love texture in fabrics, furniture, building materials, art and wall finishes. I want the design to flow and entice my clients and their guests from room to room."

And like a river, that interior flow can change over time, creating new paths. "My biggest joy and highest compliment is to be asked by a former client to redesign their home for a new phase of their lives," she says. "What we as residential designers do is so very personal, then when re-invited into a client's life...it is a great honor."

The secret to Linda Enochs Interiors' success is quite simple. "Our philosophy is based upon the principle of exceptional design, attention to detail, and strong customer service," she says. Currently, she is working on three vastly different residential projects. One is the re-creation of a lovely French chateau; another is restoring a mid-century modern model; and the third is creating a motif that combines Chinese and formal Queen Anne family heirloom furniture with sea shells from the coastline surrounding the Newport Beach seaside residence.

Linda is also well known for her charitable works, including her serving on the board of directors for the outreach organization, Human Options, which does extensive work with abused women and their children. She is still married to her college sweetheart, Bob, and loves gardening in her Monarch Beach home and spending time with her one-year old granddaughter, Kaylee Marie. She has two grown children, Jim and Lisa.

Linda's wonderfully diverse professional and life experiences have truly enhanced her design work and given her eclectic mantra a sophisticated, unique edge. ■

LINDA ENOCHS INTERIORS, INC.

2915 Red Hill Avenue

Suite A-210-D

Costa Mesa, CA 92626

949-248-1122

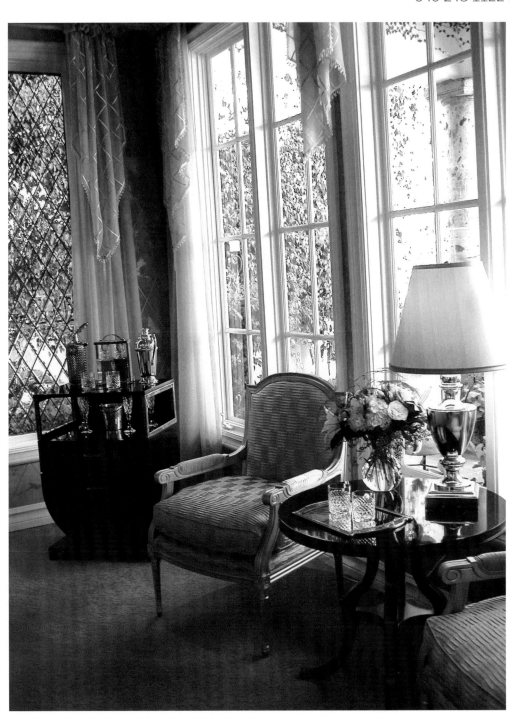

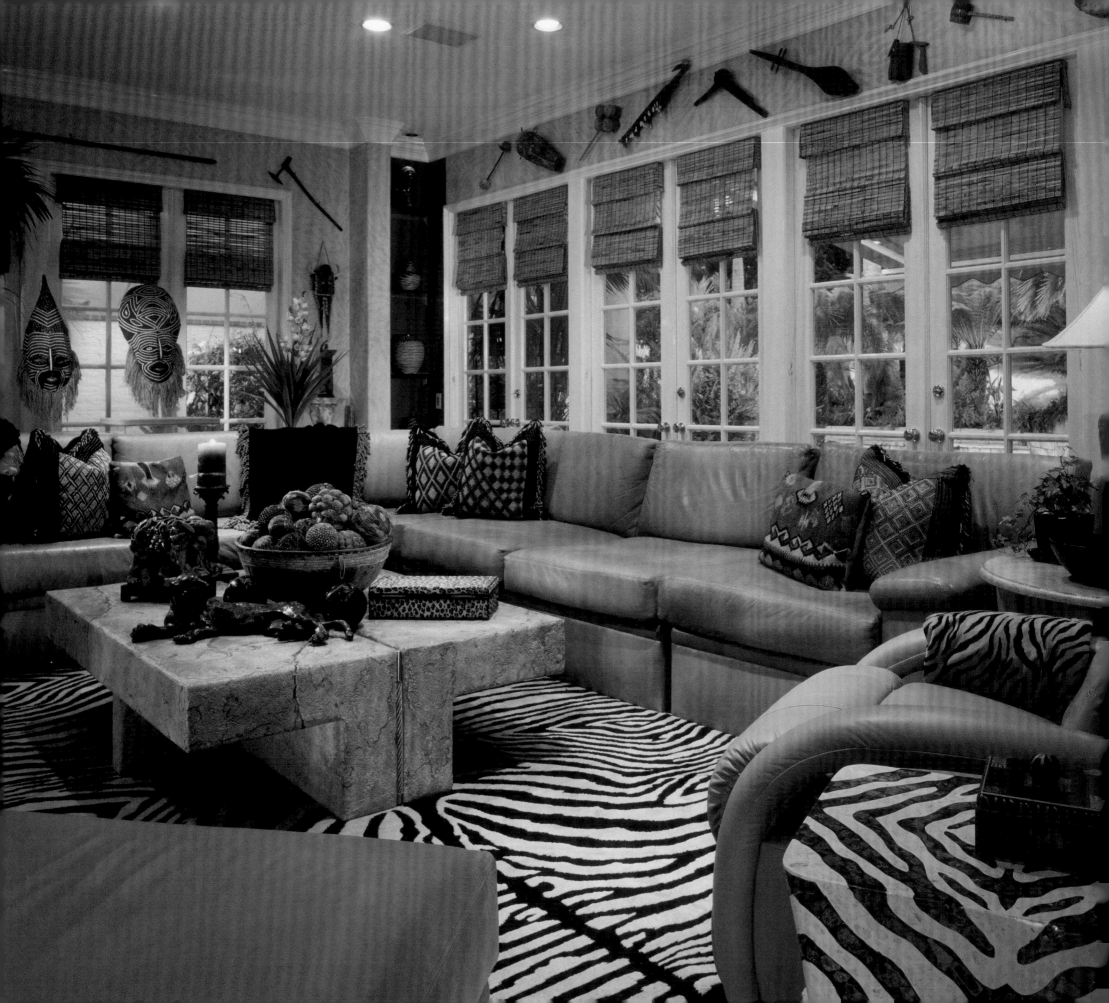

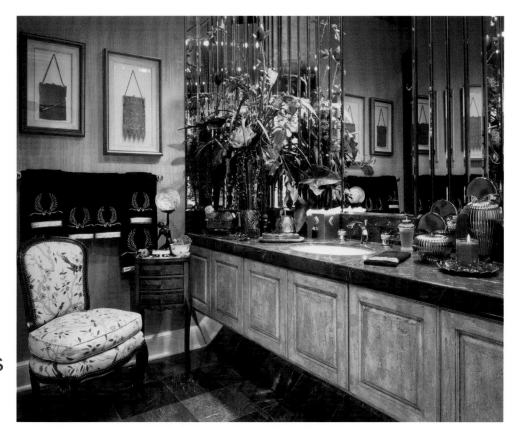

Ann Glassman,
Allied Member ASID
Glassman Interior Designs

LEFT Hand-made zebra parchment walls, a collection of African masks, weapons and musical instruments from Africa, custom sofa and carpet add a feeling of "harmony and warmth."

RIGHT Silk wall covering, marble floors and counter, rounded walls of beveled glass stripes and distressed cabinets. Antique furniture and purses adorn the walls. A large floral centerpiece adds color.

By the age of 15, Ann Glassman, Allied Member ASID, knew that design was in her blood. "Wherever I was, I saw something that had to be changed," she explains. So she took her raw talent and developed it at New York University and the Los Angeles Fashion Institute of Design & Merchandising, where she learned to develop her imagination and vision into a tangible skill.

In her 30 years of working in the field, she has owned a lighting company and two design firms, one in Corona del Mar and another in the Design Center. Today, she bases her company, Glassman Interior Designs, out of her home in Newport Beach. Her hands-on approach to design has kept her up-to-date in the decorating world and has helped her maintain a broad knowledge base. No matter what project comes her way, Ann is ready for the challenge.

People may think hiring an interior designer may be too expensive and unnecessary, but Ann assures her clients that a designer actually helps save time and money. Costly mistakes are avoided and a client receives exactly what they want in less time. "I'm always straightforward and honest with my clients," she explains. "If something isn't going to work, I let them know right away."

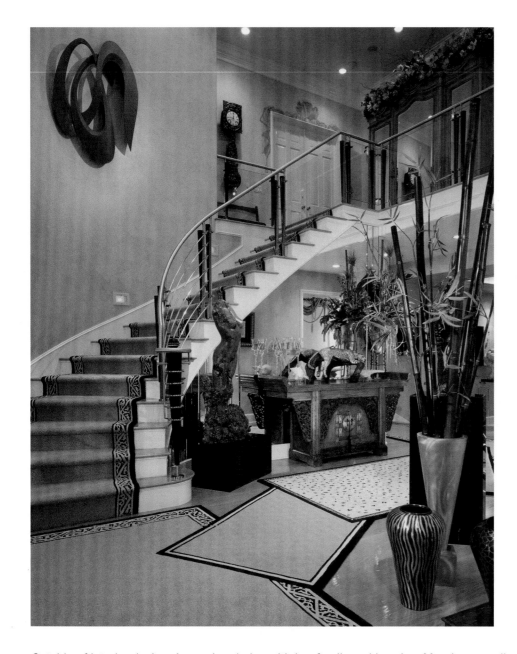

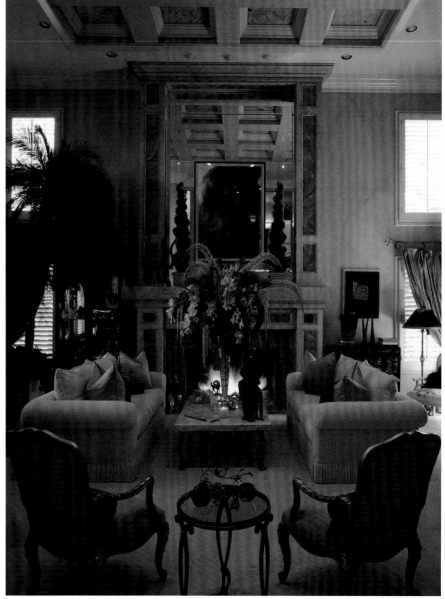

Outside of interior design, Ann enjoys being with her family and her dog, Murphy, as well as playing a few rounds of golf now and then. She spent her most recent vacation traveling through Athens, Croatia, France, Italy and Spain where she immersed herself in the culture and aesthetics of Europe. She even managed to bring home some design inspiration. "I like having my interiors draw on architecture," she says. "I love translating those exotic moments into grand style."

While she enjoys bringing some foreign flair to her work, Ann's designs always keep in mind Western comfort and sophistication. Her designs flow in ways that create a natural harmony no matter how eclectic and unusual the overall concept may seem. "I'm interested in creating dramatic statements," she says. "But I'm always concerned with the 'big bang,' the overall look."

LEFT The entry plays an important role in setting the stage for a home's design. Design inspirations come from a variety of sources. This is accomplished by adding unusual elements such as one piece entry carpet, beveled glass strips, an antique Chinese chest, stainless and black ebony railing and artwork.

RIGHT Guests who enter the residence will find harmony and balance in this room. The challenge with a room this size is to make it seem comfortable and intimate. It features faux painted walls, a clear glass fireplace, ceiling silver-leaf with red accents and contemporary art pieces.

GLASSMAN INTERIOR DESIGNS

3 Weybridge Court, Suite A

Newport Beach, CA 92660

949-721-9765

Ann usually conceptualizes a project in its entirety and gets other ideas once she can visualize the big picture. This process guarantees that no piece in the home will feel out of place or awkward. Her meticulous attention to detail and careful selection of materials ensures that all the little things come together to create a bold design that reflects the client's tastes.

In every case, Ann hopes she gives her clients what they've always dreamed of. After all, designing is her own dream come true. "I love people and love design. I think the juxtapositions between those two things is what makes me what I am." ■

TOP Solid, nuetral colors soften the look of the master suite. It features a swan bed and night stands, hand-painted bed covering and a silk hand-painted lighting fixture from Venice and parchment walls. Soft silk draperies adorn the windows.

BOTTOM Lush tropical foilage, hand-painted china and table decorations add a hint of safari to this elegant dining room. A custom chandelier lights the contemporary table with chairs upholstered in silk. Silver leaf ceiling and silk draperies add elegance.

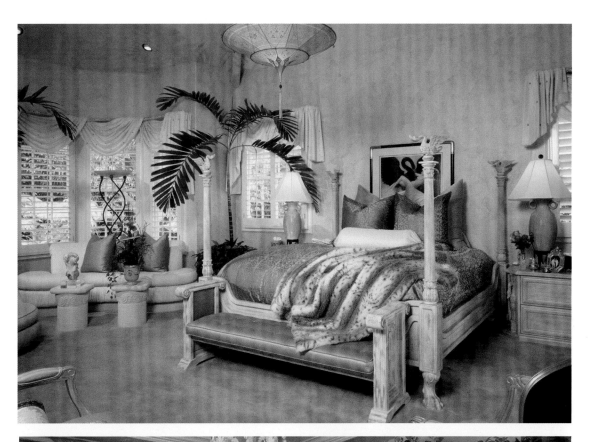

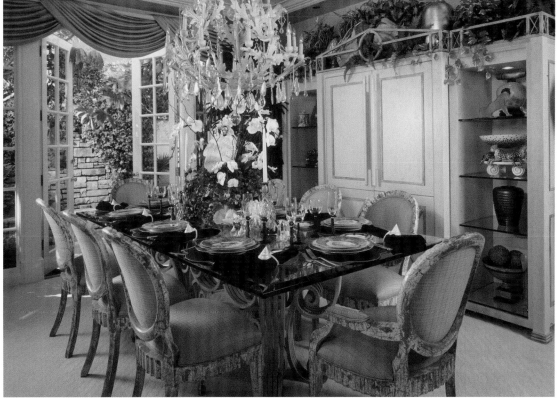

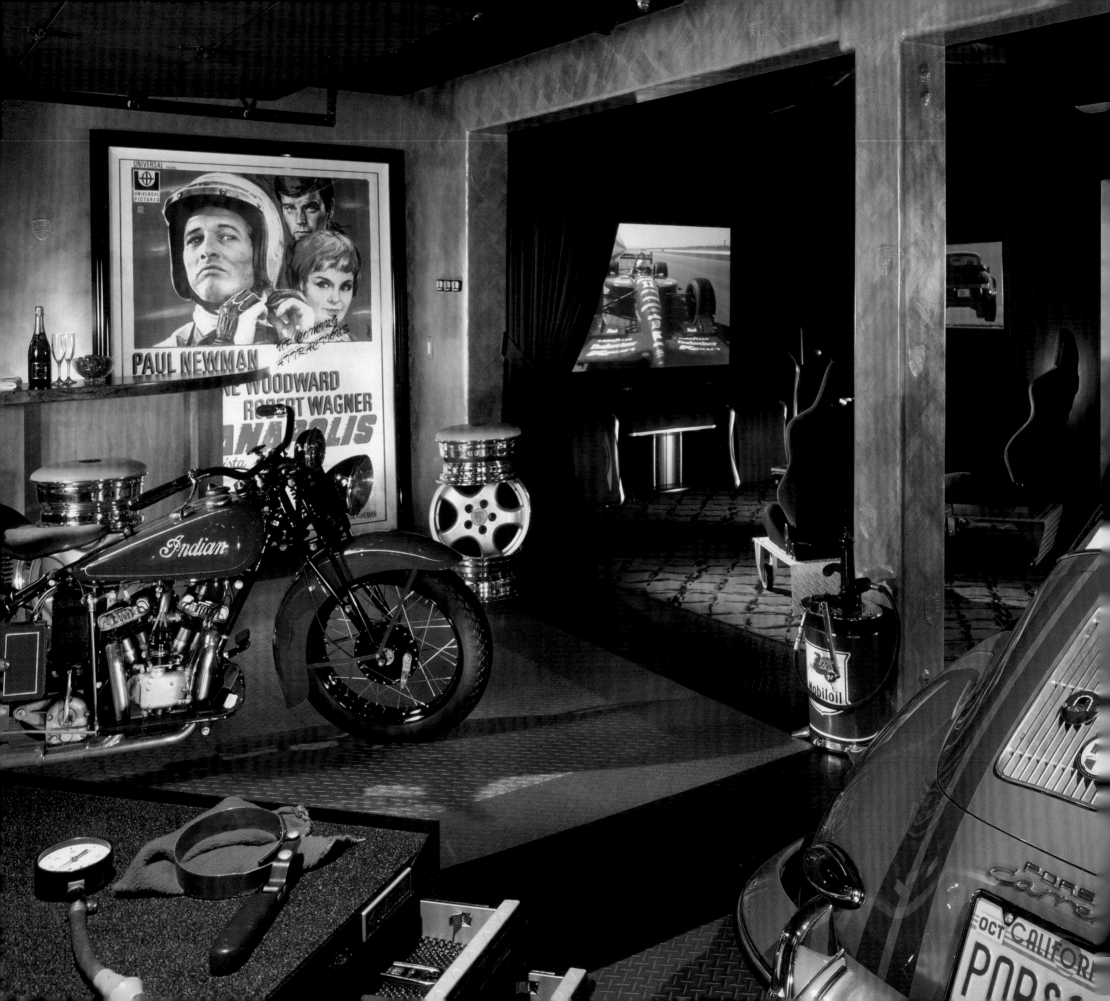

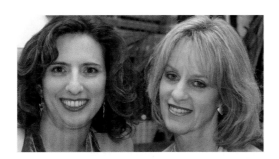

Joyce Goldstein,
Allied Member ASID
J. Goldstein Interiors

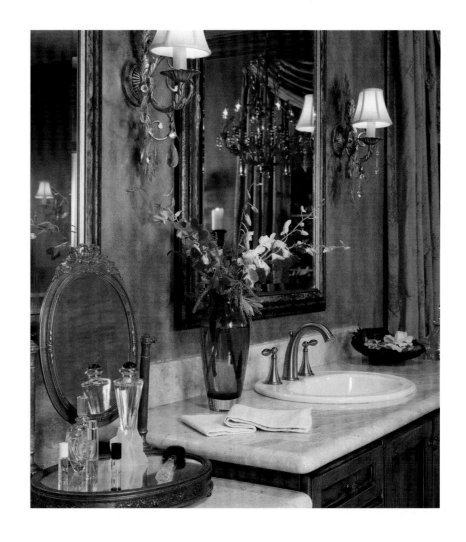

LEFT The Ultimate Garage, Philharmonic House of Design, 2005. The car collector's dream garage gives a new meaning to hanging out in the garage. 2005 CEDIA Award Winner, Best Special Project.

TOP Joyce Goldstein, right, assistant Jeannine Matsumoto, left.

TOP RIGHT An elegant and luxurious bathroom with the finest in lighting, fabric and custom wall finishes. 2003 Platinum Award Winner, Bath Design, Orange County Home Magazine Design Competition.

Some people measure success in dollars and cents, but not Joyce Goldstein. She uses a different yardstick. When her clients walk into a space she's designed for them and they break into a big smile, she knows she's won the gold.

"That's what challenges me to do my very best work with each project I take on," says the sole proprietor of J. Goldstein Interiors. "I pride myself on my instinctual ability to read clients, understand their lifestyles and create environments that work for them."

Joyce has specialized in interior design for the past six years, describing her diverse style as soft, elegant, comfortable, livable, eclectic and fun. She took a somewhat roundabout route to her current success, starting out as a floral designer, moving into landscape design for a few years, then landing solidly in interiors. Or, as she puts it, "I got married, had kids and then went indoors." That meant going back to school for her design degree and building a new business, which now includes assistant Jeannine Matsumoto.

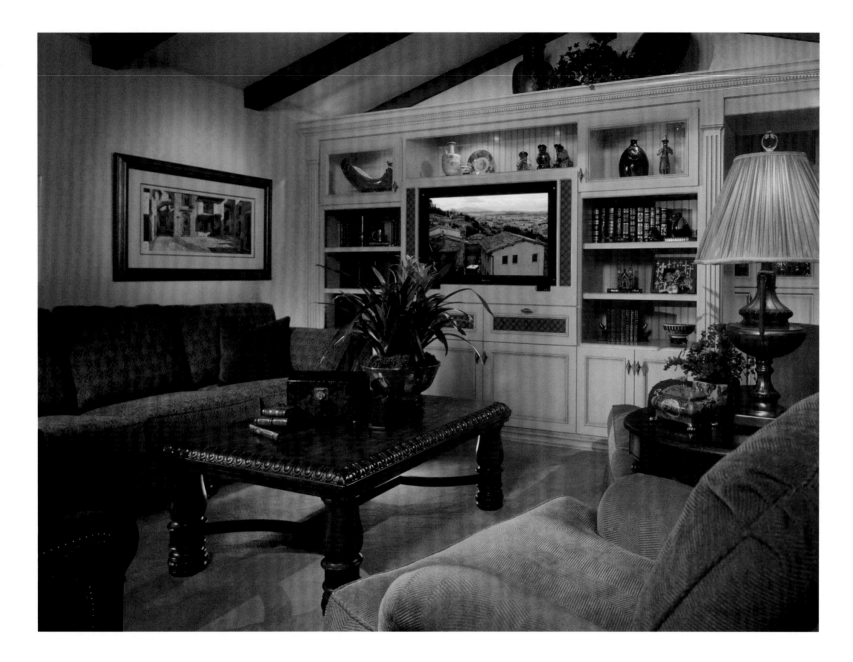

Not all of J. Goldstein Interiors' work is indoors. This is California, after all, where a person's outdoor living environment is just as important as what's inside the front door. Joyce often brings her previous careers in floral and landscape design to residential projects, adding the finishing touches to a room with plants or creating a patio design that reflects the client's personality and lifestyle.

"I want each client to experience the design project in a positive way, so I start by establishing a good rapport," she describes. "Once we have that and are really communicating, we're on our way. Many peo-ple can't articulate what they want, so we talk a lot and I pull out that one idea, and zero in on it to create a foundation for my design."

That one idea serves as Joyce's inspiration and it can take the form of the colors in a rug, a piece of artwork or an item of furniture. And if the inspiration isn't in the home?

"Then I take the client shopping," Joyce confides. "I say 'let's get inspired, let's get a theme going' so we take off to an art gallery or an antique store. Once we have that one piece, something that really talks to the client, I can build a room around it."

There's one dream project Joyce will always remember – the 2005 Philharmonic House of Design fund-raiser. Her project: a garage...but not just any garage. "It was the Ultimate Garage, a $500,000 job featuring a vintage Porsche and vintage motorcycle for the car collector enthusiast," she says.

Joyce pulled out all the stops, getting people to donate various items to give the space a Euro-tech theme. She put in a home theatre with acoustic paneling crafted to look like a road and a hand-painted trompe l'oeil mural behind the Porsche of a European street scene. She added a wine bar with a custom concrete top, featuring bar stools made from Porsche wheel rims. She then brought in a metal sculptor to create a coffee table from a floor jack to accompany the race car seating for the theatre. Joyce had the freedom to do anything she wanted and she did. "It was over the top and very creative," she remembers, "and it all worked. Visitors loved hanging out in the garage!"

And that's the kind of creativity that brings the smiles to Joyce Goldstein's clients. ■

J. GOLDSTEIN INTERIORS

Dana Point, CA

949-240-1819

LEFT The perfect environment for the family to relax in comfort and style while enjoying a custom entertainment center and cozy seating.

RIGHT Collected treasures inspired this gracious room where guests dine amid sumptuous fabrics highlighted by soft lighting.

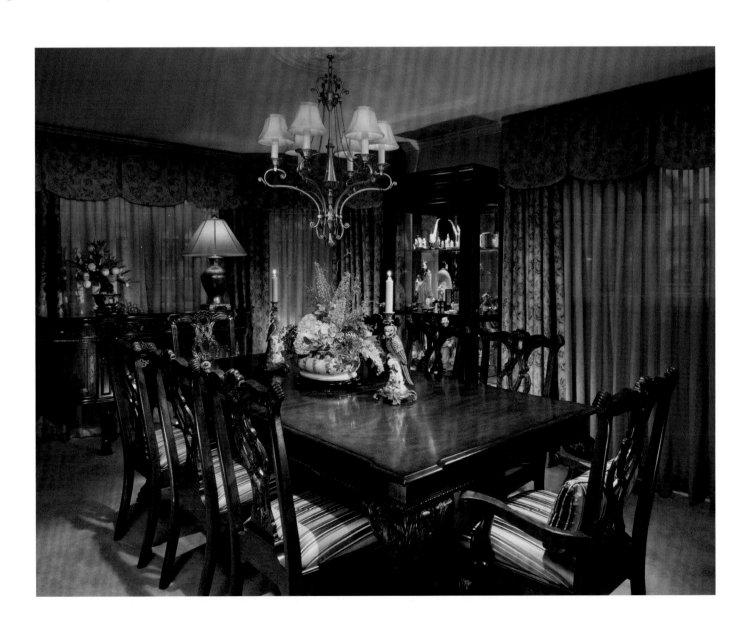

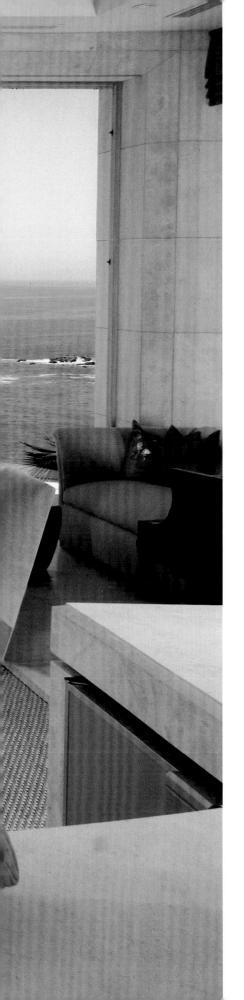

Melinda Grubbs,
Allied Member ASID
Melinda Hartzell Grubbs
Interior Design

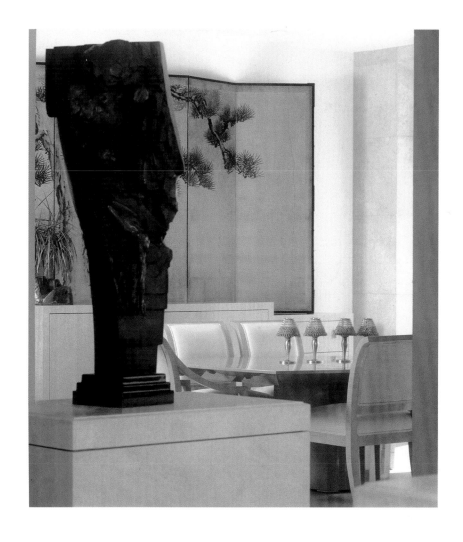

LEFT Contemporary linear lines capture and frame the landscape as art. Soft natural materials, limestone, mohair and mother of pearl blend the tones of the rock, the sea and sky outside and the furnishing within.

RIGHT Strength of character reflected in Richard McDonarld's creation of "Opheo" grounds the axis of the house. Man saving the woman he loves from the depths of the sea and certain death gives special energy and subtle reminder to the meaning of life in this home.

"The subtlety of a place is powerful. Creating an interior atmosphere that mystically dissolves into the landscape was the challenge and inspiration of this project," says Melinda Grubbs, Allied Member ASID.

Drama, elegance, function and serenity are all words that describe the creation of "home." Drama strives for an equilibrium of harmony and balance against the backdrop of the unexpected. "It's a surprise just around a corner...a delight to the eye," she says.

She believes elegance in design lies in getting the forms and composition right – the right furnishings in the right place in the right scale with the right fabrics and textures. "I like to combine uniquely textured mohair with its ever-changing sheen, with woven raw silk and cotton or mixing a natural linen with rough-cut velvet and touches of shimmering satin," she explains. "Clean lines and carefully chosen materials make for an understated environment that's easy to live in."

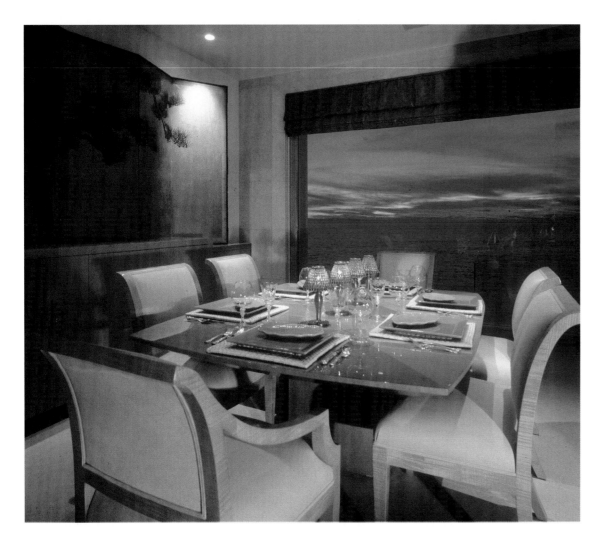

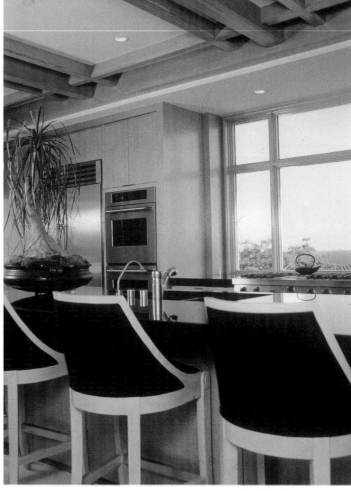

Melinda incorporates serenity into her designs, creating master bedrooms and guest quarters with beautiful, soft backdrops for well-placed furnishings. The result: inviting, subtle, sensual environments where the clients can relax and rejuvenate. "Above all, the goal for my clients is to create 'home' – rooms that are warm and comfortable and meant to live in."

Growing up in an industrial manufacturing family in the Midwest, Melinda developed her love for fine hardwoods directly from the family business. "Watching enormous walnut and oak logs being trucked into the sawmill in the early misty mornings, observing them being cut by giant saws into lumber, and then sliced into paper-thin veneers to be shipped to major furniture manufacturers made a huge impression on me," she notes. "It gave me an appreciation for nature and its elements, and how we can process these elements into all kinds of amazing furnishings."

Pulling from her background and combining it with her professional training, Melinda loves to incorporate exotic woods into her interiors. "Large wood panels mounted as art; understated detailing

ABOVE LEFT Dramatic views for sunset dining make for easy conversation as well as intimate dining experiences. The antique screen recalls the original torrey pine that once stood in it's place.

ABOVE African Absolute Black granite constrasts the African Fiddleback Anegre cabinetry in this zen like kitchen. The antique bronze water pot with ancient knotted ponytail palm vies for center of attention.

FACING PAGE LEFT The everchanging soft sheen of mohair picks up the evening glow of a setting sun. Once grey - green reflecting the color of the ocean the mohair is now warm with sun drenched shadow. Even the nickel and stainless steel surfaces pick up the warmth from beyond.

FACING PAGE RIGHT Shiny and smooth, light versus dark, rough thirsty towels versus clear liquid bottles make this bathroom easy to relax in and find serenity. Bubbles in the jacuzzi quietly call to step in.

in cabinetry faces; and strategically placed, custom furniture make my work unique," she says. Adding impact to her designs, Melinda juxtaposes a wide range of materials to complement the beauty of the wood – from steel and bronze, to limestone, leather, sea grass and knotted wools.

Over the years, her work has garnered the attention of appreciative clients and the media alike. Melinda's relaxed, innovative interiors have appeared in *Orange County Home Magazine, Orange Coast Magazine* and *California Homes* magazine.

The backbone of all her work is a well-designed, architectural interior. It sets the stage for her decor. "Natural materials, properly placed, make for a pleasing canvas to appoint a well-dressed, comfortable, and functional living environment." ■

MELINDA HARTZELL GRUBBS

INTERIOR DESIGN

190 Emerald Bay

Laguna Beach, CA 92651

949-376-2856

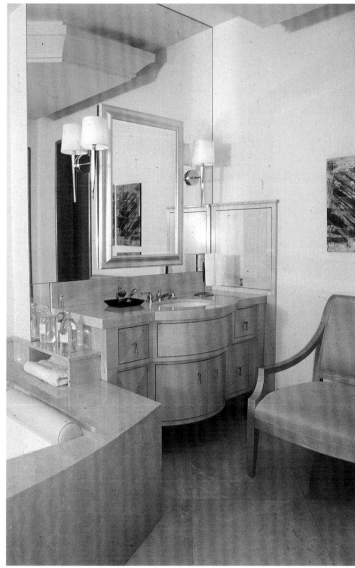

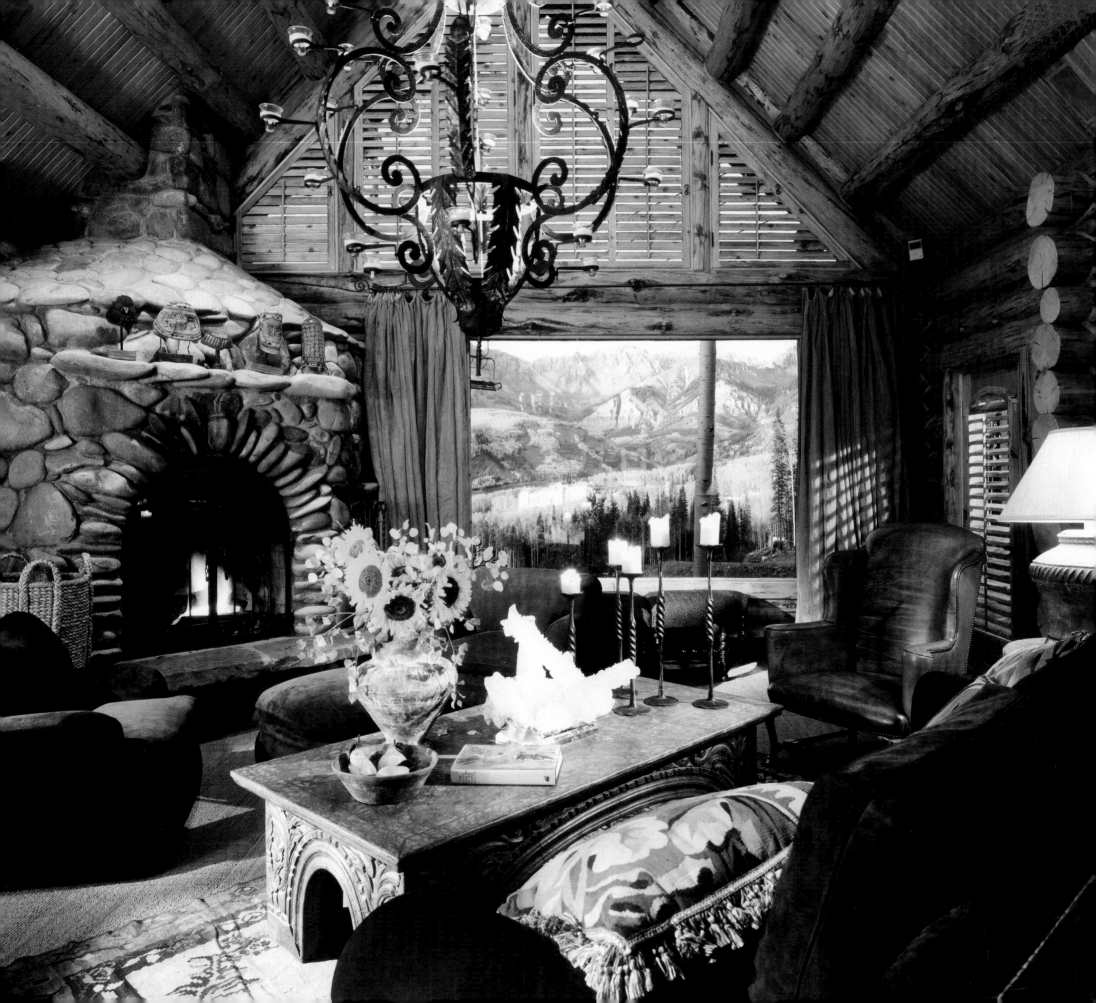

Christine Hallen-Berg, ASID
Robinson Hallen-Berg

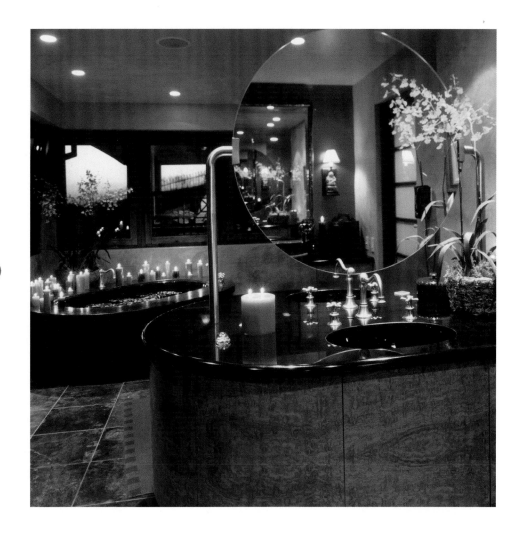

LEFT An authentic candleabra illuminates this warm, cozy Living Room in Colorado. The use of rich suedes, leathers, and antique rugs invites one in to stay a while.

RIGHT This sexy spa-like Master Bath has a floating concrete tub and open air shower that overlooks the Pacific Ocean. The color-integrated stucco was brought inside on the walls to give an indoor/outdoor feeling.

Christine Hallen-Berg never needed dollhouses when she was a girl. The full-size versions provided more than enough fuel to keep her imagination running on overdrive. "I always asked my dad to go to open houses to see the interiors," she explains. "I would mentally rearrange the things in the houses that I would visit."

Practicing interior design has been Christine's life dream since she watched her godmother excel at the profession. "She was an exotic woman with an exotic life," says Christine. "I was fascinated going to her office and seeing what she did. She had projects all over the world." After finishing college, Christine had the chance to work side-by-side with her mentor. "I freelanced for her for awhile, but then she and I got more and more calls and decided to do it full time together," she explains. "I brought her out of retirement."

The experience helped Christine establish herself as a self-reliant designer. "I felt like a sponge in the beginning," she says. "As I grew more experienced, I had more confidence in doing projects on my own and having my own ideas." Ten years ago, Christine took over the business completely, but her firm still bears the name Robinson, ensuring the legacy of Christine's talented godmother, Claire Robinson.

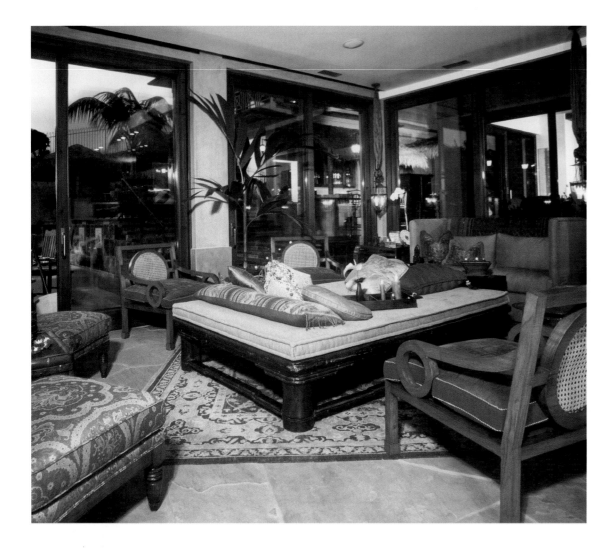

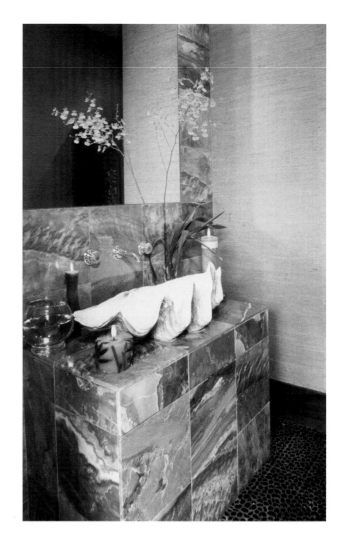

You can't learn how to be a good designer, according to Christine. "Either you have it or you don't," she explains. "In school, you learn the fundamentals and principals of design and about different periods and styles, but I believe you're born with creativity."

And Christine certainly has plenty of those creative juices in her blood. She's always changing styles, never doing the same look twice. "I've never shown the same fabric," she explains. "I'm not a cookie-cutter designer. When something starts to be used over and over, I'll shy away from it." Like the color red or chartreuse, she says. Though she loved using it years ago, now it seems too commonplace for her stand-out personality.

Luckily, Christine has plenty of creative clients who keep her filled with new inspirations and ideas. "I liked to be challenged by the client's creativity," she explains. "When a client is asking you questions and making you think, the project is more exciting and you don't get complacent. It makes me a better designer."

TOP LEFT An antique Chinese daybed was found first on a buying trip to Bali to be the focal point of the room. Lounge chairs of exotic teak and beautiful textiles surround it to create a fun lounging area for a small group or large party.

TOP RIGHT Finding the clam shell in Bali started the entire environment of this Powder Room. Stepping upon a black pebble floor and seeing the contrast of the raw, natural shell against the polished onyx surround gives the drama every Powder Room should have!

FACING PAGE This yacht interior won the prestigious Showboats International award for "Best Refit of the Year." The custom, hand painted armoire acts as a beautiful background to this warm and sophisticated interior separating the Main Salon from the Dining Salon.

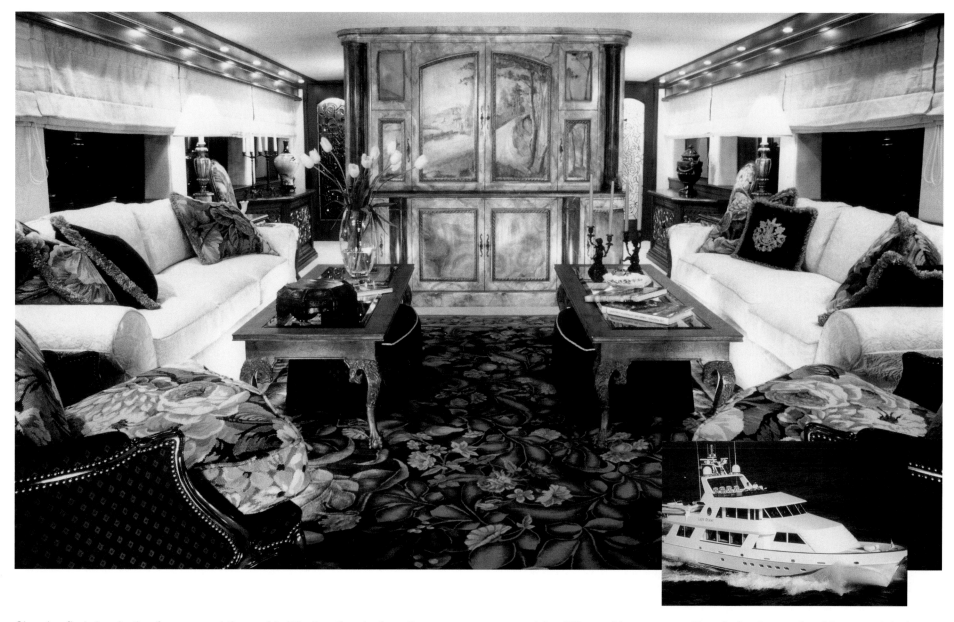

She also finds inspiration from around the world. Whether they be from Europe, Southeast Asia, or Central America, design ideas have come to Christine from every corner of the globe. In fact, her trip to Bali in the early 1990s changed her whole design philosophy. "I came home a completely different designer," she explains. "I started thinking outside of the box. Before, I was doing the perfectly matched interiors. But in Indonesia, they're so creative – it had an incredible influence on me."

Her favorite project was a house done in a contemporary Balinese style, where she was able to create a clean and comfortable style with a taste of Asian influence. Much of Christine's more recent work has reflected this kind of California contem-

porary style. "We need to come up with a design forum of architects and designers to figure out what is the 'California' style," she says. "We do everything here! But that's what makes it fun."

And fun is exactly what she had in mind when she transformed a clam shell into a bathroom sink in a powder room she was designing. "I like using different materials together and combining different kinds of stones and textures," she says. "I like to take architectural elements and turn them into something creative and functional."

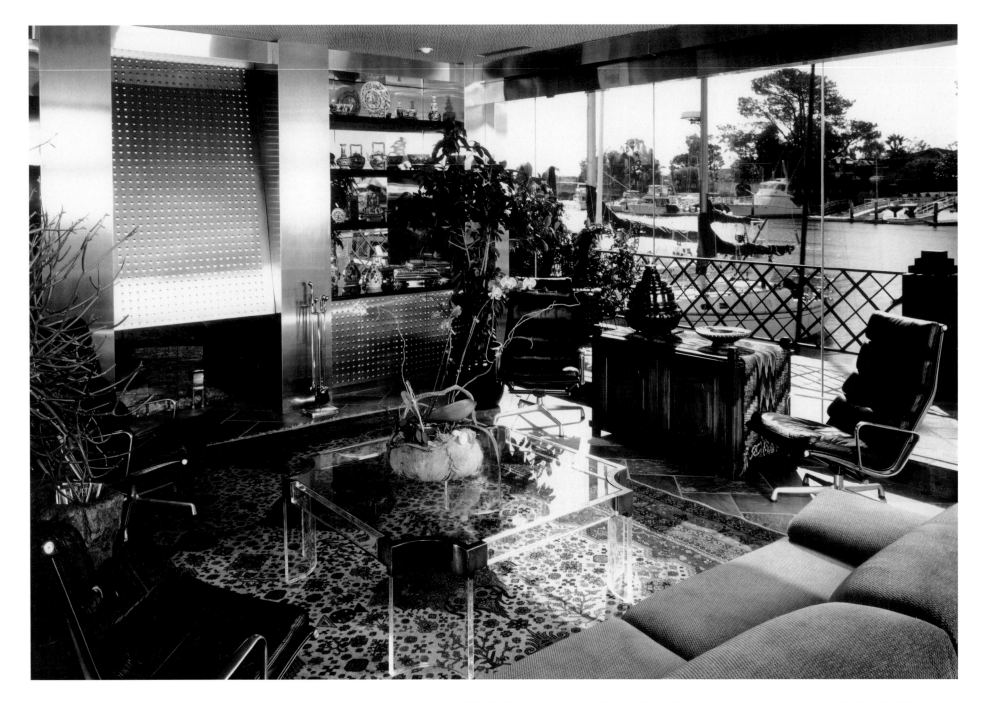

ABOVE The use of special stainless steel from Forms and Surfaces on the fireplace and adjacent cabinets create an unusual backdrop to an eclectic interior of contemporary elements with ethnic overtones.

FACING PAGE TOP The rich craftsmanship and finishing of william Oh's cabinetry with use of gorgeous honey-toned marble gives this "Italian Kitchen" a warm and inviting feel.

FACING PAGE TOP Sanctuary, retreat, refuge...the backdrop of the organic log structure adds warmth and texture to the elegant furnishings. A custom chaise made just for the owner adorns the corner inviting her to relax and read a book.

Her ability to design unique and livable spaces has garnered her appearances in numerous publications as well as earned her an award for best yacht interior. She designed the interiors of a yacht in Seattle and it has since traveled around the world, bringing the best of Christine to Italy and Tahiti.

Outside of design work, Christine and her husband love indulging in the food and wine of other cultures. In fact, they own part of a restaurant, called Tabu Grill, next door to her design firm. In keeping with Christine's unique personality, the menu features an eclectic mix of foods, grilled to perfection.

Her adventurous spirit allows her to explore new frontiers and continually expand her horizons. Whether she's designing a home, a restaurant, or a golf course, Christine is sure to bring her flair for the exotic to the most ordinary of places, transforming the mundane into magic for years to come. ■

ROBINSON HALLEN-BERG

2894 South Coast Highway

Laguna Beach, CA 92651

949-494-9951

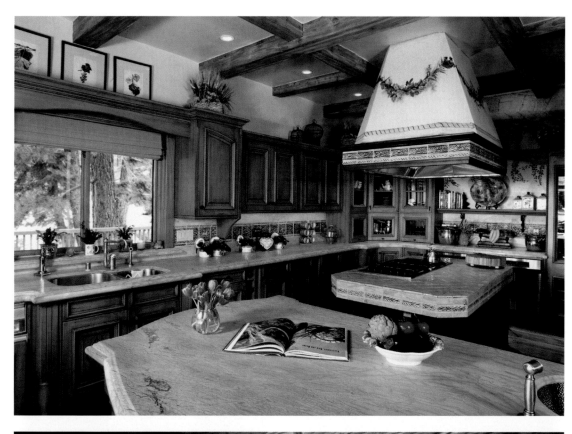

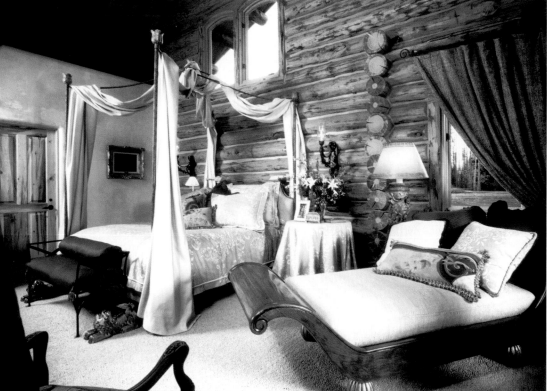

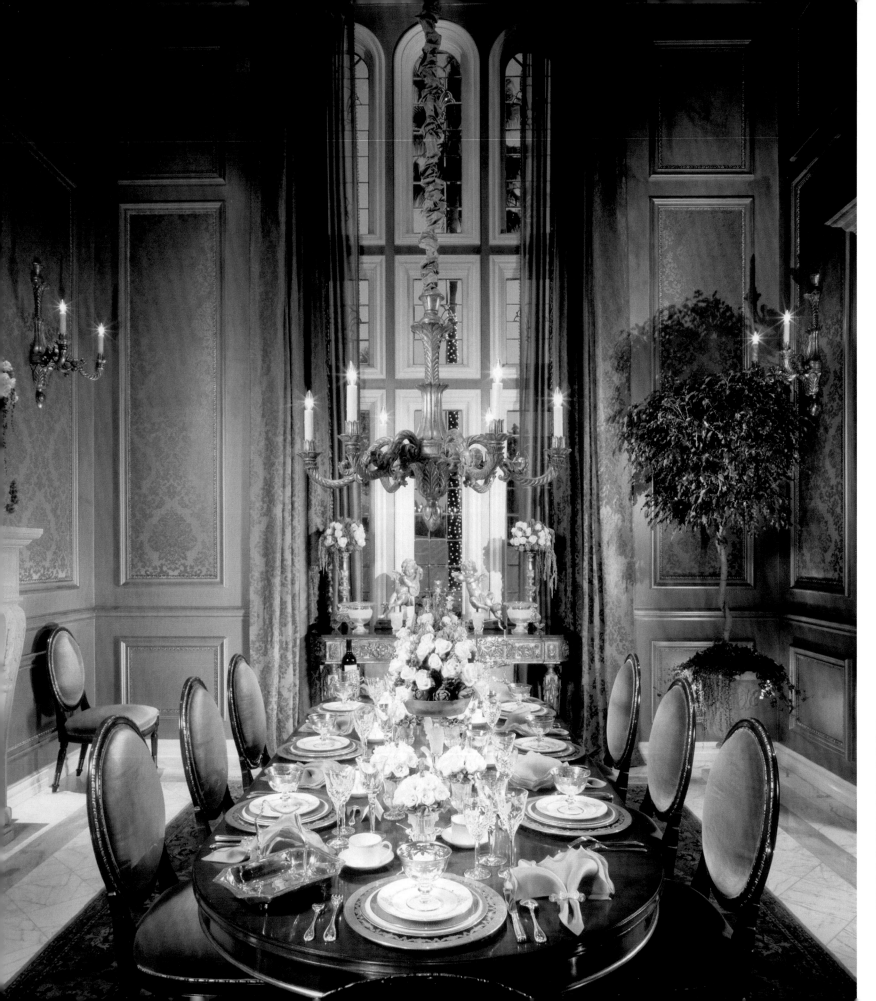

LEFT Platinum walls, decorative moldings with gilt acanthus leaf decoration, and silk damask define classic elegance in this formal dining room. The designer's talent for creating pieces expressly suited for her clients is showcased in the custom neoclassic dining table, chandelier, and sconces. An abundance of antique silver, crystal, and white florals add great style to this stunning room.

Lori Hankins
Allied Member ASID, IIDA Associate
Elegant Environments

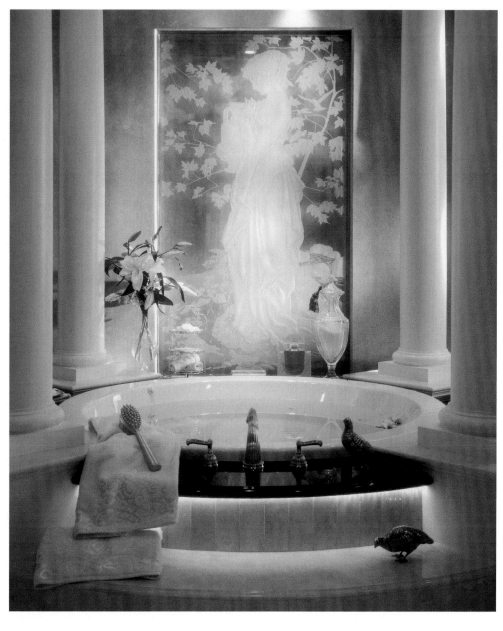

RIGHT The designer's vision of a custom etched glass panel depicting a Grecian lady is the focal point for this elaborate Master bath in Newport Coast. Walls were brought to life by layering several shades of metallic glazes. A silver leaf dome, spa tub, architectural columns and Verdi granite, laser cut into polished marble, are just a few of the opulent highlights. *Orange County Philharmonic House of Design.*

As a premier designer in Orange County, Lori Hankins' work garners significant attention time and time again. The owner and principal of Elegant Environments, her designs have been featured in eight Southern California showcase houses, the television show "Entertainment Tonight," as well as in *Orange County Home Magazine, Orange Coast Magazine, Interior Expressions, Costa D' Oro* and *Family Living* magazines. Additionally, she has won a number of ASID and *Orange County Home Magazine* outstanding interior design awards for Best Bedroom, Best Living Room, Best Home Office, Best Master Bath and Dressing Area, and Best Small Space.

"I enjoy working with clients who love classic, sophisticated style, are appreciative of new ideas, and allow you to create the total picture," she says. For more than 26 years, Lori's comfortable, luxurious interiors have showcased her talent for combining an extensive architectural knowledge, wonderful colors and unique pieces with rich fabrics. "It's the fine details of an interior that are the most important," she says. "I usually start with a particular fabric for inspiration. I love them all: beautiful silks, sumptuous upholstery, warm tapestries, gorgeous woven linens, elaborate trims and delicate braids – anything that makes every detail in the room shine. Whether I'm creating or remodeling

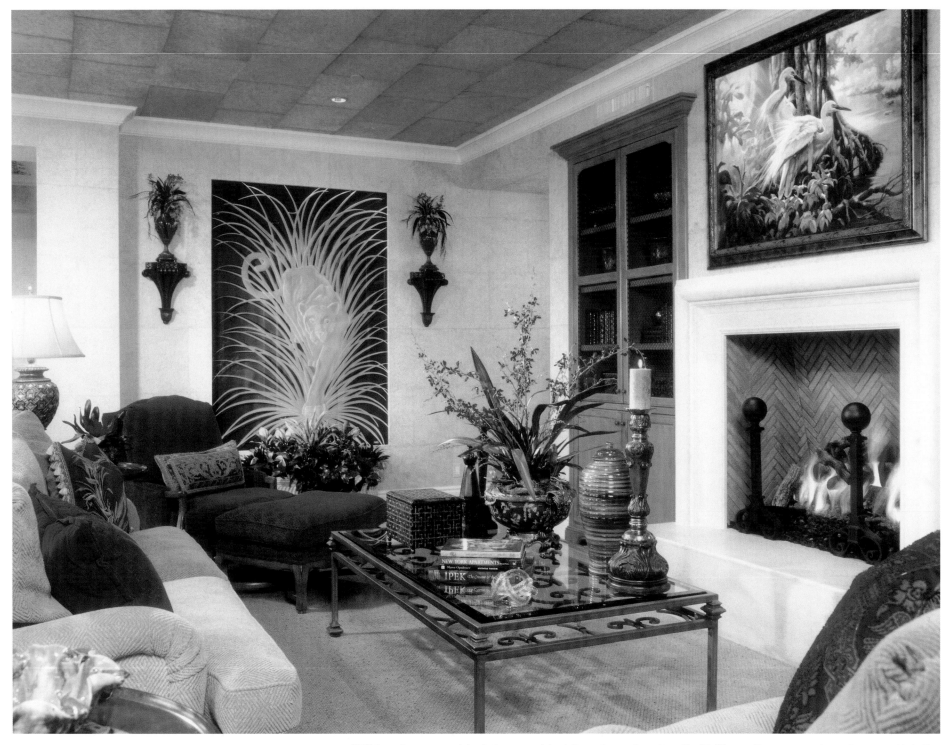

TOP A contemporary etched glass panel depicting a leopard, custom lit with fiber optics, was used as art recessed into the wall. Dyed rice papers layer the walls and ceilings. Carmel glazed built-ins disguise media equipment for family entertaining. Tasteful lighting, romantic orchids, and an eclectic mix of accessories add warmth and color to this beautiful space.

RIGHT A second etched glass panel of a tropical landscape was added above the bar and framed with wood paneling. Two exotic linen prints with tassel trim frame the beautiful windows and define the color palette. Woven shades, tapestry pillows, and contemporary art are just a few of the unique touches Lori created for this family's lifestyle.

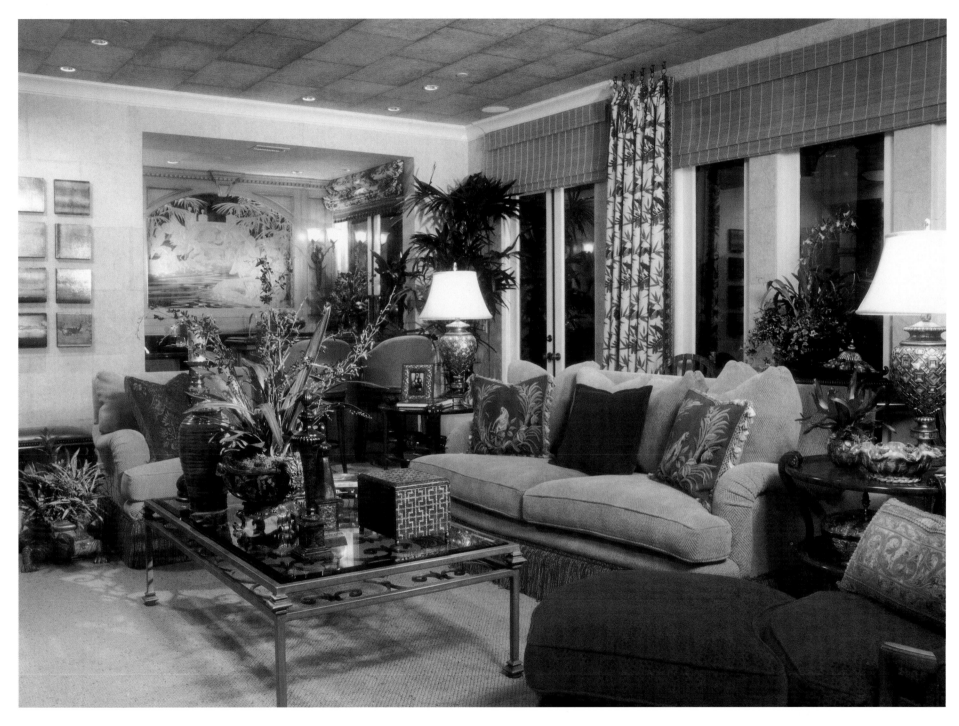

an office, a living room, a bedroom or a kitchen, considering the details results in rooms that have a high style with a touch of romance."

Together with her experienced team of craftsmen, Lori has earned a solid reputation for sound design, practical project management and client satisfaction. Her interiors are imbued with a timeless elegance and sophistication – qualities she says were shaped over the years by listening carefully to clients to hear exactly what they want. "An interior designer must work with people's spirits," she believes.

It's this philosophy of embracing the client's wants and needs that has turned her clients into repeat customers, as well as long-time friends. "The interior design process is about bringing beautiful things into clients' lives. They trust me to come up with incredible ideas that they would not have created on their own," she says.

It should come as no surprise to learn that Lori is involved with clients from the very beginning of a project – advising on architecture, landscaping, colors, surfaces, lighting, furnishings, window treatments and accessories (which she

loves). If the client wishes, she can design a completely new interior, or mix existing furnishings with a smart and stunning array of finds – contemporary, classic, antiques or unforgettable artwork – anything that sparks the imagination and creates a unique, tasteful environment.

This is exactly what she's done for an Orange County family with three children, who shortly after purchasing the home, set about remodeling and decorating with a eye on raising their kids and grandchildren there. "The work we did - both inside and out – made them feel great about their house. They don't ever want to leave what we've created," notes Lori. "With children, functionality was high on the list. Plus there was the possibility that they'd live there forever, so it was important to take into consideration the layout, as well as the ability to grow in the home, to entertain and to have functional spaces for the family. It's not just about the fabrics and how the house

looks; it's about how it feels and how it works." Custom-made furniture, interesting wall finishes and a pool featuring colorful glass mosaic dolphins are just some of the touches Lori brought to the project. In the end, Lori designed a gracious, stylish interior and exterior that works well – and most important – brings pleasure to the entire family.

In addition to practicing design, Lori unwinds by spending time at home and working in her formal garden. A series of low boxwood hedges joined in the corners with ornamental topiaries and 68 colorful, fragrant rosebushes combine to create the effect of a "mini Versailles" garden. When not exercising her green thumb, Lori enjoys life with her family and two shih tzus, Daisy and Holly. "I love anything that has to do with home and family," she says. "And I get so much enjoyment from helping others create their own elegant environments." ■

LEFT The Master Dressing area is elaborately designed with custom cabinets glazed by blending pearl and gold metallic paints. Gold plated "lighted" closet rods were selected for a striking and dramatic effect. Frosted glass hardware for the cabinets, antique furniture and a silk velvet recamier provide classic elegance to this Newport Coast residence. *Orange County Philharmonic House of Design.*

BELOW This stunning bedroom was created by combining two smaller rooms into one and repairing the home's original "plaster" moldings. Windows are dressed in a beautiful "wedding toile" print with lavish tassel trim and silk shades. The gilt poster bed, a focal point of the room blends beautifully with antiques, custom pedestals, and exquisite linens.

LORI HANKINS

ELEGANT ENVIRONMENTS

9 Hickory Fork

Coto De Caza, CA 92679

949-249-3575

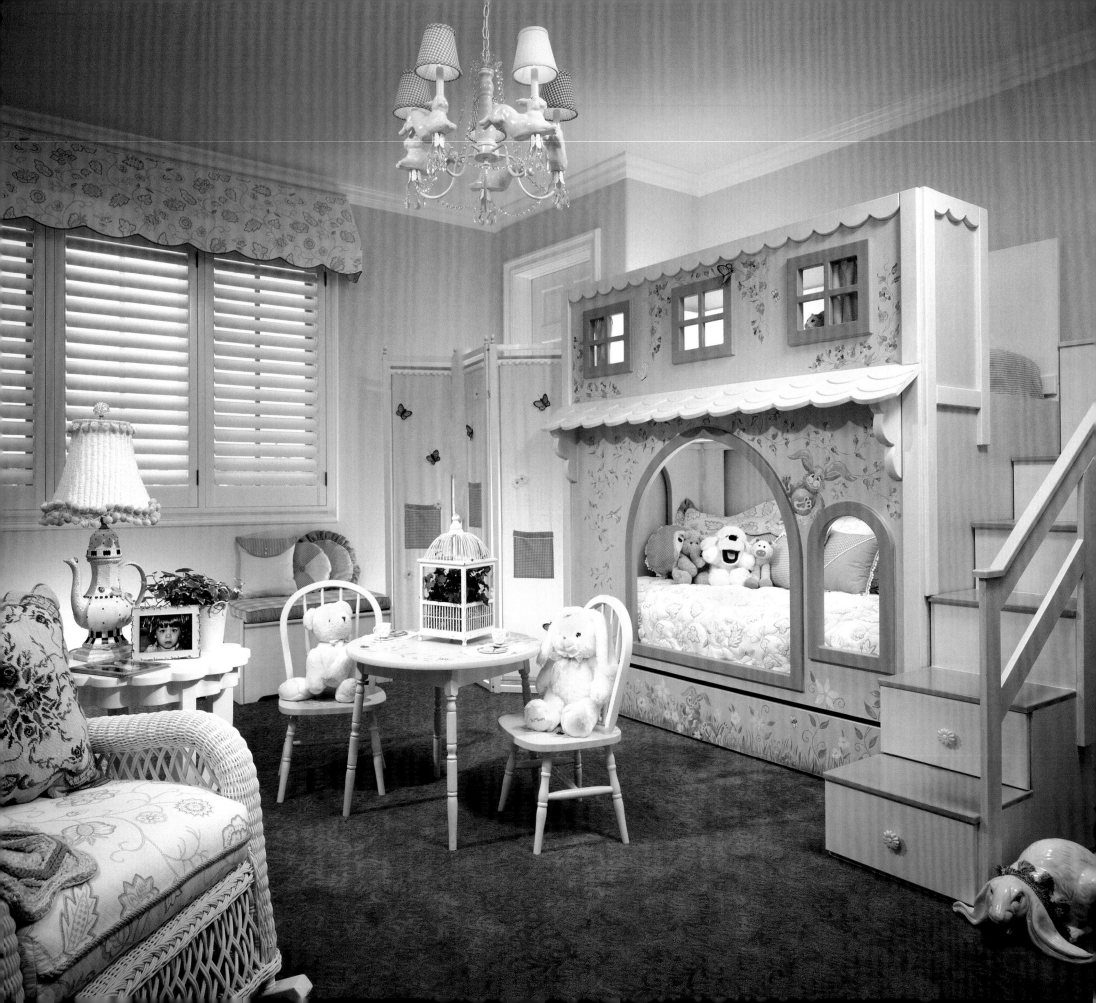

Sheila Hupp, ASID, CID
Sheila Hupp Interior Design

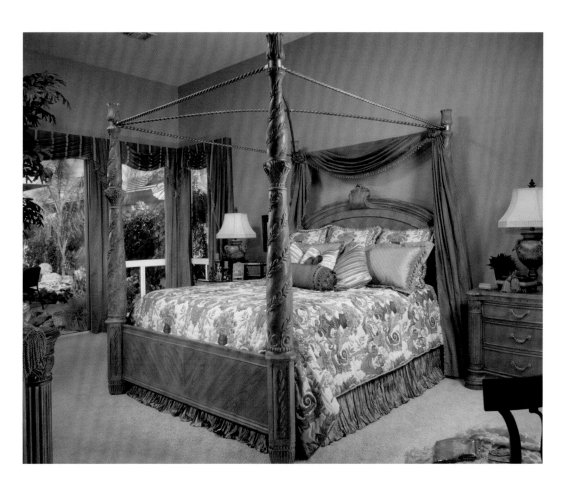

SHEILA HUPP INTERIOR DESIGN

21241 Avenida Planicie

Lake Forest, CA 92630

949-951-1591

LEFT Granddaughter's room. 2004 Philharmonic House of Design.

TOP Master Bedroom. Pauker Residence, Palm Desert.

S heila Hupp doesn't sing in the shower. While a lot of us are jump-starting our mornings belting out watery tunes, she's working out designs in her head.

"My best ideas come when I'm in the shower," confides the sole proprietor of Sheila Hupp Interior Design and the current president of the Orange County Chapter of ASID. "Design is so dynamic and the problem solving nature involved in design demands that you are always on your toes and up to date."

Although interior design was always her first love, Sheila spent the first few years after graduating from U.C. Santa Barbara teaching and raising a young family. Then she went back to school, receiving her Certificate in Environmental and Interior Design from the school of Fine Arts at U.C. Irvine in 1984. She's been busy ever since. Having worked with other firms and partners in the past, she now enjoys having her own company and is in the process of expanding her staff.

"I have a wonderful variety of residential projects going on," she says, adding that she lets her clients' wishes dictate where she goes with a particular design project. Sometimes it's Art Deco, other times it's a Craftsman or Tuscan design, often in a second or vacation home.

As busy as those projects keep her, Sheila not only finds time for her ASID work, but also finds it extremely rewarding and is proud that her efforts have helped moved the chapter forward. "Being president could be a full-time job," she admits.

But it isn't. Sheila's real job is interior design and it's a job she loves.

"The challenge is to take the 'wish list' gleaned from speaking with my clients, and integrate those wishes with their lifestyle to create a home that is functional and comfortable as well as beautiful. I hope to expand their horizons and bring about exciting solutions to their projects." ∎

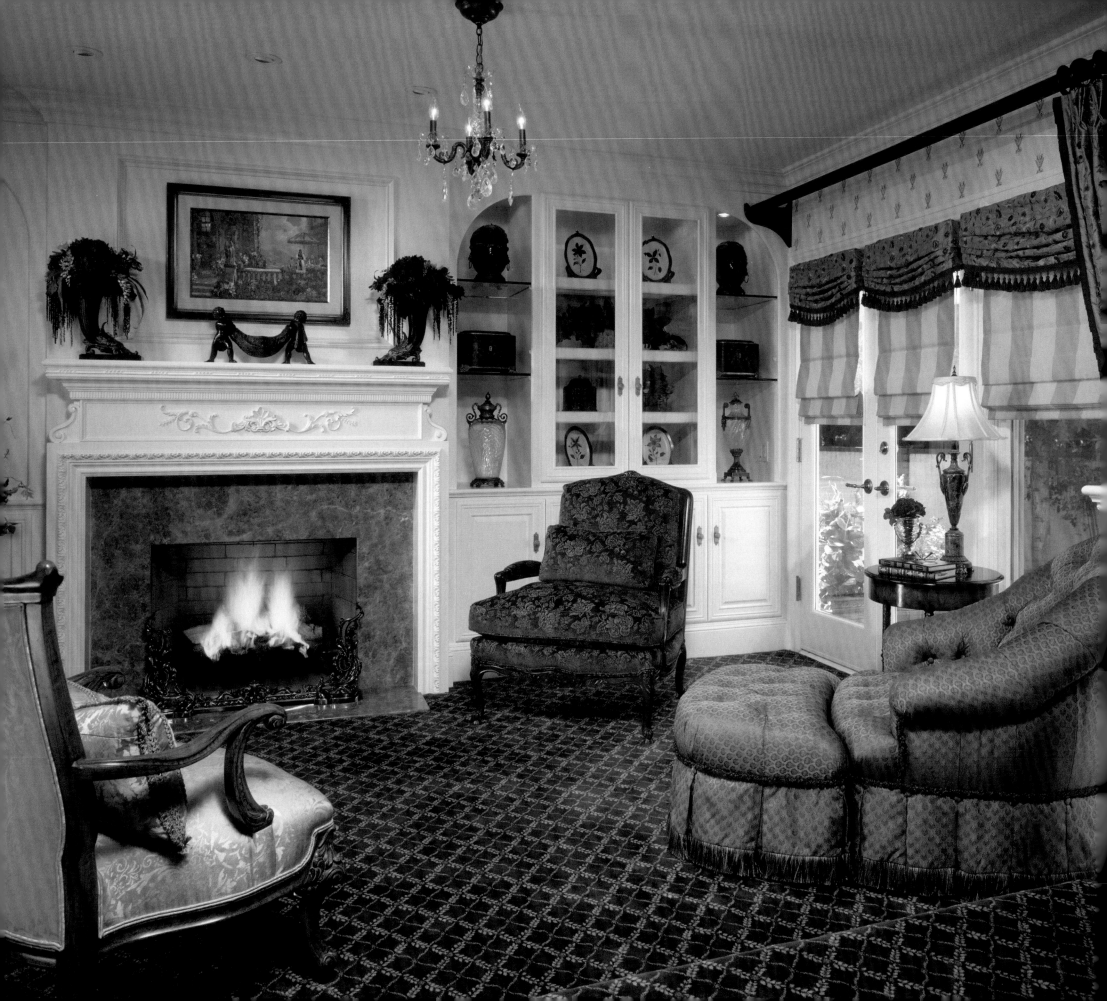

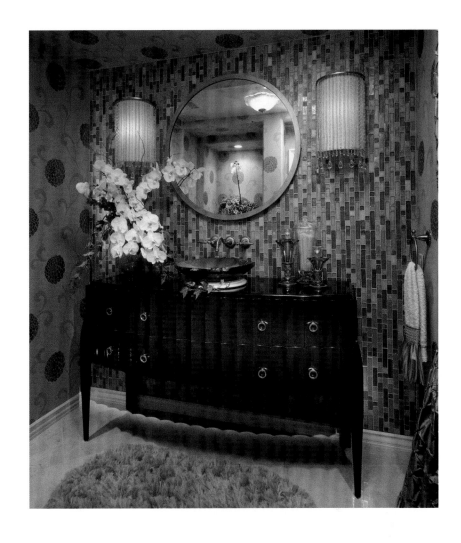

Cory Keith,
Allied Member ASID
Joyce Bright Interiors

LEFT Extensive custom millwork combined with silk, trims and carpets calls you to come and sit by the fire.

RIGHT Inspired by the 1940's, this powder bath is the essence of luxury. Glass mosaic tiles cover the entire wall with crystal sconces and shimmering vessel bowl. *2005 Philharmonic House of Design*.

"Interior design is not just about pretty things set within a pretty setting," says Cory Keith, Allied Member ASID and proprietor of Joyce Bright Interiors located in Old Towne Orange. In fact, she rather believes that "it should really reflect the tastes and interests of the homeowner."

It is important for her and her full-service design team to personally meet with each individual client and see what each client wants to ultimately achieve: completely remodeling the home and starting from an entirely new concept or working within existing core elements and just adding a few interesting touches.

This client-driven philosophy is what has been at the core of Joyce Bright Interiors since 1982. Depending on her client's needs, Cory has undertaken a wide variety of projects: unique, smaller one-room projects to the complete from-the-ground-up architectural blueprints.

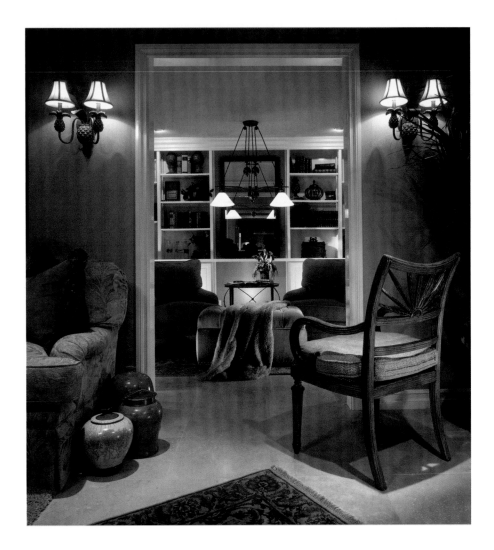

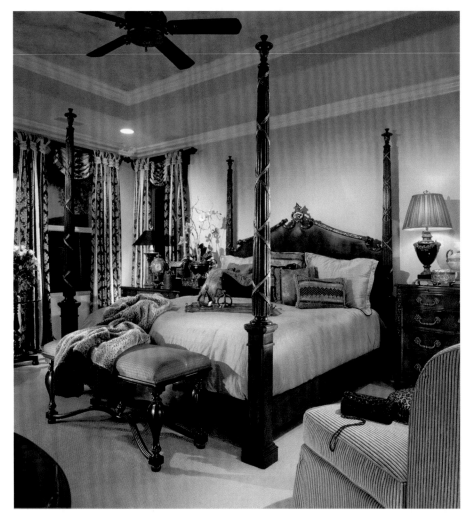

Cory's own personal style combines the traditional with the contemporary but with a twist – she incorporates contemporary art and transitional pieces to form a classic look. When pulling a room together, Cory never overlooks the value of the smallest design facets and details that provide elements of character: multiple fabrics, trims, embellishments, and exceptional accessories.

For Cory, these design elements really make a room just pop, so she is always on the lookout for such pieces of interest. She constantly scours new places to find that "something which will make a difference in a client's home," she says. And her clients are amazed when she walks in with that perfect piece that brings their room together.

That's what you need from a designer, says Cory. "To help you branch out...create scale, texture, balance and rhythm in a room and, ultimately, throughout your entire home." ■

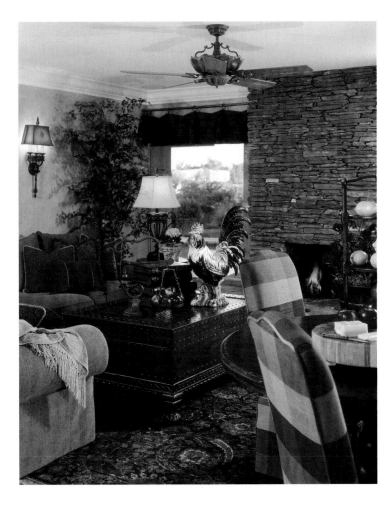

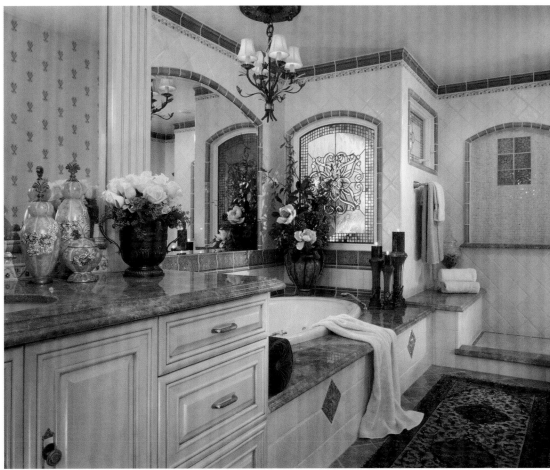

FAR LEFT Looking into this very serene and calm library, you are beckoned to come sit and enjoy the surroundings.

NEAR LEFT Elegantly appointed window treatments with attention to detail create a beautiful backdrop to the mahogany four-poster bed.

TOP European charm is evident in this family room with deep, rich colors, decorative wall treatments, hand-made rugs and original art from Europe.

TOP RIGHT This spacious master bath suite complete with lead glass windows and walk-in shower evokes warmth and tradition with the combination of natural materials and classic style.

JOYCE BRIGHT INTERIORS

227 East Chapman Avenue, Suite B

Orange, CA 92866

714-997-9430

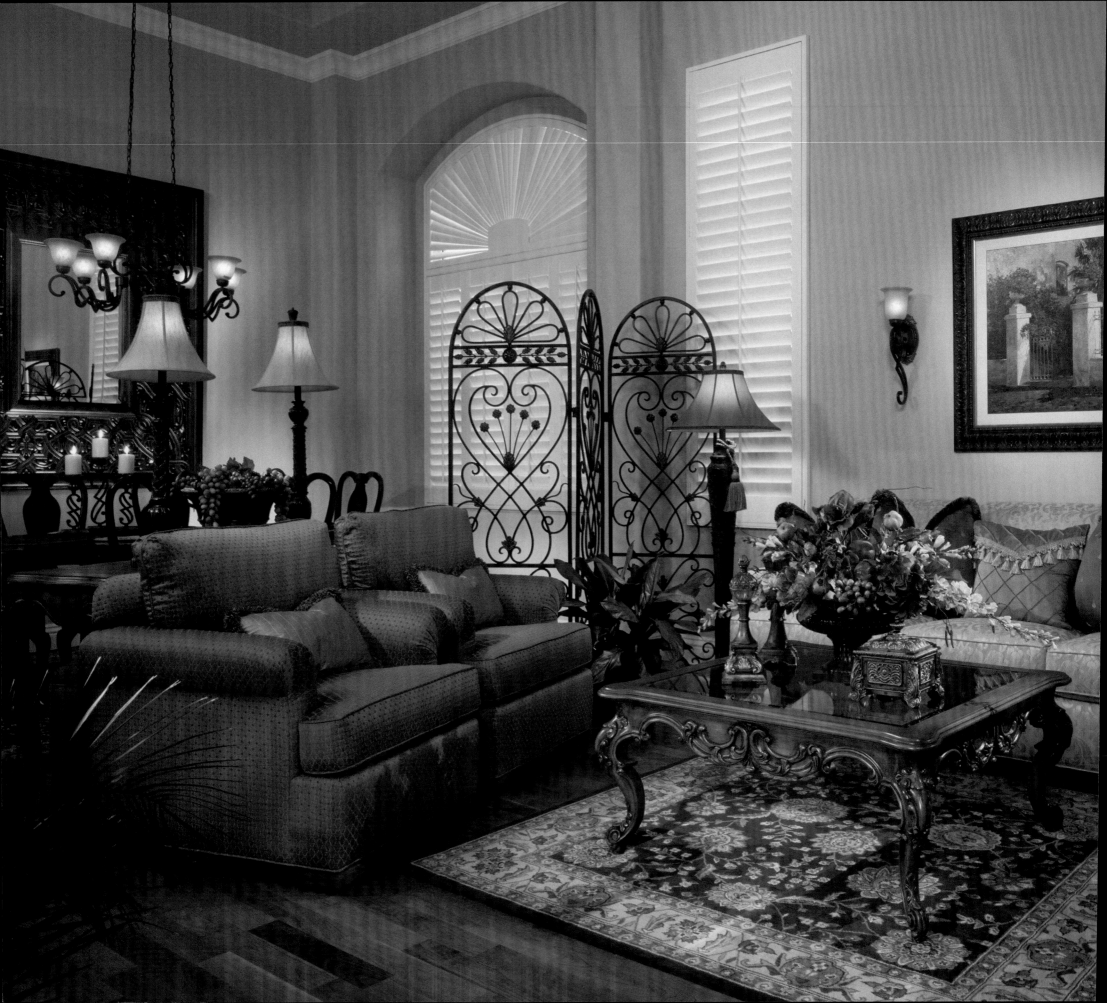

Sally Ketterer

C.I.D., Licensed General Contractor,
Allied Member ASID, IDS, CQRID
Residential and Commercial
Interior Designer
Irvine, CA

LEFT This charming Tuscan-inspired room is warm and inviting; designed in shades of gold and burgundy. The ironwork screen and chandelier bring in an Old World flavor.

When it comes to comprehensive design, Sally Ketterer, founder and principal of Sally Ketterer Interiors, believes you have to be able to see the finished project first in order to know where to begin.

Since 1989, the General Contractor, Certified Interior Designer, Allied Member of ASID and Professional Member of IDS, has been helping clients solve their stickiest design problems.

Sally takes her design cues directly from her clients. Often a work of art, an area rug, a specific piece of furniture, color palette or photograph of a room sparks a lively conversation with clients about the design possibilities. She then translates these ideas into tangible plans, and she helps clients to visualize the completed project.

From consultation to design, material specifications, coordination and installation, Sally helps clients to achieve their ultimate goals.

Her work has been featured on HGTV's "Designers' Challenge," where Sally put into practice her thorough research of the right products and materials for the project.

Her advice for clients who are feeling a bit overwhelmed by the design process: "If your budget won't allow you to do it all at once, start with a plan, and pick a room or an area to do. By working in phases with a qualified designer, you'll see where the money has been spent and feel a sense of accomplishment." ■

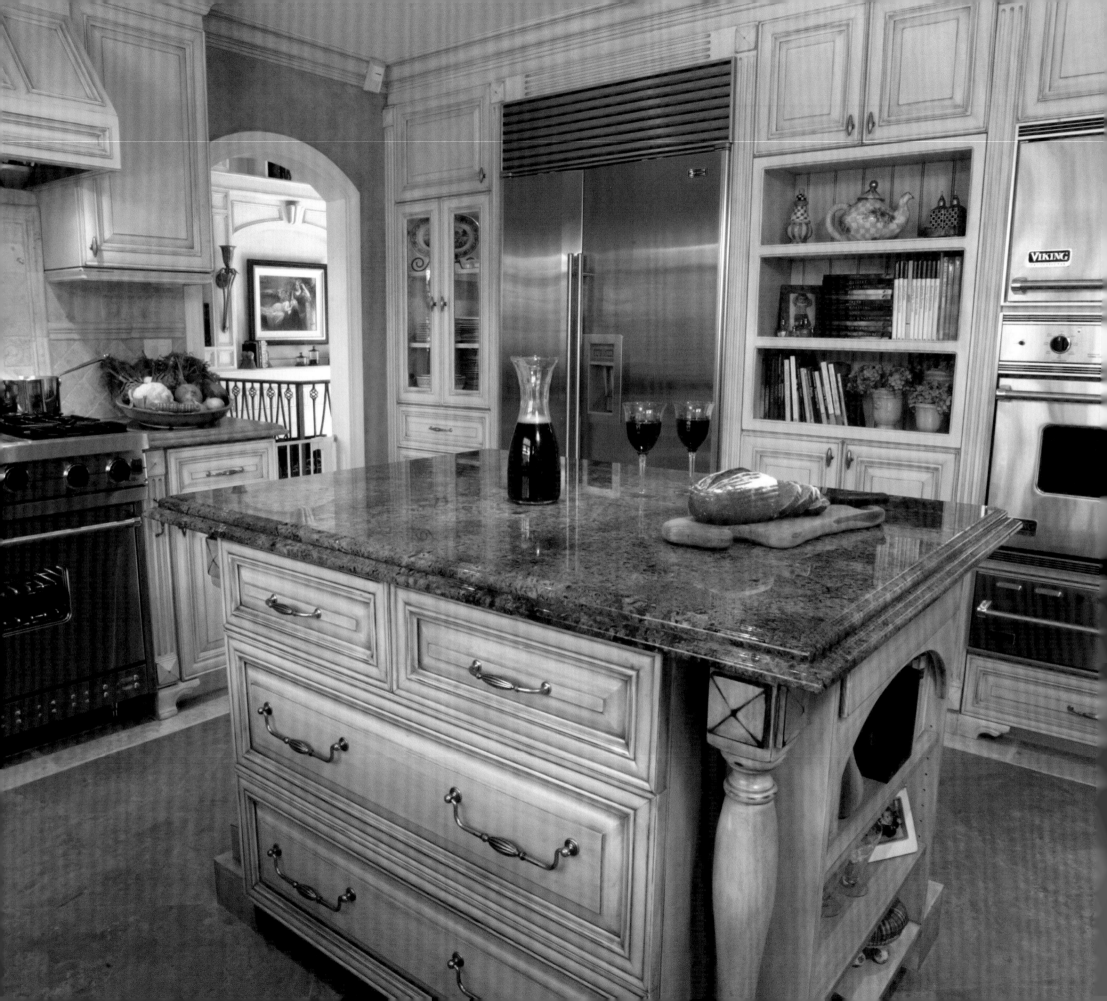

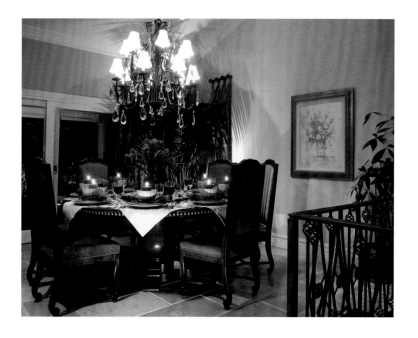

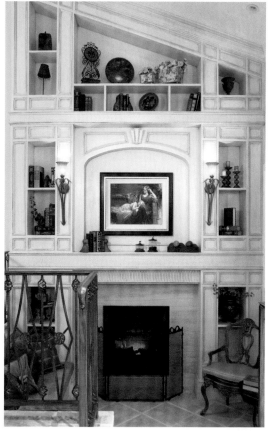

Sabine Klingler Kane, Allied Member ASID
KK Design Koncepts

KK DESIGN KONCEPTS

Tustin Ranch, CA 92782

714-404-9816

FACING PAGE All cabinetry in this light and airy French Country kitchen is custom made. The island is finished in a contrasting color with a Seafoam Green granite top in order to set it off from the rest of the kitchen. The kitchen remodel is part of an overall remodel of the entire home.

TOP The dining room in the same residence reflects a casual elegance achieved through simplicity and understatement. The chairs are upholstered in two alternating fabrics and the big iron chandelier adds drama. The walls are finished in a subtly textured stripe and the floor is done in Pavia Antico Classico, a beautiful Roman travertine.

TOP RIGHT The floor-to-ceiling custom fireplace surround is a perfect display space for books, art and accessories. A built-in bench (on the left) makes for a cozy reading area. The rod iron railing is also custom designed.

The seamless blending of diverse styles and an uncanny instinct for finding the inner truth of an interior space is the hallmark of Sabine Klinger Kane's design work. Born in Germany, the former documentary filmmaker brings an auteur's focus to her dynamic living spaces.

Sabine moved to California in 1998 and trained her cinematic eye on interior design as a new vocation. She opened up her own shop in 2002...and business has never been better. Over the years, her reputation – and subsequent workload – have grown to the point where she's considering hiring an assistant. "I do everything from architectural drawings for home additions to selecting fringe for pillows," she says. "I like to do it all. It's fun, but serious work."

As a filmmaker, Sabine sought to capture as many fresh perspectives as possible. She's also brought that aesthetic to her approach to her design work. "For grand houses that don't have a personality, an interior designer has to step in to give the home a personality, with the help of the client," she says. "The house has to be a reflection of the client, otherwise you have just another model home...gorgeous, but without soul."

Influenced by Italian, Scandinavian and German design, she blends different styles to create an eclectic combination that is customized to her client's tastes – always with an element of surprise. "I think that when the architect builds the house, he builds a box," says Kane, "You, as the interior designer, make the shoe for that box...and that shoe better fit perfectly. I open clients' creative horizons and help them go a step beyond what they would have thought was possible." ■

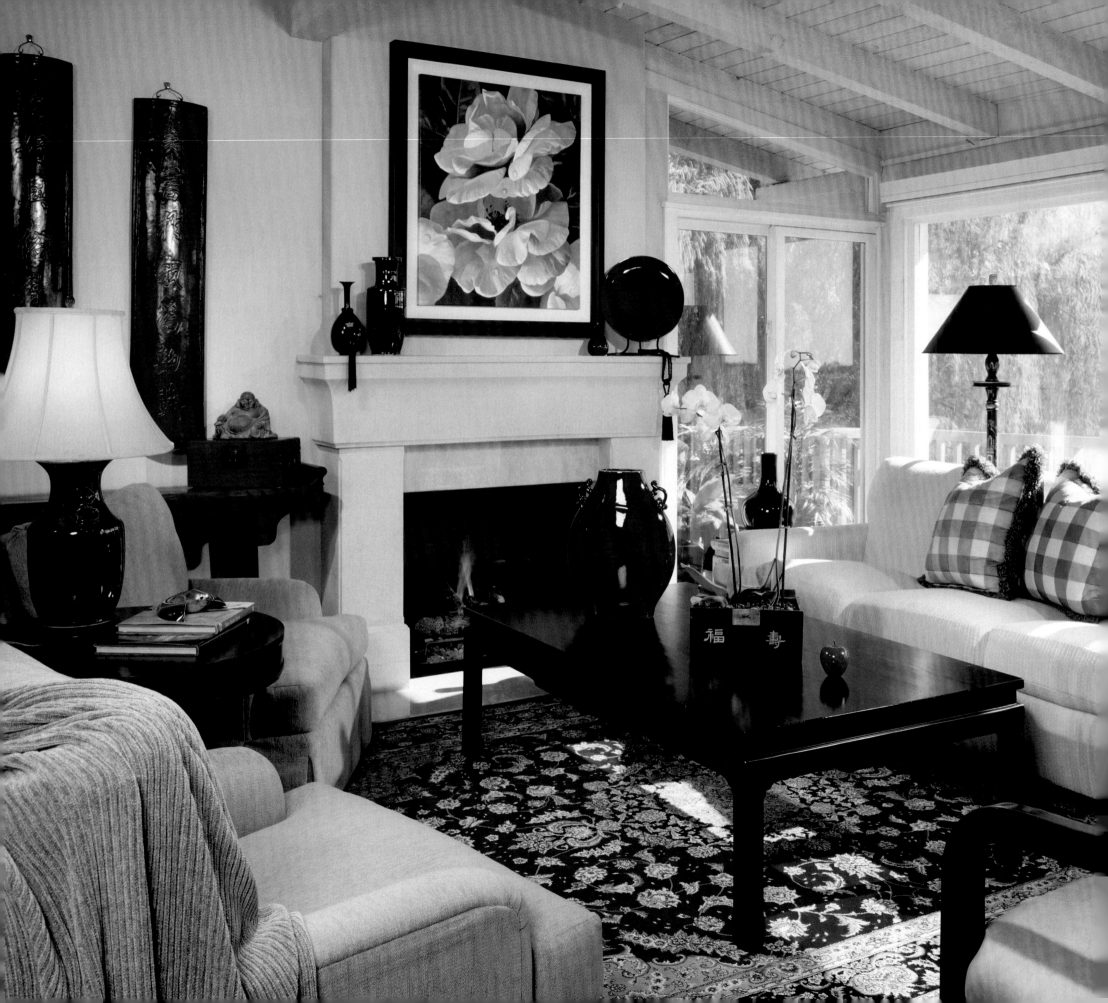

Marianne Kreter, ASID, CID
Marianne Kreter Interior Design

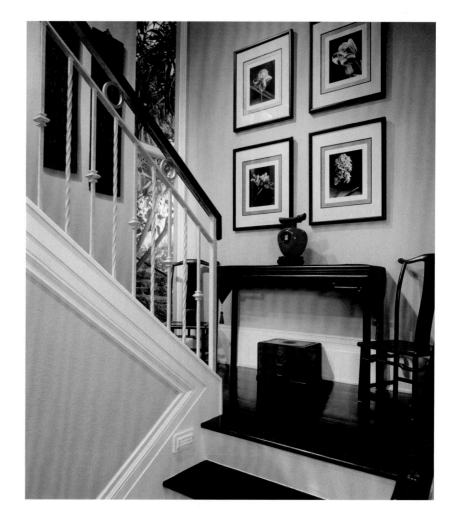

LEFT This living room is a strong study in color with sage green walls, white woodwork and red and black accents combined with heavily textured upholstery. These all combine to draw guests in and make them feel comfortable.

RIGHT This landing introduces guests to the living room on the left in this unusual floorplan where the living room is on the second floor.

Marianne Kreter is the owner and founder of Marianne Kreter Interior Design and president of the Orange County chapter of ASID for 2005-2006. She and her husband raised three children before Marianne started her own business while still in design school, and she "hasn't had a quiet day since." She credits her success to great clients, true friends, hard work, an incredible family and a genuine love for everything about design.

Growing up in Vancouver, British Columbia, Marianne was heavily influenced by that city's cosmopolitan flair. From years of working with busy clients throughout the Southern California area, her goal is to create calm havens that serve as an escape from a stressful world. And her clean, warm interiors – generally displaying an Eastern influence – have produced many happy clients. She says her personal style could be described as "soft West Coast contemporary. It is an uncluttered look with a strong Asian influence." But she adds that she enjoys working in many different styles.

Marianne enjoys a challenge. In addition to her 17-year career as an interior designer, over the last few years she earned her contractor's license, as well as CID (Certified Interior Designer in California), the CQRID (Council for Qualification of Residential Interior Designers), and NCIDQ (National Council for Interior Design Qualification) designations.

With the pace and stress of life today, Marianne believes that residential design has never been more important. Pleasing surroundings affect one's quality of life and the way one responds to the pressure of the day. One's home must be a sanctuary and a welcome retreat as well as a place to entertain family and friends.

Marianne believes that good design requires serious contemplation and diligence. It is not a whimsical or "off-the-cuff" endeavor. She finds that clients are always surprised at the number of decisions and the depth of thought involved in every project. The process requires both an overall vision and the ability to consider innumerable details. In explaining the design process, she says, "designers do not experience a sudden inner explosion of inspiration, but rather we build a project, layer by layer, all the

TOP This Balboa Island home is often referred to as the "Father of the Bride" home because of the similarity to the movie of that name. Home to a busy family of five, everyone who enters feels welcomed into the room's rich gold and sage color palette and family-friendly fabrics and furnishings.

FACING PAGE The dining room is stunning with French doors emphasizing the California lifestyle of indoor/outdoor living. The décor suits this beach location where the fresh salt air makes al fresco dining possible most of the year.

while considering the principles and guidelines that are inherent in a quality result. Good design involves planning, organizing and executing a plan and preventing problems before they begin." Above all, she believes in quality, both in craftsmanship and in furnishings and art.

When she is not working, Marianne enjoys musical theatre, tennis with her husband, and time with their family and soon-to-be eight grandchildren. She also is a strong believer in the intrinsic value of volunteering her time and energy to her professional organization, ASID. ■

MARIANNE KRETER INTERIOR DESIGN

409 Vista Grande

Newport Beach, CA 92660

949-644-8766

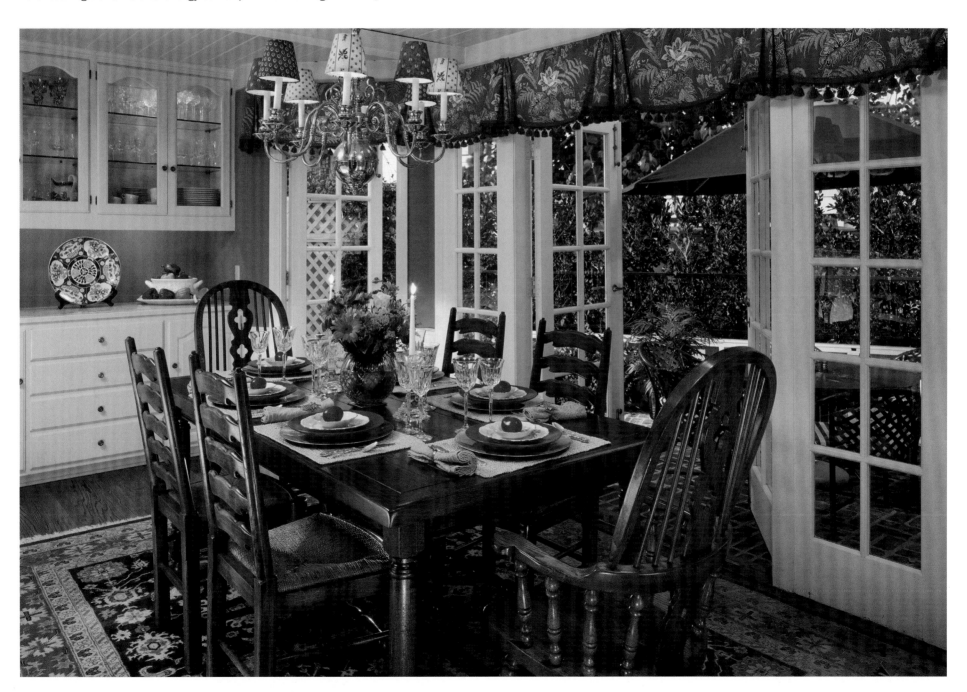

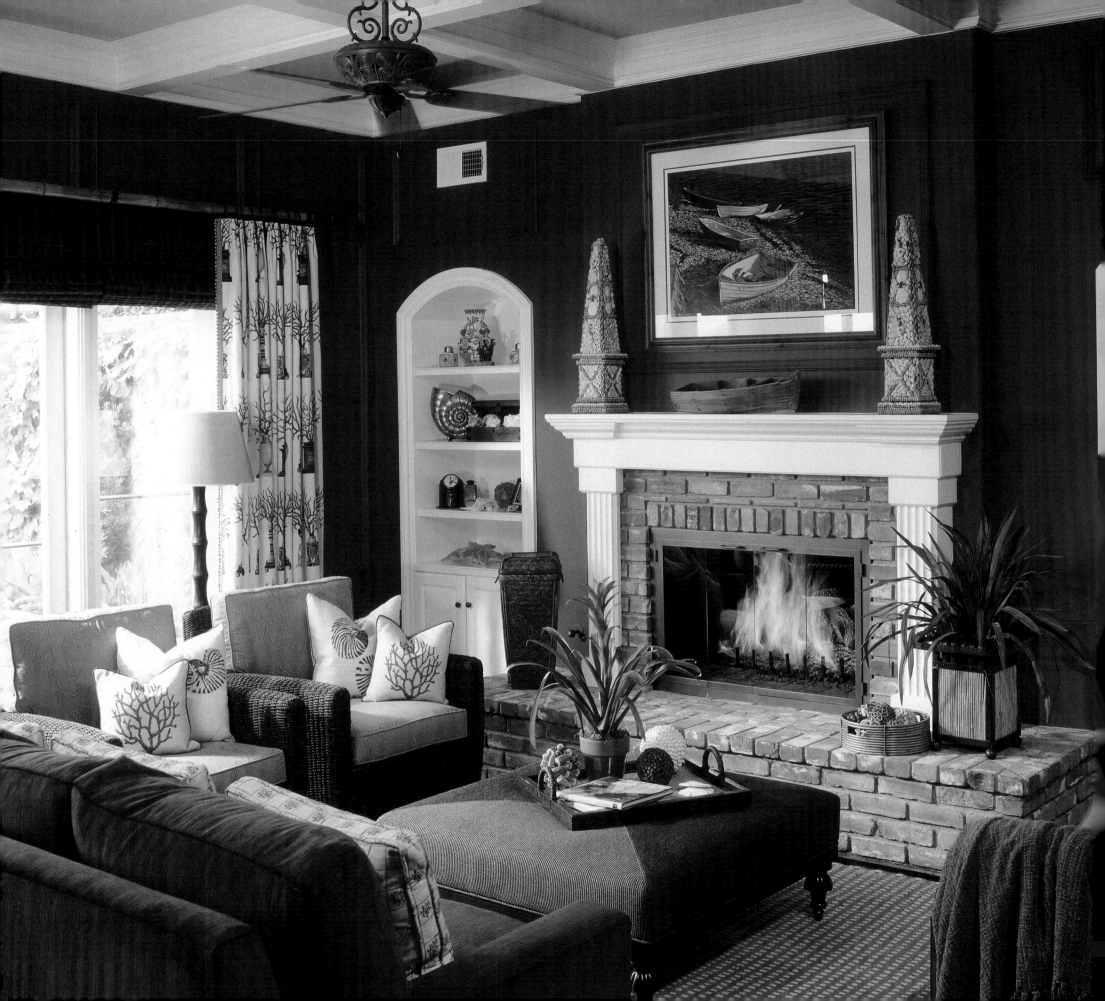

Jeanette Kyser,
Allied Member ASID
Kyser Interiors, Inc.

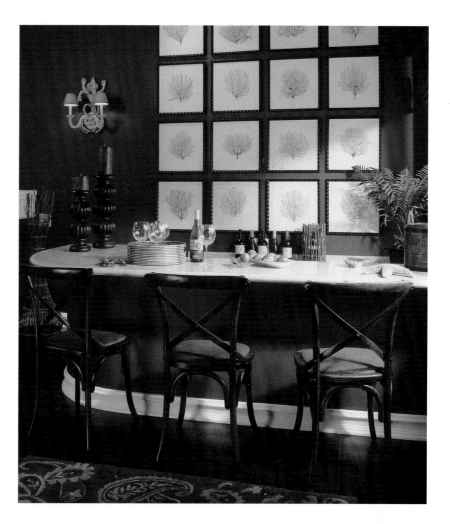

LEFT Rich colors and comfortable furniture make this an inviting family room. A knotted rope rug and rattan chairs provide texture, while beach-inspired accents add a stylish flair.

RIGHT Framed coral slices clustered above this built-in bar provide a unique sophistication for this functional space, the perfect place to serve coctails or hors d'oeuvres.

The philosophy that guides designer Jeanette Kyser can be summarized in the simple statement: "Put one foot in front of the other and do the next right thing." So after helping her friends design their homes, she found it only natural to take the next step and attend design school in order to develop her talent for design into a career. Over the next 30 years, she transformed her business into an endeavor worthy of being featured in local and national magazines, including *California Homes, Orange County Home Magazine, Decorating Ideas, Decorating Solutions, Kitchen Solutions* and *Good Housekeeping*. She also received the platinum award for design excellence in the *Orange County Home* Magazine design competition.

When Jeanette first meets with a client, her priority is to connect with the homeowner, asking them "about their family, their lifestyle and how they use the various areas of their home." She's also careful to note the architecture of a home. "It's important that the interior furnishings reflect the architectural integrity of the home," she says. Given her years of experience, it's not difficult for her to pull even the most eclectic elements together into a sophisticated and streamlined design.

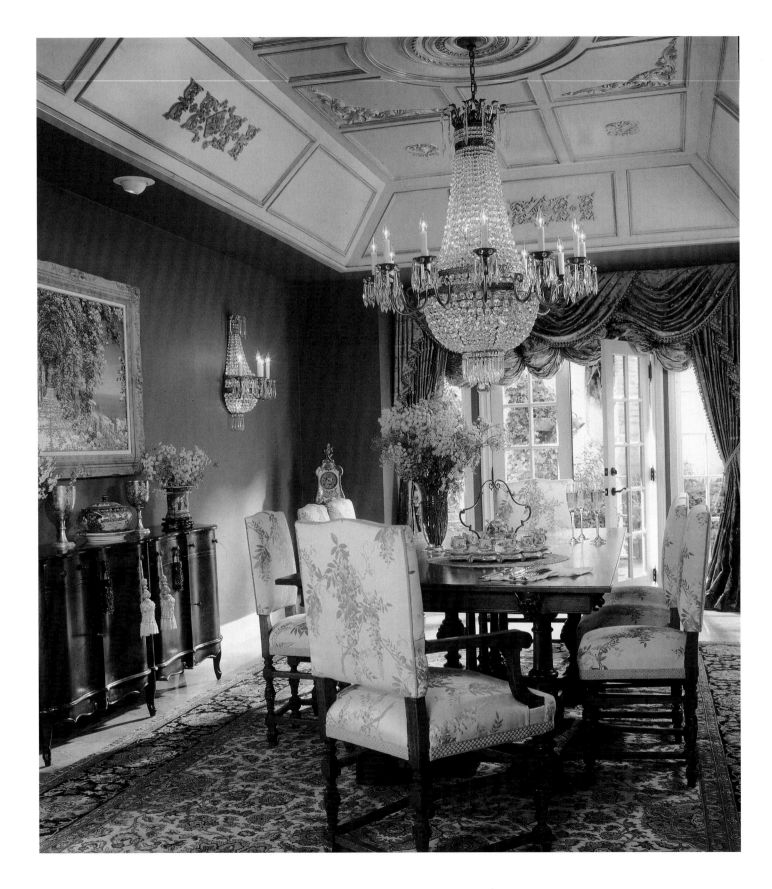

LEFT Detailed ceilings, antique furnishings and an exquisite custom chandelier bring elegance to this formal dining room. Silk drapes and crystal wall sconces provide additional refinement.

RIGHT This living room exudes old-world sophistication with plush fabrics and rich wood tones. Velvet-covered wingback chairs and a comfortable couch create a warm environment.

FAR RIGHT A delicate chandelier, layered drapery treatments and recovered antique sitting bench fashion softness and complement this room's main treasure, the family heirloom grand piano.

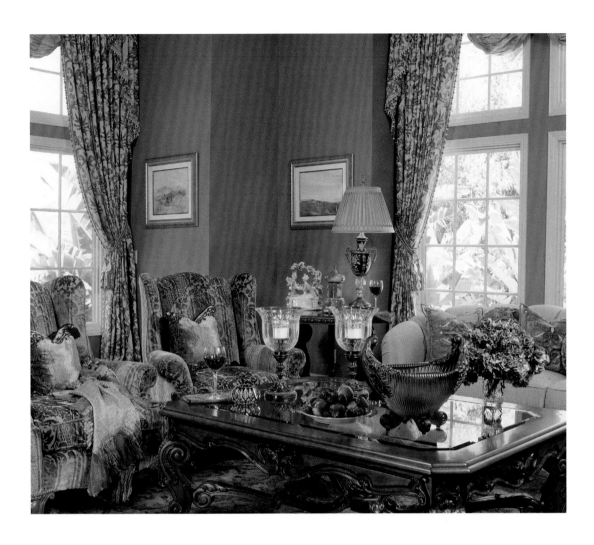

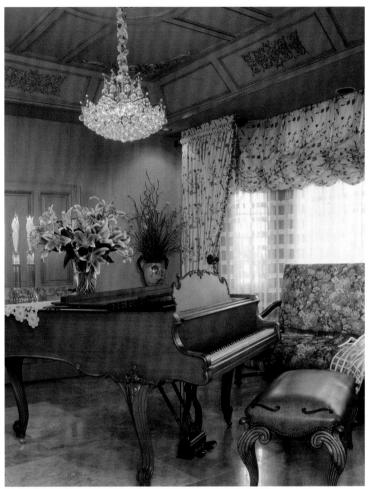

While understanding the importance of listening to her clients, Jeanette knows that design is a two-way street. "Part of my job is to educate clients, and open their minds to new ideas," she says. During her initial meetings with clients Jeanette quickly develops a good idea of their preferences. She then researches colors and fabrics that reflect their tastes, and in subsequent meetings presents options for furnishings, colors and fabrics that will work in their home. "I find fabrics that the client connects with and we build from there," she explains. "Often this process involves suggesting ideas or concepts to clients that they otherwise may not have considered."

Jeanette's projects can take six months to a year to complete, but for her clients it's worth the wait. "My clients are excited about what I do," she says. "I want to make sure I get the right furnishings, flooring, tile, lighting, accessories, artwork and every other detail that will make the home reflect the client's taste." In the end, her home environments are comfortable and pleasing. "When my clients trust me and we work as a team to put the home together, they are always pleased with the results," she says.

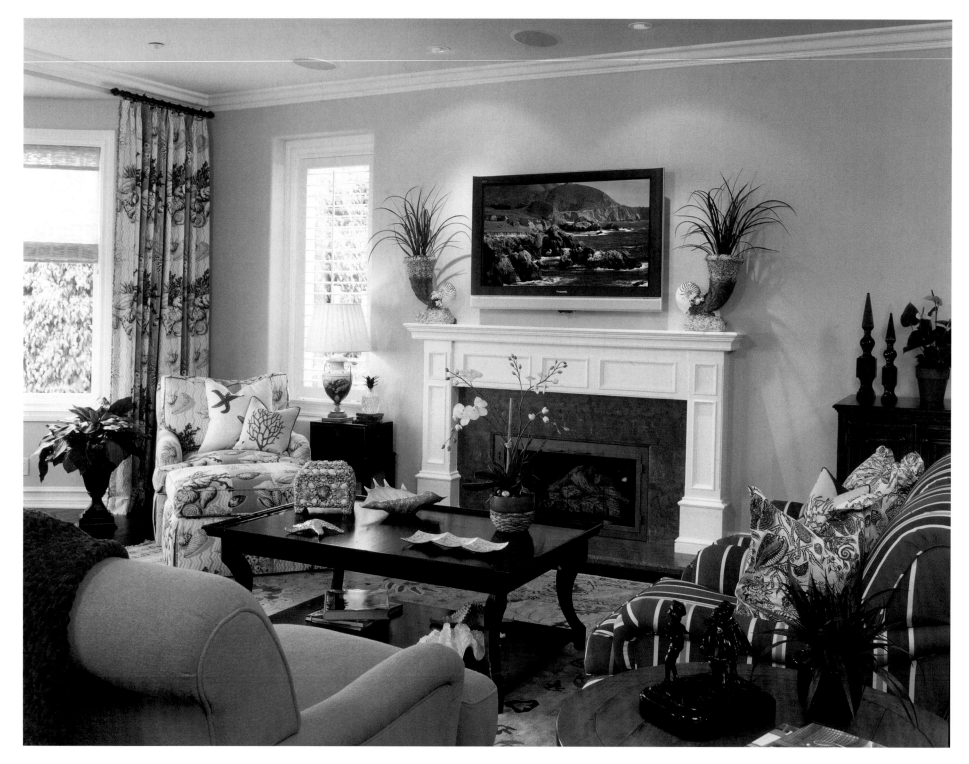

ABOVE Vibrant beach-themed fabrics and accents, dark wood floors and a graceful fireplace make this an inviting living room. Light blue walls reflect the room's dramatic sky and ocean view.

This one-of-a-kind flair she brings to all of her clients has allowed Jeanette to run her business primarily on referrals. "When a client hires a designer, they are hiring a professional," she explains. "They're hiring experience and knowledge." Jeanette continues to build both of these qualities to ensure her business brings only the best to her clients. "I love what I do and feel blessed that I have the opportunity to do it, to work hard and provide my clients pleasant and functional living environments." ■

KYSER INTERIORS, INC.

23 Kara East

Irvine, CA 92620

714-731-2886

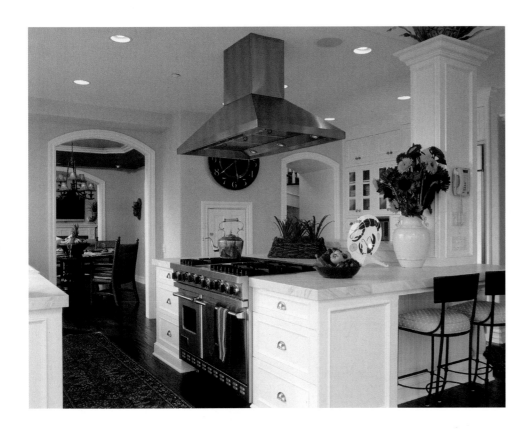

ABOVE This re-designed kitchen boasts an oversized island with Viking range and hood, white marble countertops and custom cabinetry, creating a fresh, clean look.

RIGHT Colorful draperies flank the floor-length windows illuminating this dining area with round pedestal table and comfortable, textured chairs. A tropical chandelier with bamboo shades graces the colorful, recessed ceiling.

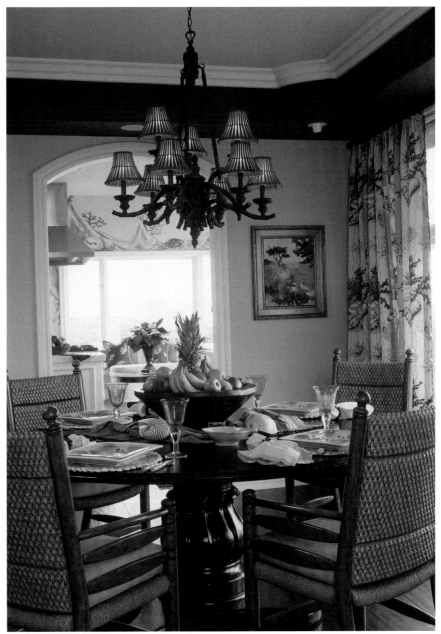

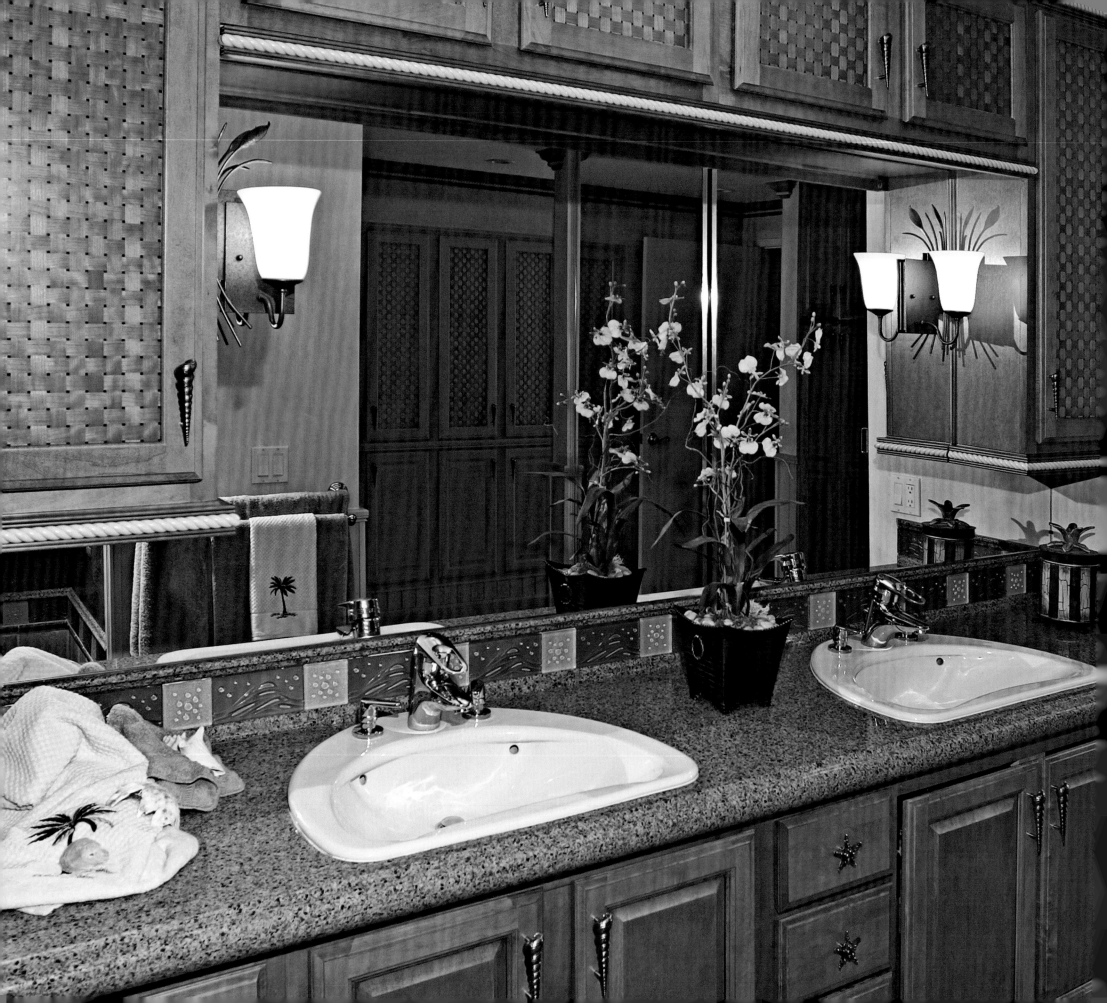

Carol Lamkins, ASID, CID
Design Vision

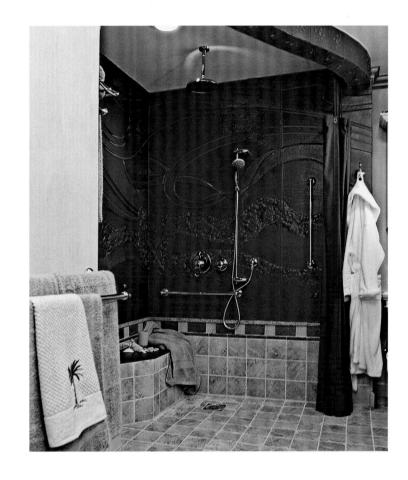

DESIGN VISION

3901 Madonna Drive

Fullerton, CA 92835

714-738-7171

FACING PAGE Accessibility meets beauty with easy-to-maintain materials such as pull-out spouts at the lavs, glass art tiles and rustic basket weave door inserts encased in glass with shell and starfish cabinet pulls. Cattails embrace the light sconces to complete the surf and sand motif.

TOP Earth, wind and water art glass surrounds the shower walls with safety grab bars and shower seat. Shifting sands mark the warmed porcelain tile, pebble and board walk flooring.

An interior designer since 1980, Carol Lamkins has also been a spatial planner...a product showcaser...a teacher... and an in-demand public speaker. In addition to ASID, this Renaissance woman is a Certified Kitchen Designer, a Certified Bath Designer, a Certified Interior Designer and Certified in Family and Consumer Science. She has been an annual recipient of the CKD/CBD Merit Award since 1989 and recognized for leadership and outstanding service to ASID for the past seven years. Designing practical living spaces that combines form and function with heavy doses of harmony has always been her passion.

Carol teamed with kindred sprit Denise Turner of The Room Turners. Denise is a Certified Interior Designer, Color Expert, Feng Shui Practitioner and Certified Seminar Leader. Denise is a past (2003-2004) ASID President, Palm Springs/Inland Chapter, and an active member of The Color Marketing Group. The duo have collaborated on several projects, including a master bathroom to accommodate the client, who is a quadriplegic. Carol's expertise in kitchen and bath design, combined with Denise's expertise in color and finishes, make them a dynamic team. The completed room was a smashing success, and will be featured on HGTV's "Designer's Challenge."

"When you remodel or make purchase decisions, it's important to look to the future and say: 'Is this going to serve me or am I going to have to serve it?'" says Lamkins. "If you make the right decision, you can choose to live there or move." She contends that too many older people end up having to leave their dream houses because the spatial surroundings make moving about difficult. Carol takes an organic and harmonious approach to design that anticipates the march of time, in a practical and elegant way. "Design to age in place is a high priority in my design," she says. "Harmonious housing is something everyone can live with." ■

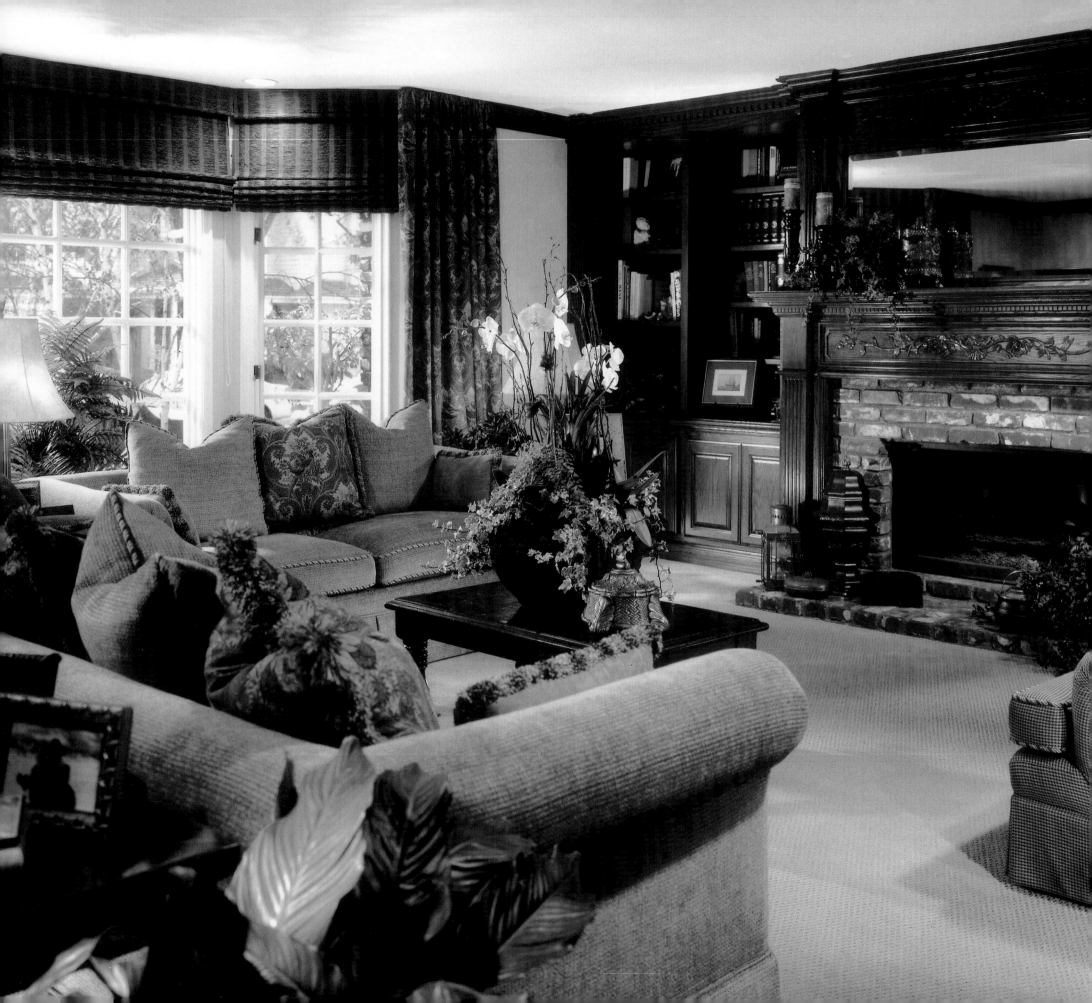

Linda Leach, ASID, IIDA, CID
Trinity Bay Interiors

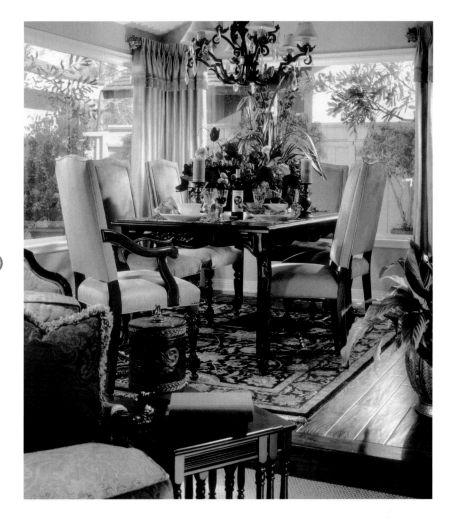

LEFT This seating arrangement in a palette of neutral colors, with accents of red, creates a respite in the family room where the fireplace is the focal point. Custom window treatments of waterfall panels fall over Conrad shades to frame the view.

RIGHT Bold colors in the hand-knotted wool area rug anchor the Country French dining set in this sun-drenched dining room, featuring a hand-made iron and crystal chandelier by Dana Creath and custom silk draperies with Finestra finials.

Understated elegance and sophisticated simplicity-these concepts drive the life and design of Linda Leach. To every space she designs, Linda brings an attention to detail that results in a seamless balance between her client's desires and her own experience.

Linda has practiced design since she was a young girl, decorating the living spaces of her dolls and choosing the colors and fabrics of her teenage room. Inspired by her ability to create beautiful and interesting spaces, she pursued her education at the Interior Design Institute in Newport Beach, graduating with a B.A. in interior design. In 1999, she established Trinity Bay Interiors, a full-service design and construction firm specializing in high-end residential design. Headquartered in Newport Beach, the firm recently opened satellite offices in La Quinta and Dana Point.

Linda's staff of gifted designers enables Trinity Bay to create spaces that are beautiful as well as functional. "We have the expertise and ability to take projects varying in scope from ground-up construction to dishes on the table," says Linda. "We are involved in many kitchen and bath remodels, as well as providing custom-built furnishings for our most discriminating clients."

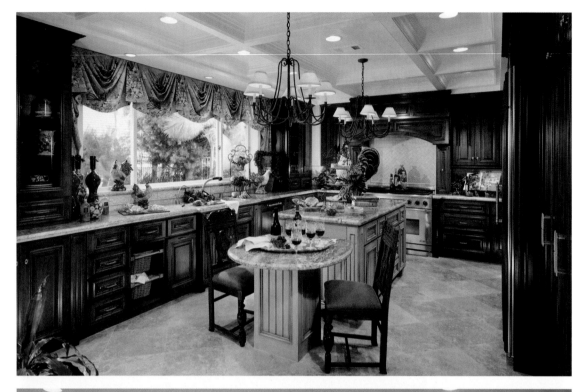

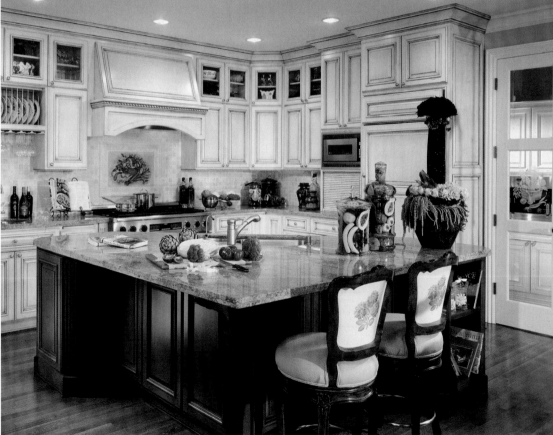

Initial meetings with clients are always spent assessing the client's needs and desires. "Only then will I sit down to create a plan for the project. My ego is not so large that I need to create a 'Linda-styled' project for each client," says Linda. Instead, she focuses on creating for each client the very best project for them. "I realize that each project will, in some way, capture the essence of 'Linda' through the clean lines and attention to detail that I require."

When she's not devoting herself to her clients, Linda likes to spend the weekends with her family. Her husband, four adult sons, and four grandchildren keep her busy when the whole family gathers at their beach or desert homes.

Her love for her family has led her to volunteer her design services to many child-focused charities. She has donated design and furnishings to the Ronald McDonald House of Orange County and also participated in the Showcase House for the Philharmonic Society of Orange County, benefiting the children's music programs of the Philharmonic. Linda has contributed her talents to the Showcase House of the Greystone Estate in Beverly Hills, raising funds to preserve the estate built by the famous Doheny family.

TOP LEFT An abundance of natural light enhances this kitchen that is beautiful, as well as highly functional. Custom cabinetry with furniture details in a stained and glazed finish, a two-level island finished in a contrasting painted glaze with granite top, and a soffited ceiling with decorative moulding detail create a space designed for relaxation and entertaining.

BOTTOM LEFT "Sophisticated Beach Cottage" was the theme for this high-tech, custom kitchen. The contrasting color and detail of the island complement the hand-glazed cabinetry. Tumbled travertine with hand-painted art piece provide the focal point over the Dacor range.

FACING PAGE This gentleman's retreat at the Beverly Hills Showcase house at the Greystone Mansion combines the decorative elements of leather, zebra, and Asian-influenced accessories to create and ambiance of casual sophistication.

Wherever she goes, Linda continues to broaden her education, spending her last vacation visiting northern Italy to study the art and architecture of Palladio. "Education and experience are very important when looking for a designer," suggests Linda. "A good designer brings wonderful resources, as well as years of training and experience to a project. These resources will greatly enhance a client's own perception of artistic ability."

There's no question that Linda brings her own distinctive design resources to every project. "My clients' dreams are filtered through my own taste to create spaces that are well-balanced and sophisticated." ∎

TRINITY BAY INTERIORS

419 30th Street

Newport Beach, CA 92663

949-642-4660

www.trinitybayinteriors.com

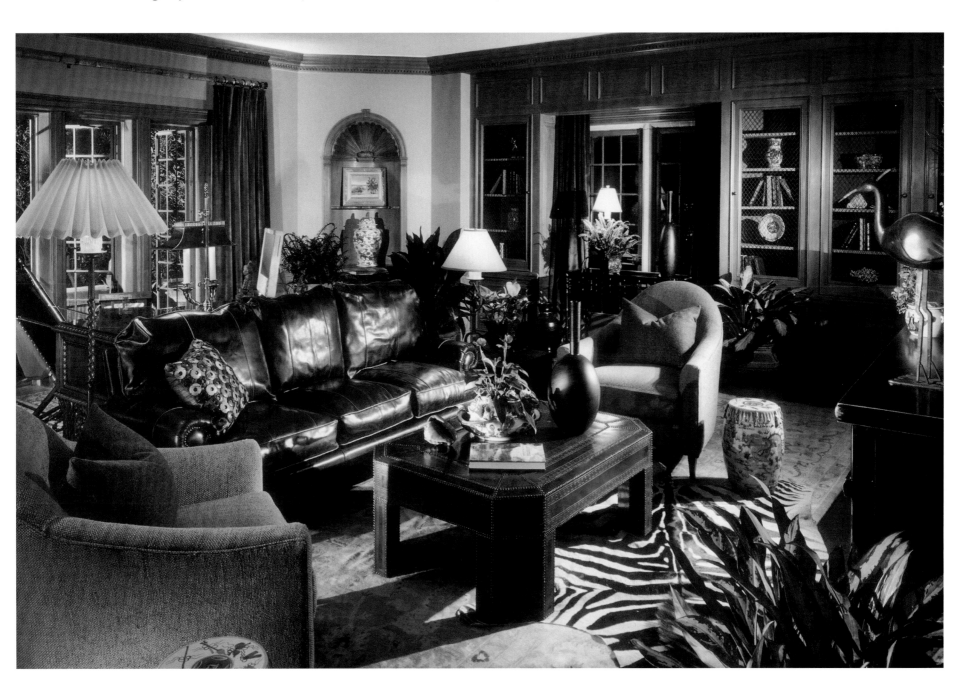

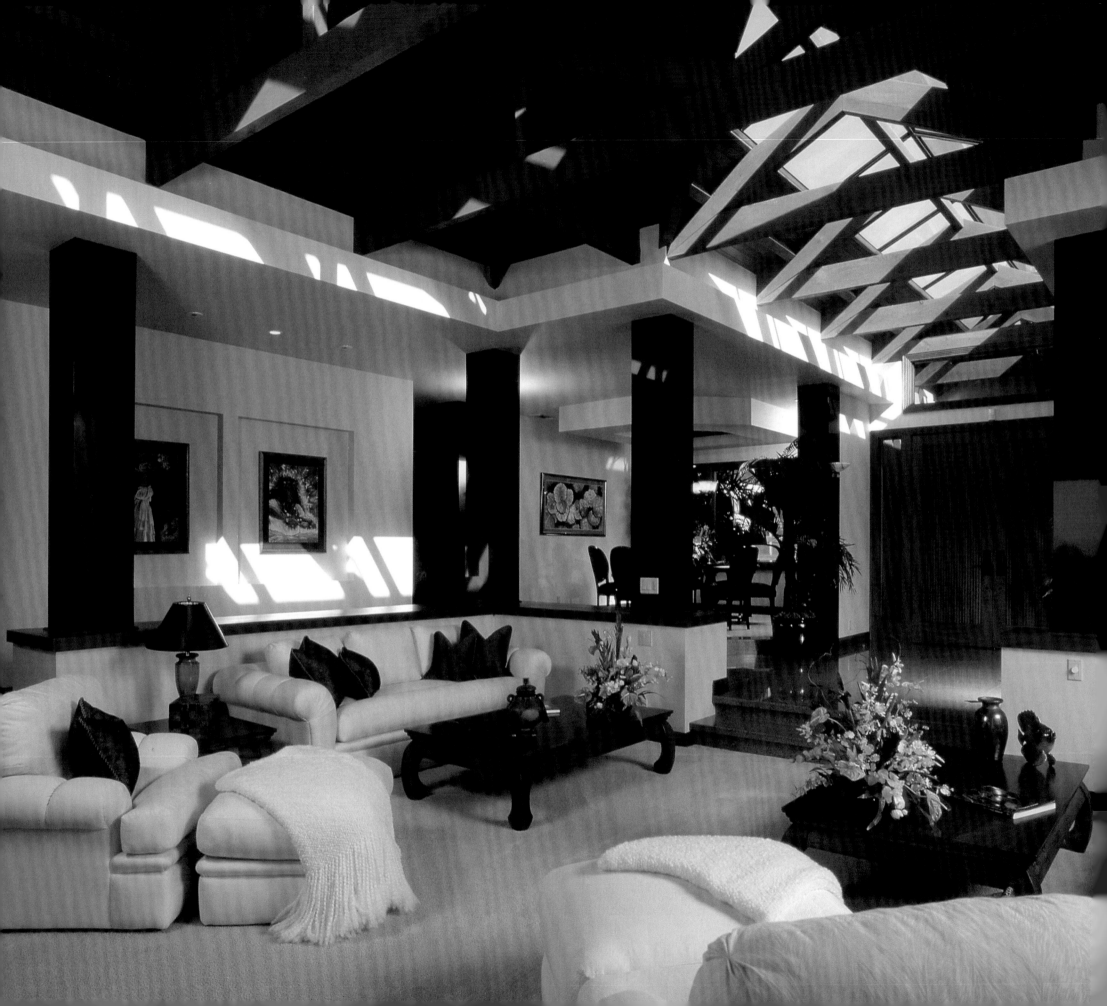

Gayle Lee, Allied Member ASID
Gayle Lee & Company

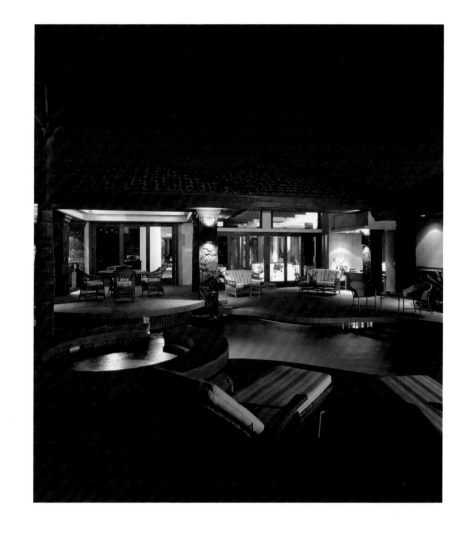

LEFT Warmed with exposed beams, a ridge skylight, imported granite and luxurious custom furnishings, this beautiful living area is, at once, both elegant and inviting.

RIGHT The art of seamlessly blending exterior space creates a truly unique living experience.

There aren't too many interior designers who started out in the construction business, but Gayle Lee did. The owner of Gayle Lee & Company gives much of the credit for her success to her experience developing and selling custom high-end spec properties in Lake Tahoe, Southern California and Hawaii.

"That experience taught me how to work as part of a team on projects, and gave me the opportunity to allow design to influence the process of creating a home from start to finish," she says.

Purchasing undeveloped lots, Gayle managed projects from home site design and development through construction to interior design, furnishing and final sale. Perhaps this vast personal perspective of the development process is the reason clients of Gayle Lee & Company rave about the exceptional level of professionalism and integrity she brings to every design project.

One such client are the homeowners of the 2005 Philharmonic House of Design who were so impressed by the design concepts Gayle Lee & Company brought to life in the guest rooms, they hired the firm to expand those

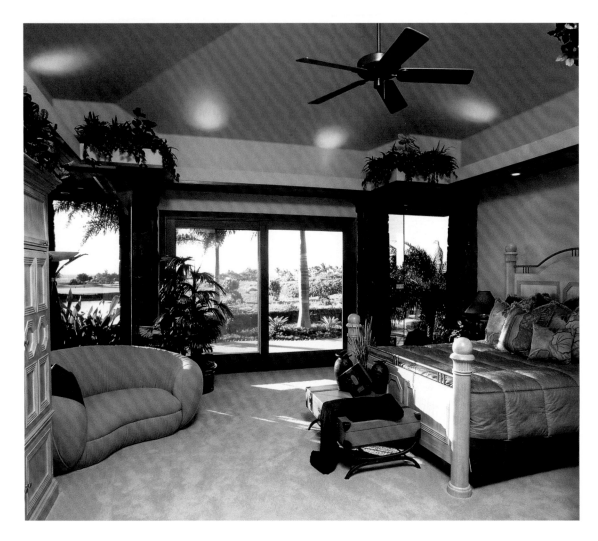

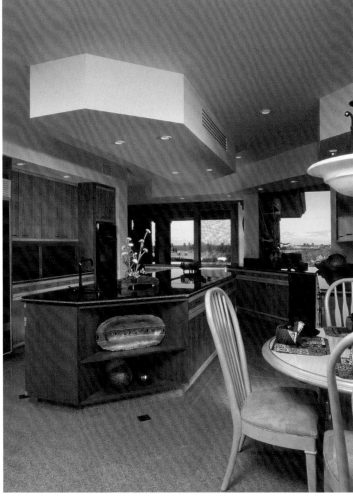

concepts throughout their 7,000-square-foot residence. But they weren't alone. Nearly 15 others who saw the showcase home walked away convinced that Gayle Lee & Company could help them realize the design potential of their own homes.

"After the House of Design closed to the public, there wasn't a room that we didn't touch in some way to bring it into harmony with the client's personal taste," Gayle recalls. "The homeowner has a design background and he found, in the rooms we designed, the same attention to quality and detail he wanted exhibited throughout his home."

With a hard work ethic that cultivates a high standard of performance, the firm boasts an impressive reputation for developing thoughtful and personalized designs that utilize an array of styles reflective of her clients' lifestyles and tastes. The designer looks for inspiration all around her. An interesting aspect of a home's architecture may find its way into other facets of the design palette, perhaps a furniture detail, to create a consistent style throughout.

TOP LEFT Corner windows with floor-to-ceiling glass that is set into rock walls set the backdrop for this extraordinary master suite.

TOP RIGHT Imported Brazilian granite combined with custom Koa wood cabinetry make this remarkable kitchen a gourmet's delight.

FACING PAGE This guest room of the 2005 Philharmonic House of Design is an elegant retreat with a peaceful sense of welcoming serenity.

Still, she says, "The most powerful inspirations come from my clients, seeing where and how they live and what their personalities dictate about their living space."

The company services clients in premier residential areas of Southern California including Newport Beach, Newport Coast, Crystal Cove, Lemon Heights, Cowan Heights, Corona del Mar, Balboa and Laguna Beach, as well as Las Vegas and Hawaii.

Gayle Lee has a passion for design and oversees all aspects of her company's projects, from conception to completion, from ground-up construction to consulting on art and accessories. "There is something very satisfying about working with a client to maximize the possibilities of a space," she says. "Helping clients realize the dreams they have for their homes is what I seek to do each day. By really listening to develop an understanding of the client's needs makes it possible to create a beautiful and enjoyable interpretation of their style." ■

GAYLE LEE & COMPANY

3800 East Coast Hwy, Ste. A

Corona Del Mar, CA 92625

949-673-0222

www.gayleleeco.com

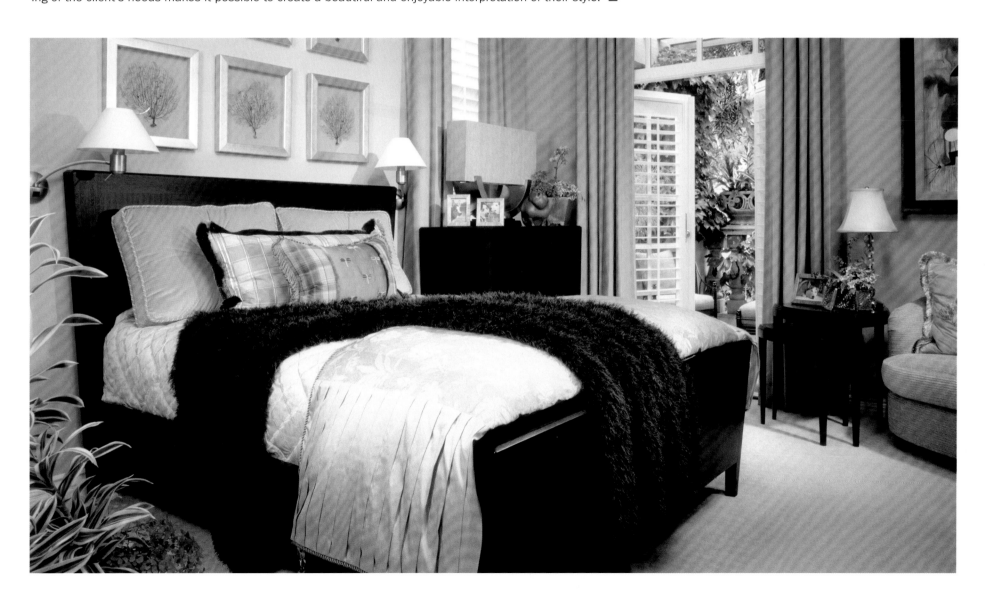

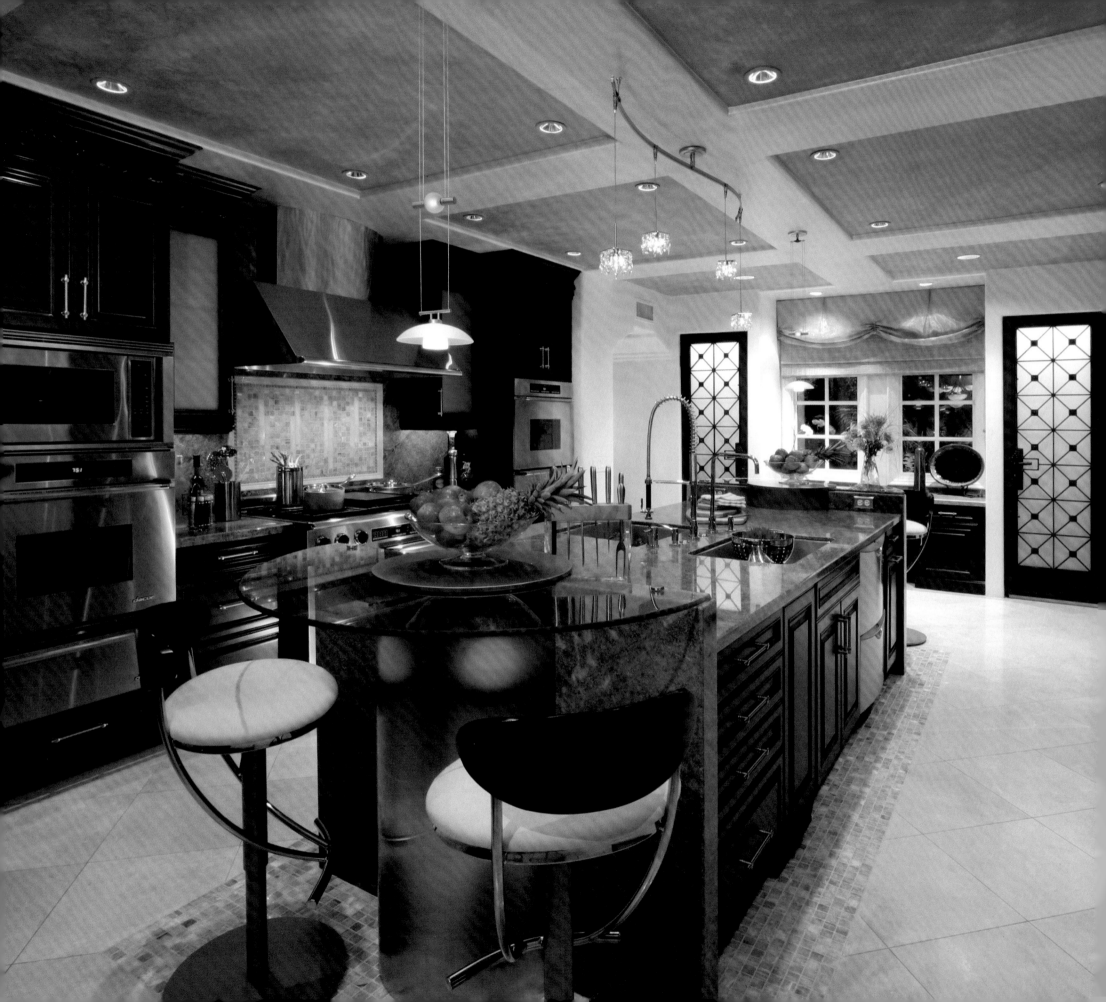

Barbara McLane, ASID, CID
By Design Kitchens, Etc.

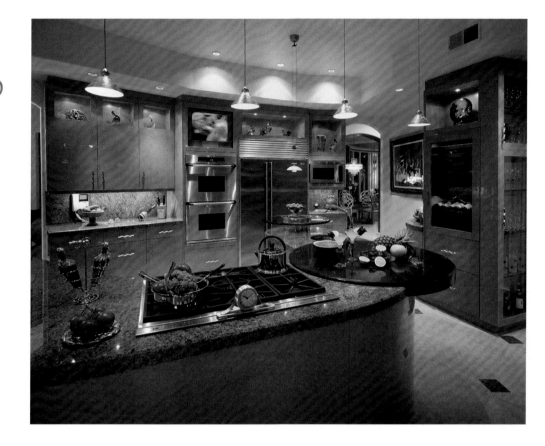

BY DESIGN KITCHENS, ETC.

714-540-3360

949-716-0926

LEFT 2005 OC Philharmonic House of Design. This culinary entertaining style kitchen features innovative and elegant design solutions. It is equipped with Dacor state-of-the-art appliances, Cuisines Laurier cabinetry and Dornbraht gourmet faucets for two sinks placed vis-a-vis in the island.

TOP RIGHT This kitchen received a Platinum award for creative design. The use of geometric curves and clever choice of materials communicates elegance and brilliance; a splendid composition makes life and work in this kitchen an enjoyable experience.

Combining the best of European design with elegant form and function is the hallmark of interior designer Barbara McLane, who brings a wealth of knowledge to her interior design projects. Born and raised in Poland, she travels to Europe frequently. "I greatly admire the art and architectural heritage there," says McLane, "and I always come back inspired and ready to infuse some of the classic European style into my work."

After studying art history in Europe, Barbara studied architecture for four years at the School of Architecture at the University of Hawaii. She received her Fine Arts degree in Interior Design from Chaminade University of Honolulu in 1985. She worked for an architectural firm and upon moving to California, she joined an interior design team for a major homebuilder, and later also became an associate for several kitchen showrooms.

Drawing upon her vast experience, she established her Orange County-based company, By Design Kitchens, Etc. and it has been thriving ever since. For the last three years, she has designed exceptional showcase rooms for the Orange County Philharmonic House of Design, all which received media attention and were featured in various publications.

Barbara's design accomplishments can be seen in a large number of Orange County's beautiful, high-end custom homes. When she designs, she likes to begin with the kitchen because she perceives the room as the heart of each home. So important is the proper design of a kitchen that Barbara chose to specialize in that area. "The kitchens are the central focus of our homes today and they need to be highly functional and also equal in grandeur," says McLane. "It's where we spend a lot of time with our family and friends and therefore kitchens should be designed with sophistication to be enjoyable to work, entertain and live in."

After extensive consultation, she designs a kitchen to reflect all of the client's dreams and expectations. "To come up with a creative, unique and utmost functional design is an elaborate process," says McLane. "I enjoy stepping out of the box and coming up with creative ideas and innovative design solutions for all my projects." For Barbara, the kitchen truly is the heart of a home.

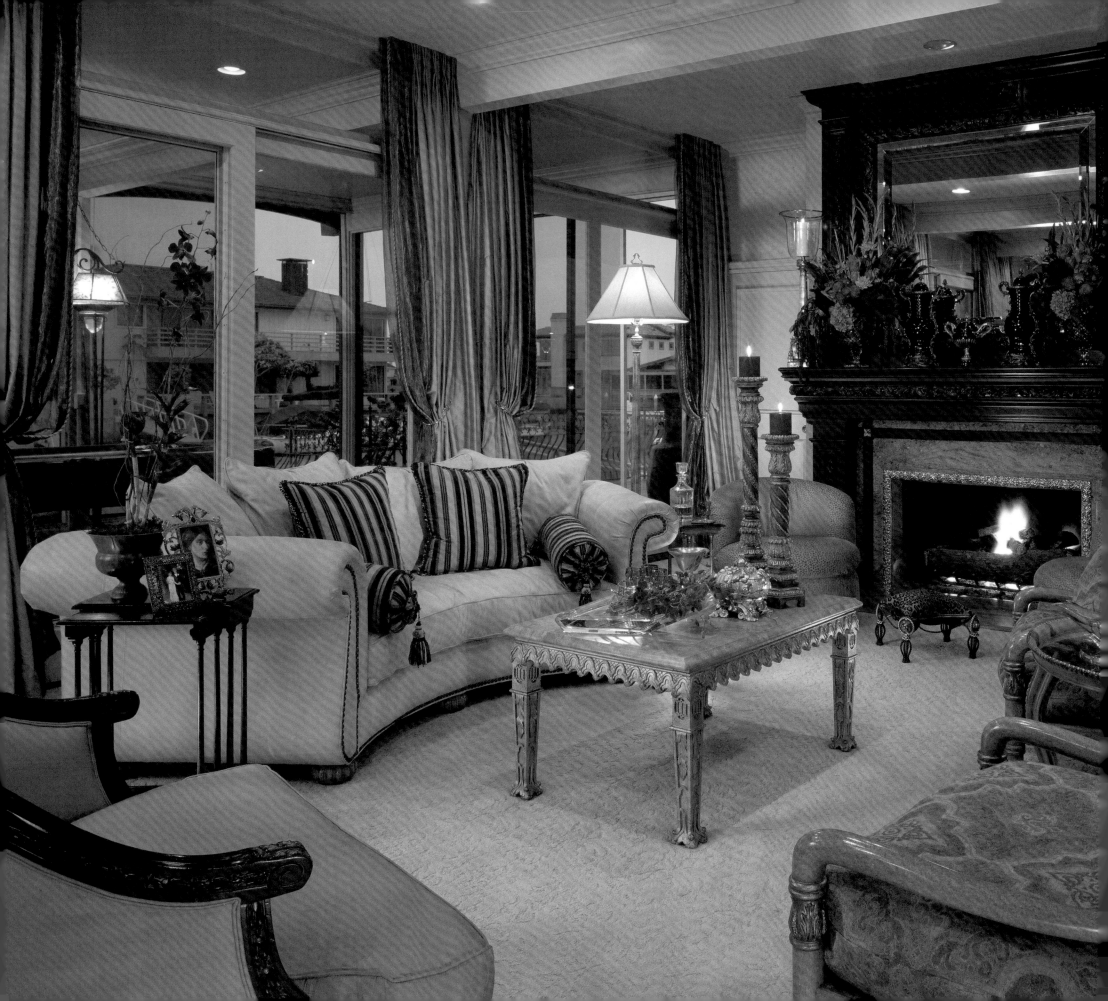

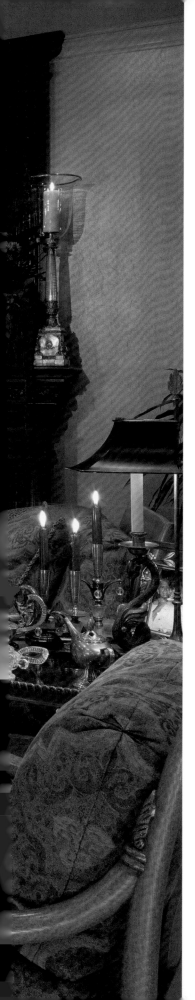

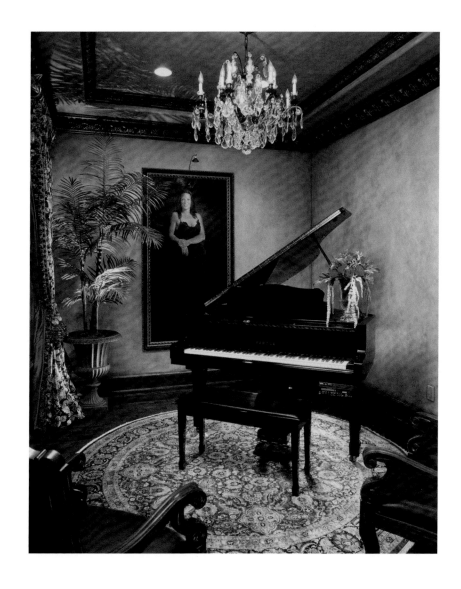

Wendy Ann Miller,
Allied Member ASID
WAM Interior Design

LEFT A hand-carved mahogany fireplace is the center piece of this elegantly appointed waterfront living room. A truly intimate setting for welcoming family and friends.

RIGHT "A room for the woman who brings music to my life." -Dr. Lawrence Feiwell

Twenty years ago, Wendy Ann Miller was on her way to becoming a lawyer. But the non-linear, creative side of her brain finally threw the book at her Perry Mason career plans. She opened up her first firm before she even finished design school and never looked back. Ironically, her first clients were several attorneys, who still swear under oath their long-standing loyalty.

Today, her firm, WAM Interior Design, boasts a 3,000 square foot, full-service, state-of-the-art studio with all the trimmings. The firm offers construction and remodeling services, as well as design consultation for commercial and residential projects.

In addition, Wendy has one of the most extensive resource libraries of fabrics and materials in Southern California. "It's easier to have all the information here at the firm, so I can pull things from my library, rather than waste time finding them," she says. "I have fine imported fabrics from around the world, plus generic and unique fabrics from every manufacturer. With our firm, clients don't have five fabrics to choose from, they have at least two hundred and fifty."

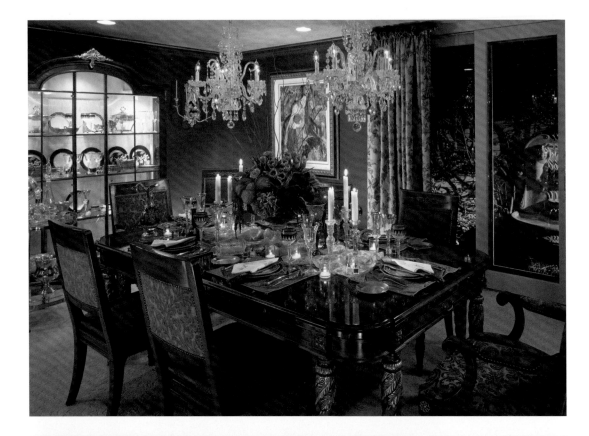

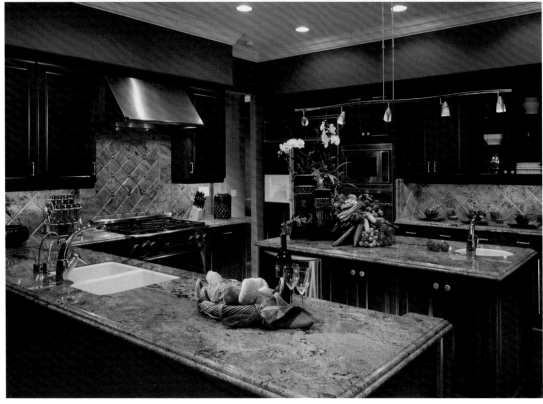

But for her, fabrics are not the only game in town. Wendy also works extensively with hard surfaces, such as tiles and exterior facades. She carries a broad variety of trims in all shapes, sizes and textures. "When we're doing a bathroom, the client may be only thinking about a fabric, but I'm also thinking about the tile and the decorative elements we can use," she says.

Wendy has the innate ability to key directly into a client's needs. She looks at "the cars they drive, the way their wear their clothes, their children, what they do for a living and hobbies. You have to be a good psychologist in this job." These psyche-soothing skills are especially important when it comes to remodeling assignments. "Some people want to micro-manage and other just want you to handle it start to finish," she says. Her firm is always prepared to handle any job with sensitivity and finesse.

She says her own ego is completely sublimated to fulfill the creative wishes of her clients. "If I did me, everything would look like the Palace at Versailles," Wendy says jokingly. Her attention to detail is one of her greatest assets. "Not only do we pick out the sofa, but I make sure that the nail heads, the welt cord, and the trim attached to the sofa is exactly the way it should be," she notes. "Or in a contemporary kitchen, we may do a stainless steel cabinet and inlay, then fiber-optically light it. I do everything from ultra-chic contemporary, to post-modern arts and crafts, to French and Southwestern influenced design."

TOP LEFT Pure luxury with hand-carved marble inlay, gold leaf accented dining table. Silk upholstery, brocade tassel drapery, and crystal chandeliers complete this fantasy dining experience.

BOTTOM LEFT Kitchens being the center of all family life, must be an elegant environment with all the bells and whistles, as well as a practical work space.

She has a design plan for every space and room accent. Her favorite spatial challenge is the bathroom. "It needs to be a surprise when you walk in," says Wendy, "We did one that every time you walk in, it feels like you're in a box of Godiva chocolates." The finest in confections meets one of the finest in interior design delights. As they say, everything goes with chocolate. ■

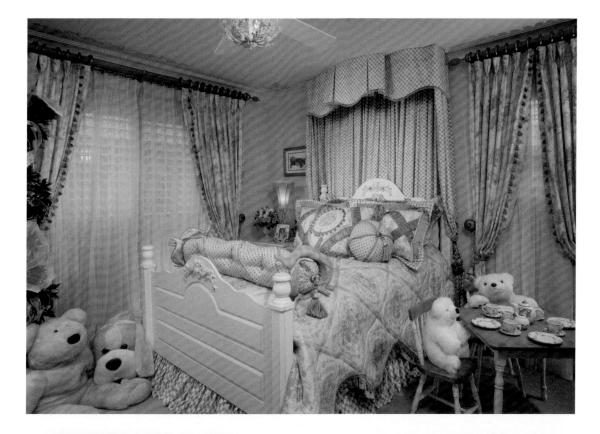

TOP RIGHT Once upon a time, in a land far, far away, there lived a young princess... Whimsical elements to carry this sleeping beauty to dreamland.

BOTTOM RIGHT ...and when she grew up, her needs hadn't changed much. A furniture style vanity anchors a romantic master bath retreat.

WAM INTERIOR DESIGN

1938 North Batavia Ave., Suite C

Orange, CA 92865

714-283-0694

www.WAMInteriorDesign.com

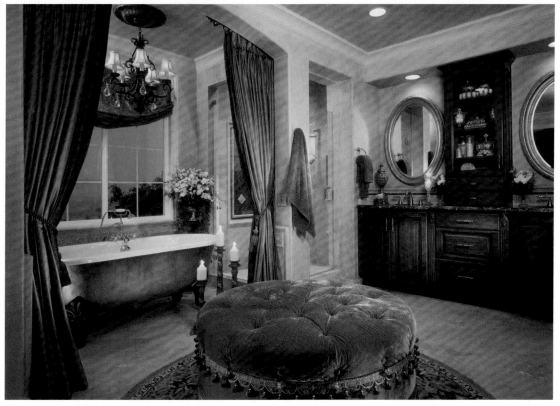

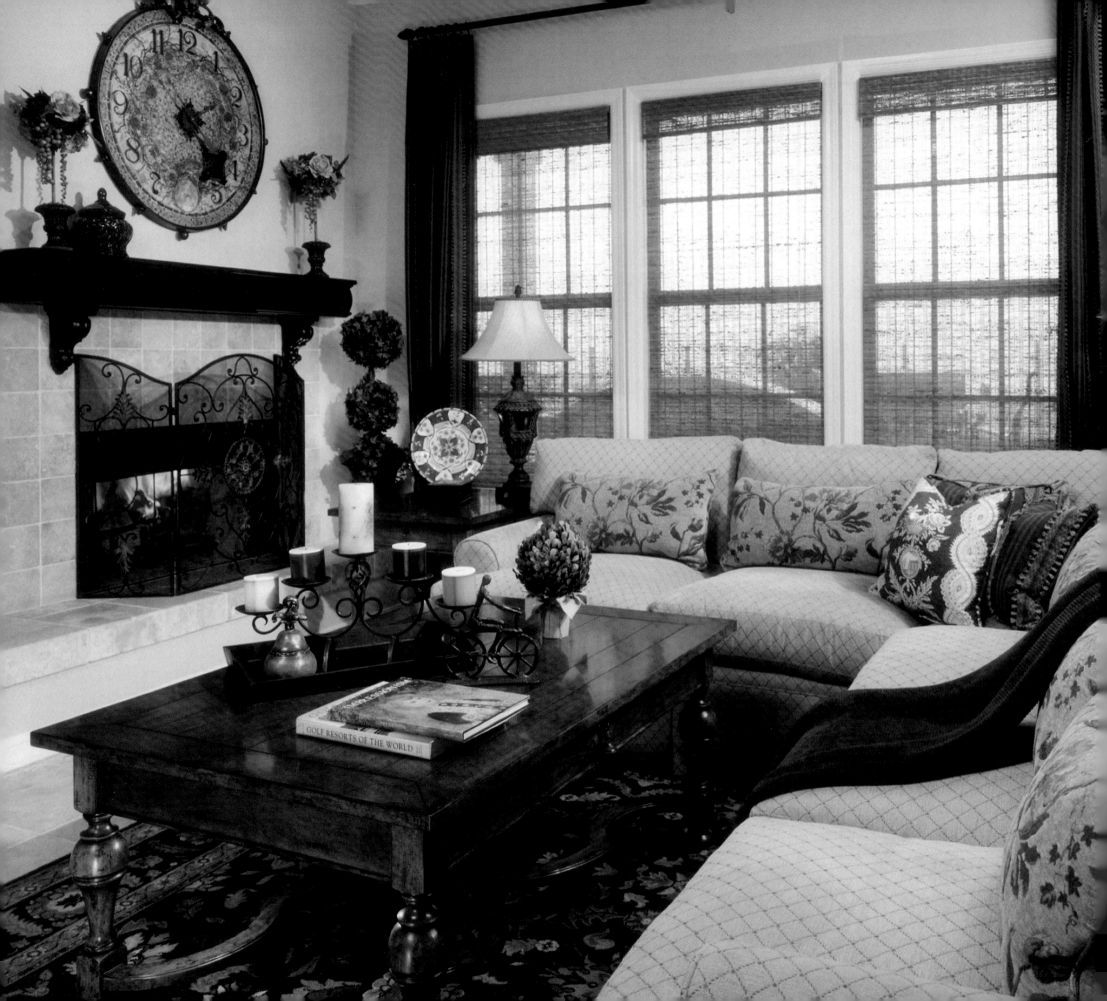

Tamra Mundia,
Allied Member ASID
Concept Design

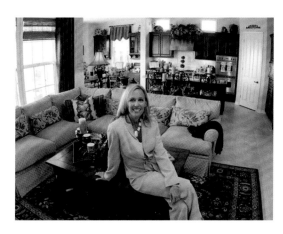

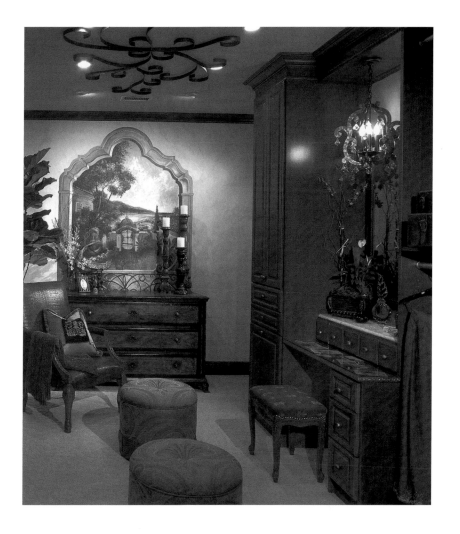

LEFT This central living area located in The Reserve East in San Clemente features a fireplace and media center (not shown) that warms the ambiance of the entire space.

RIGHT This Santa Barbara-style master closet in Shady Canyon boasts a dry cleaning machine for its owners. *Philharmonic House of Design.*

As a young child, Tamra Mundia begged her mom to move furniture around and to redecorate. Despite these early inclinations toward the world of design, she started out in college majoring in psychology and theatre arts. By her third year, however, she realized her true calling and transferred to study at the Interior Designers Institute.

After graduating, Tamra went to work for Shores Interiors, specializing in yacht design. She then moved to a high-end residential firm in San Clemente. She eventually decided to take some time off after having her children and teach art appreciation at the elementary school level. A few years later, a girlfriend asked her for help with interior design. "From there, it grew into a business from word of mouth," she explains. "And here I am in my seventh year of business with more work than I could ask for."

Her own personal design style reflects transitional and Tuscan influences, but Tamra enjoys the challenge of working outside of her own tastes. "It's fun and challenging to get into the heads of my clients and see what their styles are," she explains. "Half of the fun is figuring out what will be wonderful for them to live in."

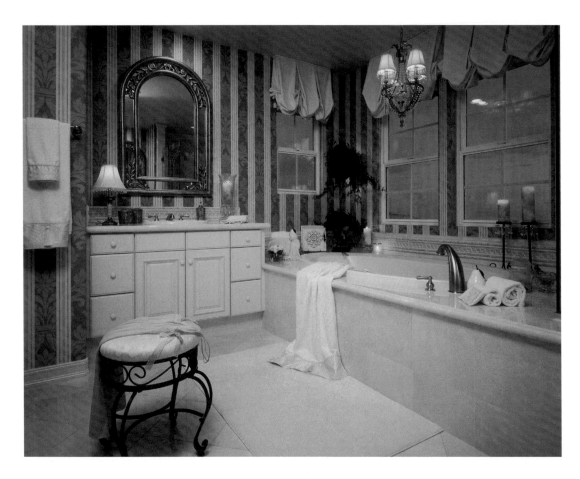

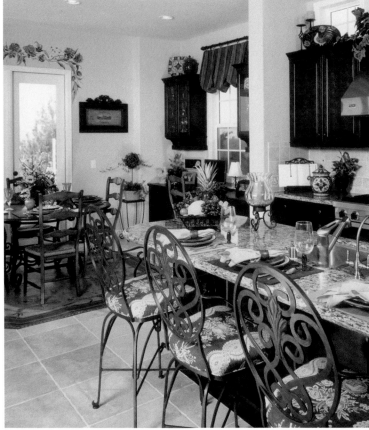

To this end, she's worked in styles ranging from Santa Barbara Spanish to French Provincial, always researching the style before delving into the project.

Tamra enjoys taking on the full spectrum of projects – from top-to-bottom new construction to designing a single, beautiful room. She is currently working on a large project in Shady Canyon, and a small powder room remodel in Laguna Niguel, among others. "There is a wide range of flexibility with the awareness people now have about using a professional interior designer."

She often finds inspiration from nature and her walks on the beach. "I love the bright orange and red sunsets contrasted with the gray-blue ocean and the neutrals of sand," she says. "If you can capture those colors and feeling in an interior, you know people will be happy."

Keeping people happy is always a challenge when couples have divergent tastes, but Tamra maintains an open ear to both sides and is often able to work out a compromise. "A couple from Ohio hired me because I was neutral – I wanted to achieve an interior environment that worked for both people," she explains.

TOP LEFT The Lauro's Master Bath was designed as a soothing retreat after a busy day. We achieved that goal with the calming color palette where only the scenery intrudes.

TOP RIGHT The bold colors of Provence play in this happy space. The professional-grade kitchen adjoins a lively morning room where decorative painting and a floor mat were custom painted to complement the fabrics and give interest.

RIGHT "Casual elegance" was the theme for this formal dining room. It was made comfortable with texture. The rush seats on the black ladder-back chairs contrast the distressed walnut table. We pulled the iron-top buffet in to anchor the space, and kept the color palette flowing with the fabric on the Parson chairs and window treatments.

On top of running her successful design firm, Tamra recently opened a furniture showroom located in her design studio in San Clemente. She decided she couldn't let one-of-a-kind items slip through her fingers just because they may not work for her current projects. Now, she's able to stock up on great buys and open the showroom for designers to find that special piece for their own clients.

Whether she's designing or working to stock her showroom, Tamra hopes she is helping people achieve their dreams. "To create a fulfilling environment for someone is a great feeling. It's wonderful to know I've helped them achieve that goal." ■

CONCEPT DESIGN

1389 Calle Avanzado

San Clemente, CA 92673

949-361-0053

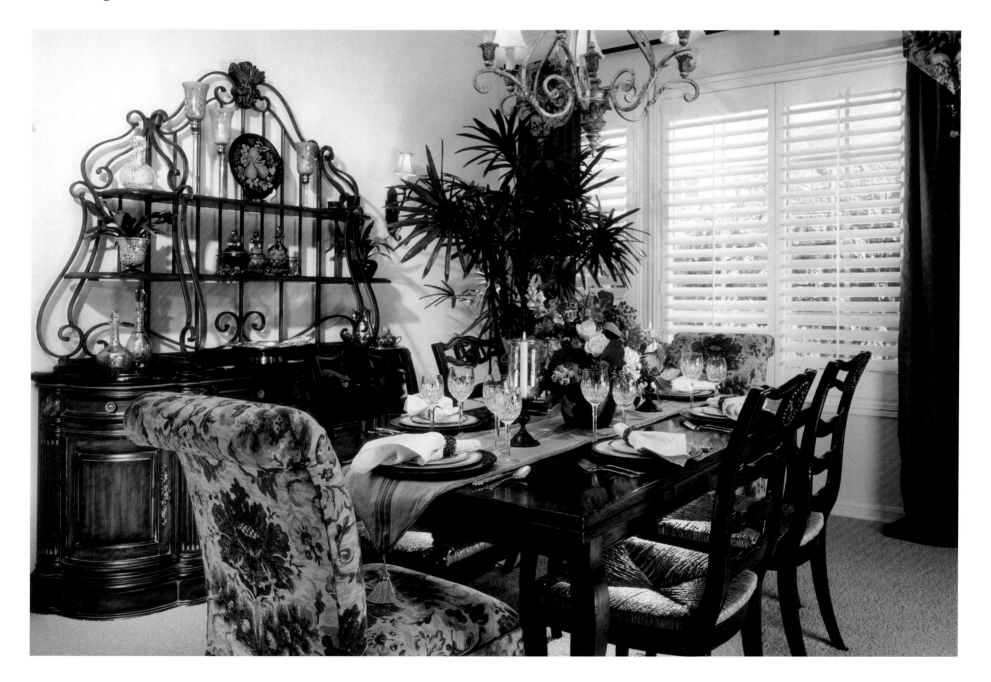

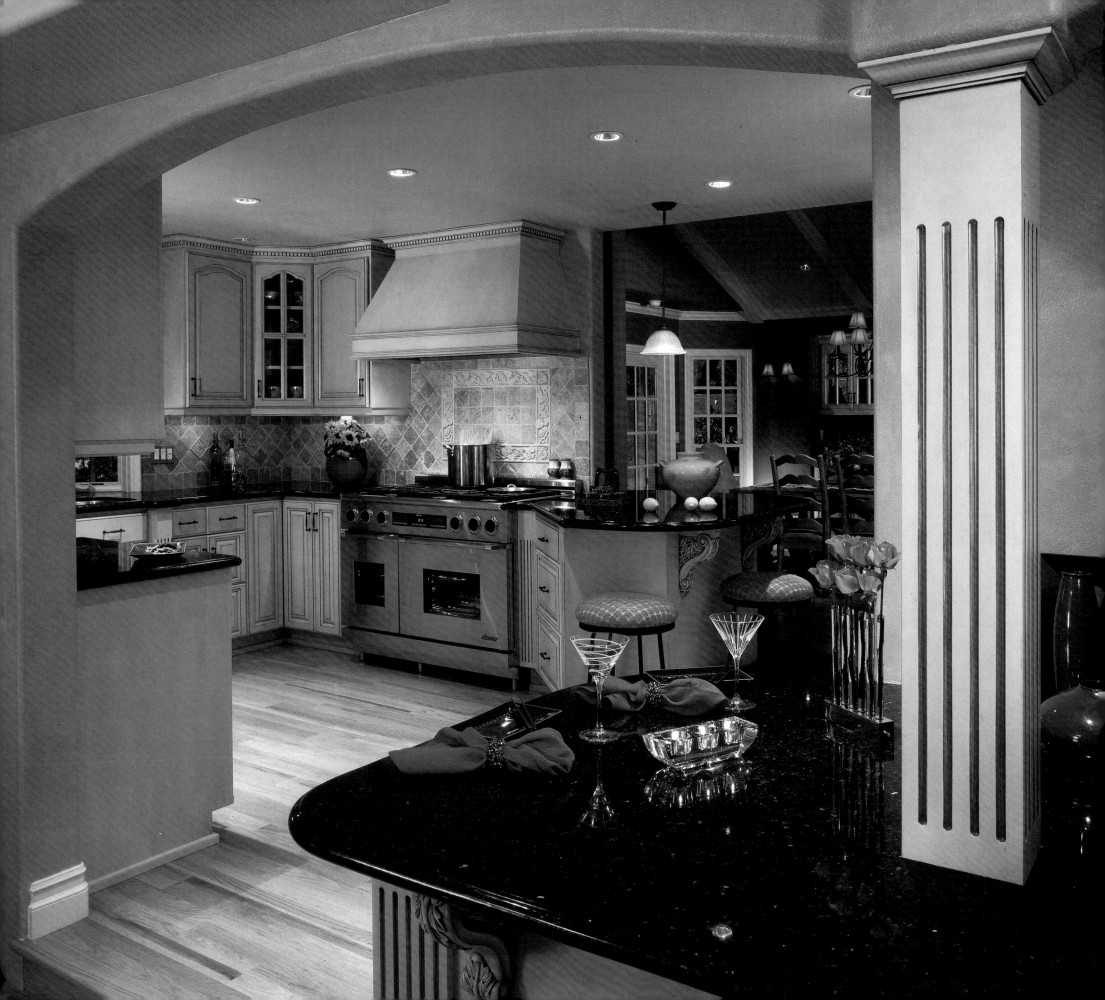

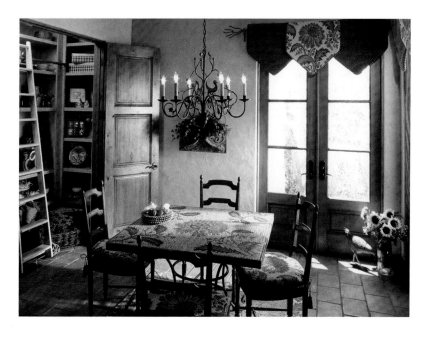

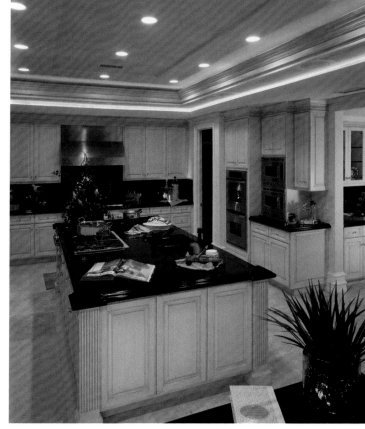

Jamie Namanny
Allied Member ASID
Interior Matters

INTERIOR MATTERS

18520 Morongo Street

Fountain Valley, CA 92703

714-962-3346

FACING PAGE By removing two walls in this Huntington Harbour kitchen, the family and dining rooms became accessible to buffet/preparatory counters, a breakfast table and the bar.

TOP Shady Canyon's Santa Barbara architecture influenced the deep, golden, heavily textured walls and custom sunflower mosaic table inspired by the window and chair fabrics. *Philharmonic House of Design.*

TOP RIGHT Newport Coast's dream kitchen accommodates one to multiple *chef de cuisine*. Featuring two of every appliance with abundant storage in "butterscotch" glazed cabinets. *Philharmonic House of Design.*

Jamie Namanny had been working in business management for years when she began to remodel and decorate her home as well as her friends' and relatives' homes. This avocation led to an unexpected career change, which led her into becoming a professional interior designer. After receiving a degree in interior design and acquiring years of experience, Jamie launched her own firm, Interior Matters. Today, she focuses her passion on remodeling with an eye toward designing unique, functional kitchens for a wide range of clients.

"I create kitchens for crowd control," she says. "Everyone follows the home chef into the kitchen. I love transforming a room into something beautiful, although functionality is considered first. I am a full-range interior designer, but I quite often focus on the kitchen because it's the heart of the house – the center of most entertainment and everyday family activities. As a result, it needs to be designed where people can comfortably sit and visit with the home chef." Jamie closely consults with clients to determine how her designs will fit seamlessly into their lifestyles. In her custom kitchens, Jamie's imagination is unlimited. "Every house is different with its own requirements, so it allows for fresh and unique ideas," she says. "I like challenges that stretch the imagination and create extraordinary results." Given the variety of her work, the one thing that Jamie always insists on in any room is good lighting. "It's the make or-break of all design."

She also encourages clients to use their own good judgment and supports them in making practical decisions on their selections. "If a client's budget doesn't allow using top-of-the-line materials for everything, we can always compensate by utilizing a focal point – a beautiful view or an interesting range hood. When the 'bones' of a project are done well, it all comes together effortlessly." ∎

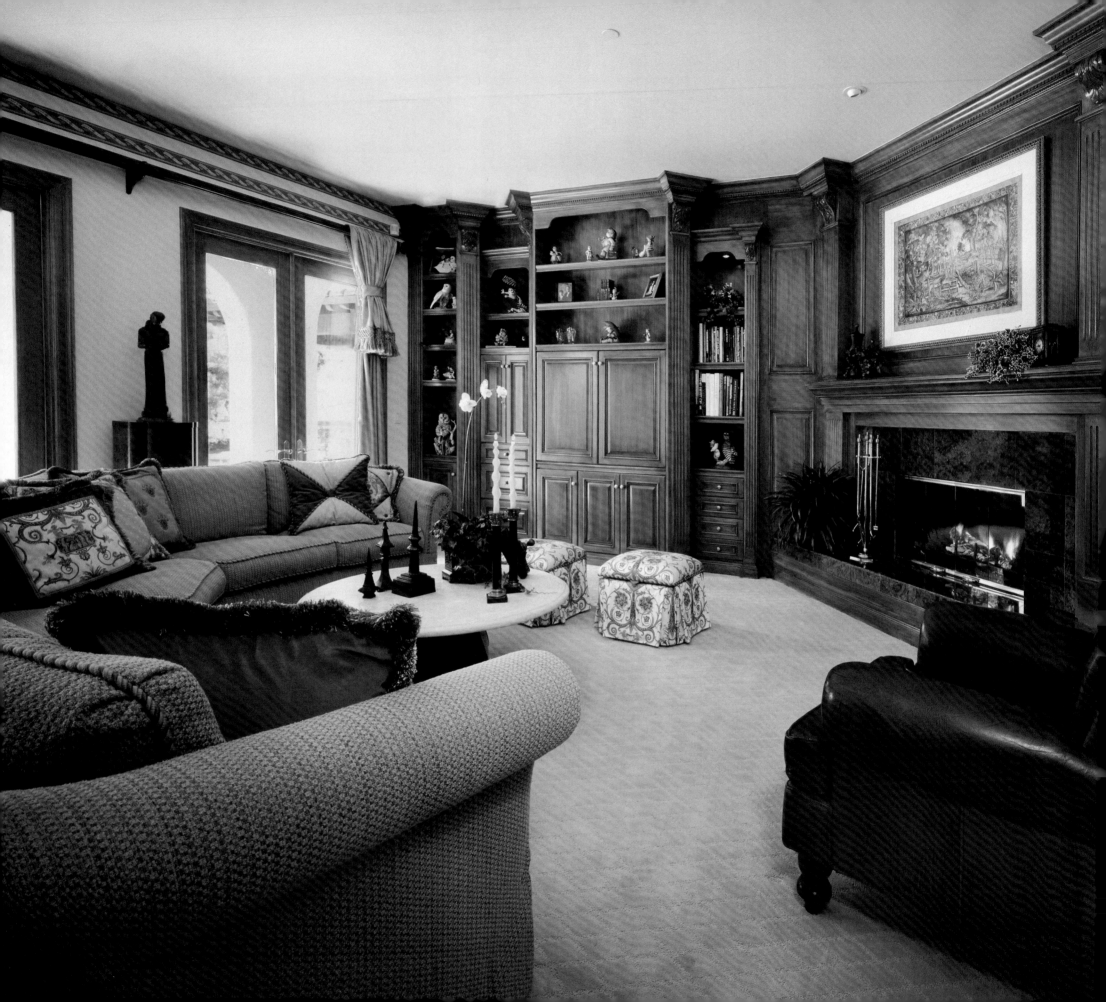

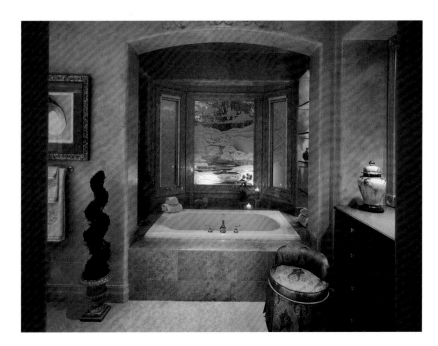

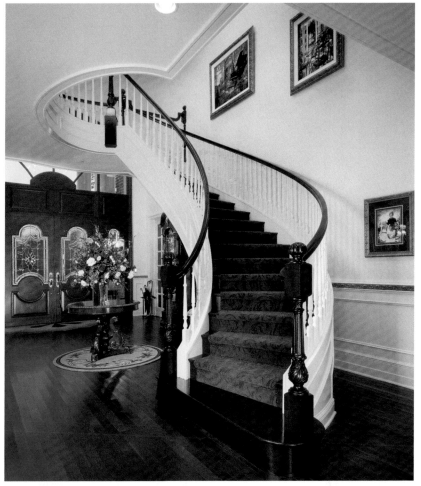

Dawn Piel, ASID, IIDA, CID
Design Expressions

LEFT The clean lines of this comfortable family room are enhanced by the beautiful woodwork design of the entertainment center and the fireplace detail, creating a warm, yet impressive appeal.

ABOVE The carved glass vista in this master bathroom was designed to complement the "real life" view of the mountains which can be seen through the top of the glass, thus creating privacy and an unobstructed view beyond.

ABOVE RIGHT The gracefully curved staircase adds grandeur to this impressive entry way. It is complemented by the Georgian inlaid table and the custom woven area rug. The walls have been stenciled to simulate a damask pattern.

By the age of nine, Dawn Piel knew that she would be an interior designer. "My family was moving to the Middle East into a house that was being built for us and my mother hired a designer to furnish it," she recalls. "The woman was so glamorous and sophisticated. Sitting there with my mom and looking at the terrific designs, fabrics and materials, I said, 'This is exactly what I want to do.'"

Dawn has spent the ensuing years polishing her artistic talents, working with Orange County's top interior designer such as Ted Von Hemert and Lois Harding. "What I took away from the years of experience was a strong work ethic – from Lois, she made me realize that you didn't have to work in a box; you can translate your designs into anything you want them to be."

Since 1996, Dawn has been the founder and principal of Design Expressions, Inc. where she specializes in traditional residential design. A firm believer in continuous learning, Dawn takes every opportunity to explore new areas for design inspiration. "I go to High Point, North Carolina every two years, as well as San Francisco and Los Angeles annually, to see what's new. I developed a foundation and appreciation of

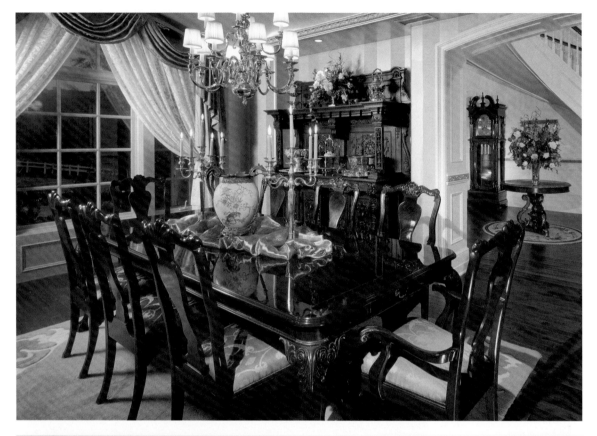

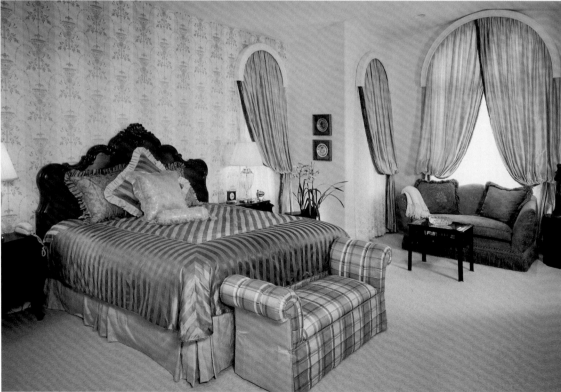

design from living overseas for so many years – I've lived in Kuwait, Rome, and Switzerland and have done a lot of traveling. Being exposed to so many different ways of life has had a tremendous influence on my design practice."

The confident designer is as thorough in her research into her clients' tastes as she is in uncovering the colors, textures and accessories of a particular design style or historic period. Before getting down to work, Dawn has clients do some homework: pouring through magazines and pulling out any photos that strike an emotional chord. "Another part of the discovery process is having clients complete an extensive questionnaire," she says. "If the clients are a couple, I tell them that I don't want to see just one kind of handwriting – both of them need to fill out the questionnaire. It's an important step because people have different expectations about what they want to achieve in their home. Often, my clients are very surprised by what comes out when I show them the various photos and comments that they've collected during our discovery. There's always a common thread that helps us to determine how to slant the design."

One of Dawn's strengths is working with a client's existing collections – and helping them develop new ones. "Everyone has something that they've inherited from a relative or a piece that is pivotal in their lives," she notes. "People hire a designer because they want affirmation that their choices are good ones; some want a designer to create a total environment and then there are those clients who know exactly what they want. I like the challenge of giving someone a design that's even better than what they already see" ∎

FACING PAGE TOP This dining room was created and built to show off the wonderful antique sideboard. The walls have been painted in a metallic and plum strip that coordinates perfectly with the plum silk of the chair seats and the drapery. The silver metallic barrel vault ceiling adds luster in daylight and romance at night.

FACING PAGE BOTTOM Silks and chenilles give texture and interest to the serenity of this classic bedroom. The carved imported French headboard adds elegance.

BOTTOM Quiet sophistication is enhanced by extremely detailed woodworking on both the fireplace wall and the dramatically coved and crowned ceiling. The drapery treatment in its simplicity complements the extraordinary view.

BOTTOM RIGHT This impressive cherry library was created to showcase a collection of civil war memorabilia and books, the gorgeous antique partners desk shows to advantage while the work area created behind it allows for a comfortable working area.

DESIGN EXPRESSIONS

21701 Shasta Lake

Lake Forest, CA 92630

949-588-9616

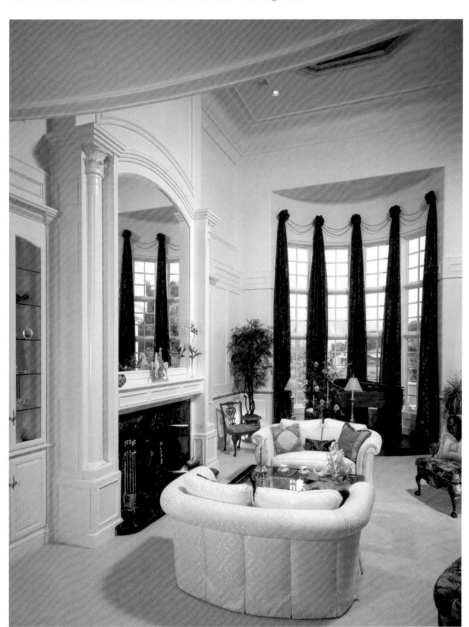

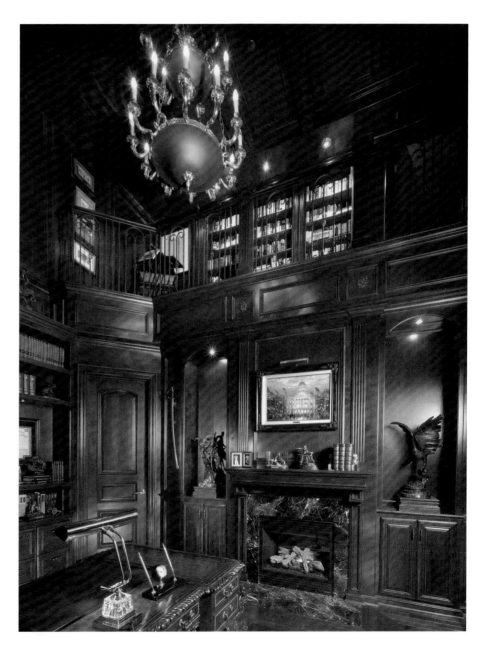

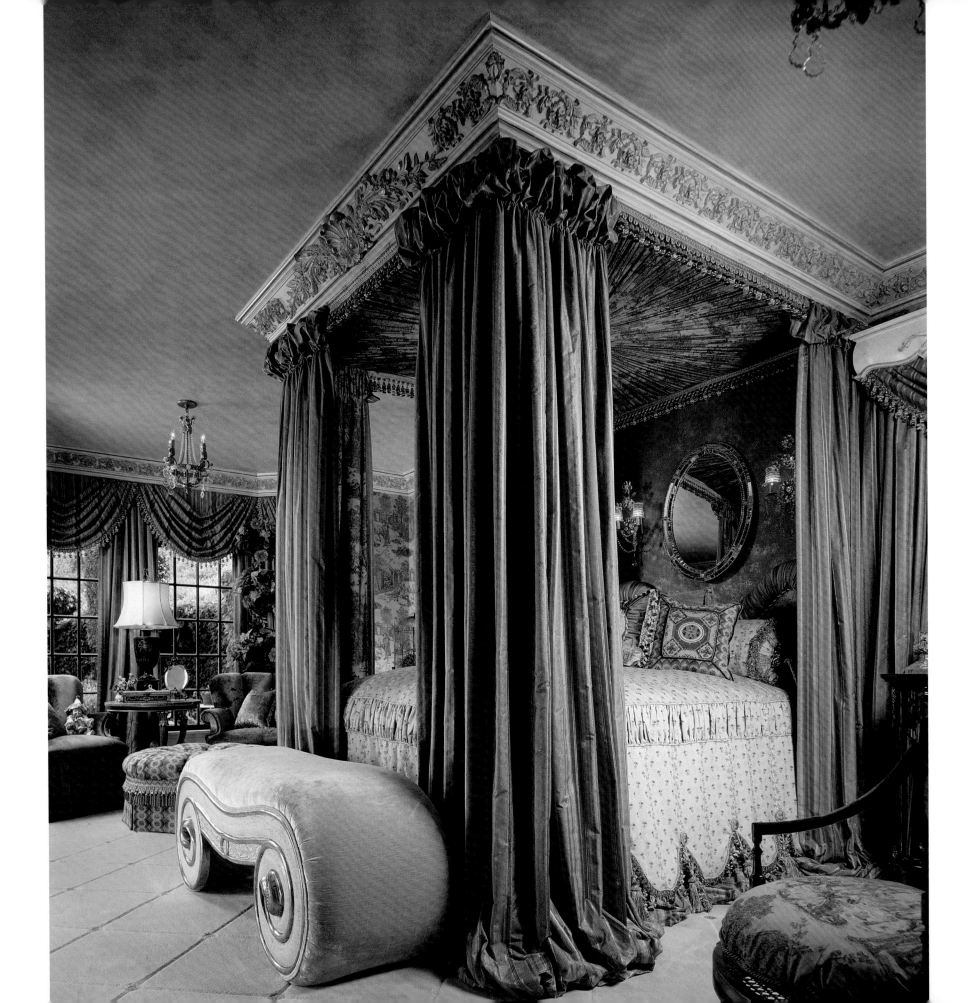

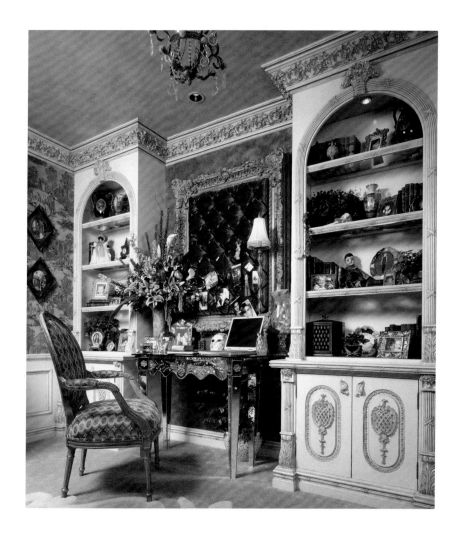

Frank Pitman, Allied Member ASID
Frank Pitman Designs

LEFT A custom canopy bed is the centerpiece for this "Princess Suite." Designed for a college-bound teen, this space doubles as a guest suite.

RIGHT Flanked by carved bookcases, a Venetian desk is adorned with antique Murano rosettes. Antique hat-pins organize thoughts on a guilt-framed keepsake board.

Forget the concept that less is more. Noted designer Frank Pitman of Frank Pitman Designs Inc. is known for his extensive use of fine materials and his relentless pursuit of details. Taking history as his inspirational muse, he loves the elaborate architecture and interiors of the great palaces and castles of Europe and the grand estates of America.

Offering full-service interior design, Frank and what he describes as his "wonderful" staff handle a variety of projects, from homes to restaurants to commercial spaces. The lion's share of the firm's work is residential, with interior architecture its specialty.

"Most of our clients want elaborate, carved interior elements: paneled walls, pediments, columns, coffered ceilings, detailed door and window surrounds and architecturally inspired custom kitchen cabinetry," Frank points out. "The most time-consuming part of these projects is specifying the numerous components and creating all the drawings by hand, and that ability gives me an edge. It eliminates the guesswork, so the client knows exactly what the finished project will look like prior to completion."

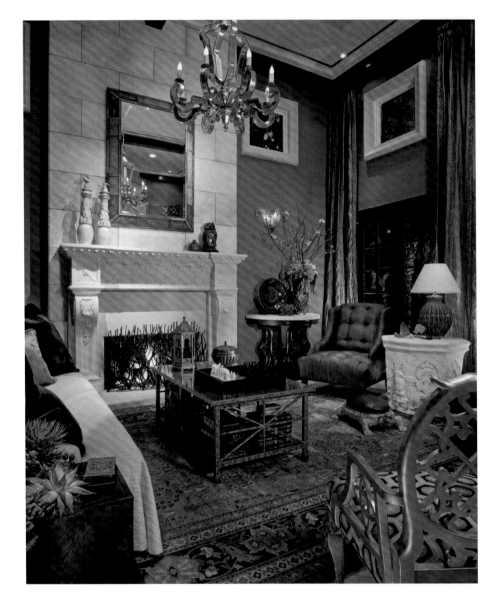

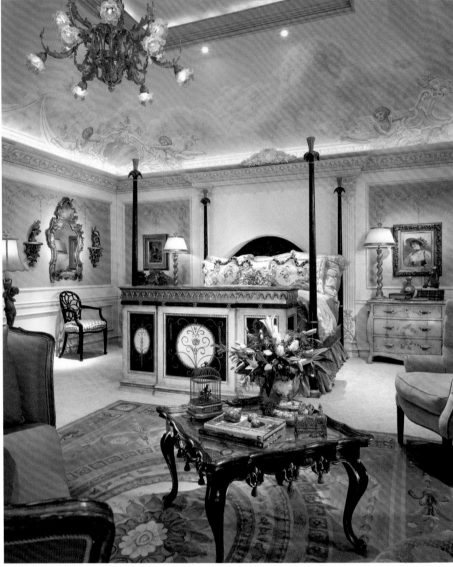

That edge isn't a surprise. Frank had his eye on a career as an architect, which took a turn when he realized that interior design was much more to his liking. So the young man who was drawing two point perspective at the age of five entered design school and was hired straight after graduation by the renowned design firm Rolling Hills Interiors. He struck out on his own in the 1980s and has never turned back.

"It seems that everyone in the industry is afraid of being referred to as a 'decorator,' but I'm not," he declares. "Some of the most brilliant designers in the world went through their careers being decorators and I have so much respect for them."

TOP LEFT Cocoa sueded walls and an antique rug anchor this formal living room, where carved limestone and cream fabrics are the compliments in this earth and mineral color scheme. *2005 Philharmonic House of Design.*

TOP RIGHT A large, rotating television rises from a custom cabinet at the foot of this hand-painted bed. Custom painted wall frescoes with Italianate motifs compliment the ceiling mural. *2004 Philharmonic House of Design.*

Frank cites "decorator" Tony Duquette as a major influence on his work, as well as Rochelle Baratucci. "Rochelle is a color genius who coined the phrase 'casual elegance,'" he notes, "and Tony Duquette is the master of scale and creating ambiance."

Believing that the elements of elaborate design can be easily translated to a moderate budget, Frank feels that the roots of great architecture can be infused into any interior, which his clients are able to see and appreciate upon the project's completion. ■

FRANK PITMAN DESIGNS

25421 Posada Lane

Mission Viejo, CA 92691

949-768-3943

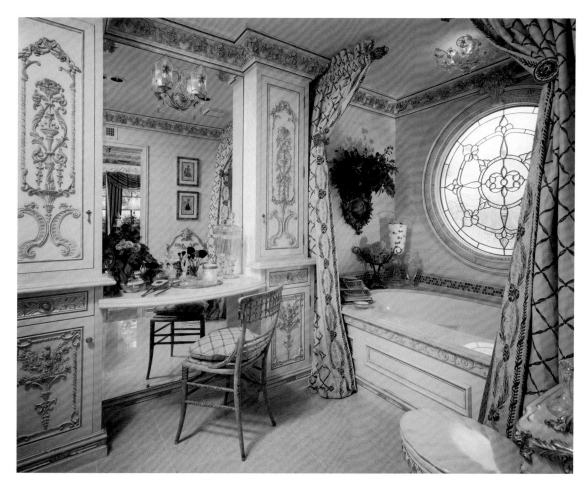

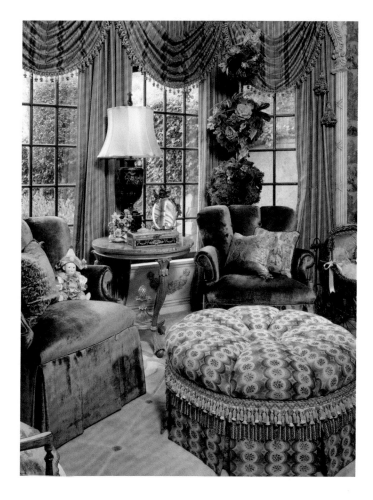

TOP LEFT Installing a custom window over a sunken tub adds luxury and romance to this spa-like Ladies Bath. The antique chair was hand painted to coordinate with fabrics and French fixtures. *2003 Philharmonic House of Design.*

TOP RIGHT Silk velvet boudoir chairs and a tufted ottoman round out the sitting area of the "Princess Suite." Extensive custom woodwork frames the bay window, which overlooks English gardens. *2003 Philharmonic House of Design.*

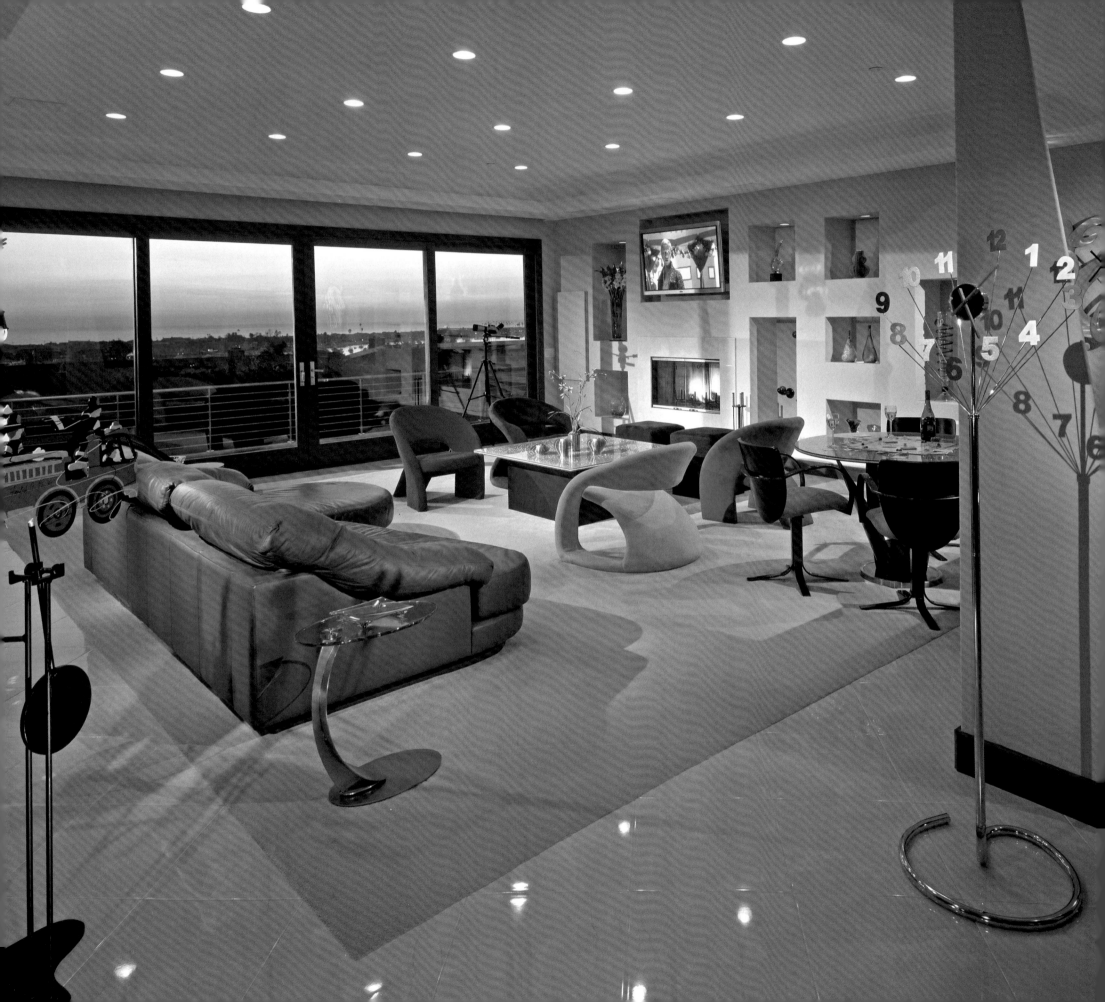

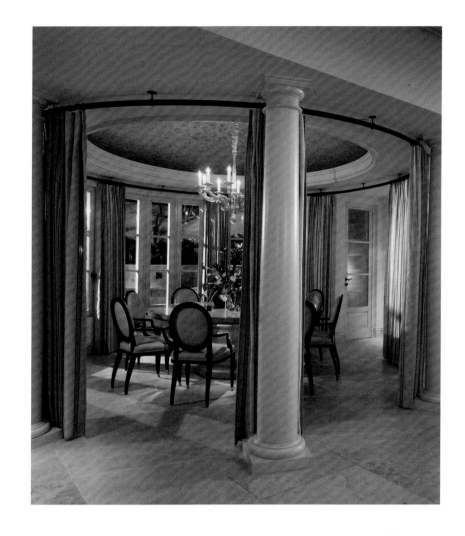

David Rance, ASID, CID
David Rance Interiors

LEFT Corona Del Mar -- Clean and colorful. This residence was built for family, friends and entertaining. New technologies, artwork and several conversation areas are integrated in this design.

RIGHT Pelican Crest - A classic French Deco dining room, offers glamour and a gracious invitation. Draped in striped silk, elegant lighting, the sound of a fountain enhance this space.

The cutting edge is where David Rance likes to be. Eleven years of working in the computer industry kept him up-to-date with the latest technological advances, but David missed his need for creativity. "I had the big office and perks, but something was missing," he explains. So in 1988 he decided to make the jump to a design career. With an educational background in architecture and fine art, David returned to get a degree in interior design. Upon receiving his degree, and having several years of management and corporate organization, David was ready to open his own studio.

David works primarily in new construction and with major remodels. "I'm involved from beginning to end." Much of his work reflects a clean lined style. "I'm not a person who is going to do frilly, overly cluttered design," he notes.

Though he's designed homes for celebrities and even a Saudi Arabian princess, David's favorite jobs are still the ones where he really gets to know the client. "I listen to them to get an idea of where they want to go and draw on the range of elements that the clients bring to the project," he says. "Then I add in new innovations or new ways to use a particular item. My design has to reflect the client's lifestyle, and it has to be refined and detailed with classic ideals. "

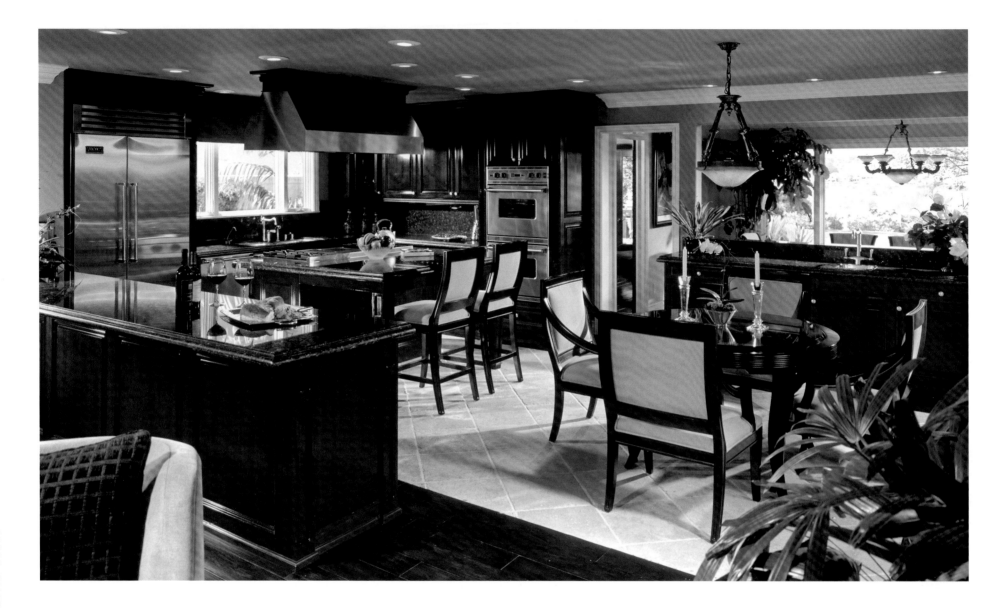

ABOVE Newport Beach -- Refined for entrepreneurs on the go, this is home and hearth designed with class. For a meal with close friends, or a glass of wine with a client, this space offers it all.

David is proud of his ability to make rooms multifunctional. Though most rooms have a primary space plan, today's clients have needs for multifunction within a given space. David explains that there are different ways to stage a room depending on the time and occasion. Recently he designed a contemporary-styled home with an adjustable dining room. "I provided two square dining tables for eight settings each. Then I created an abstract coffered ceiling with a monorail lighting system, so the client could move the lighting as the table configurations changed for different entertaining styles," says David.

Every home that David designs is as exclusive as his clients. "I want every turn to be a new experience for people coming into my clients' homes." Use of new items and fresh innovative ideas develop into dynamic presentations. Another of his recent projects started with a French Provincial theme and ended

up reflecting the styles of the French Riviera, Art Deco and California Eclectic. "It's as if you bought an old chateau on the French Riviera and furnished it with modern pieces," he explains. "There's an old-world kitchen and an Art Deco media room. But as you walk from room to room, it all flows."

Interior Design has become a wonderful element to David's life. He truly enjoys his profession. This creates a very enjoyable design experience for David's clients. He is a believer in the saying "a man that loves what he does will never work a day in his life." ■

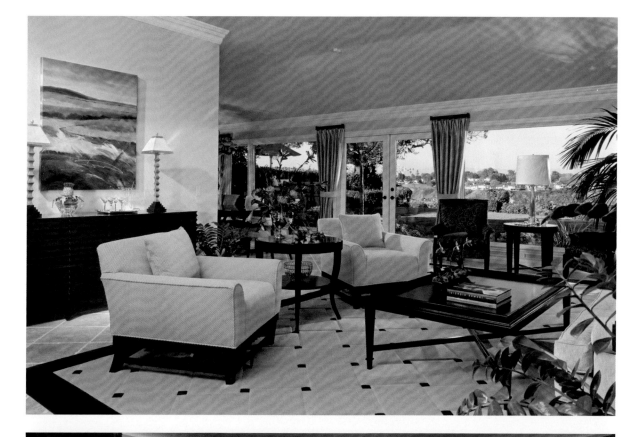

TOP RIGHT Newport Beach, Refreshing as the sea breezes, this living room offers classic design and comfort. Conversations, reading, listening to music, this room would inspire a novel.

BOTTOM RIGHT Pelican Crest, Hollywood nostalgia and theatre inspired this sumptuous media room for private screenings. Leather seating, Lalique lighting, and exotic woods make one feel special.

DAVID RANCE INTERIORS

207 N. Broadway, #A

Santa Ana, CA 92701

714-835-2408

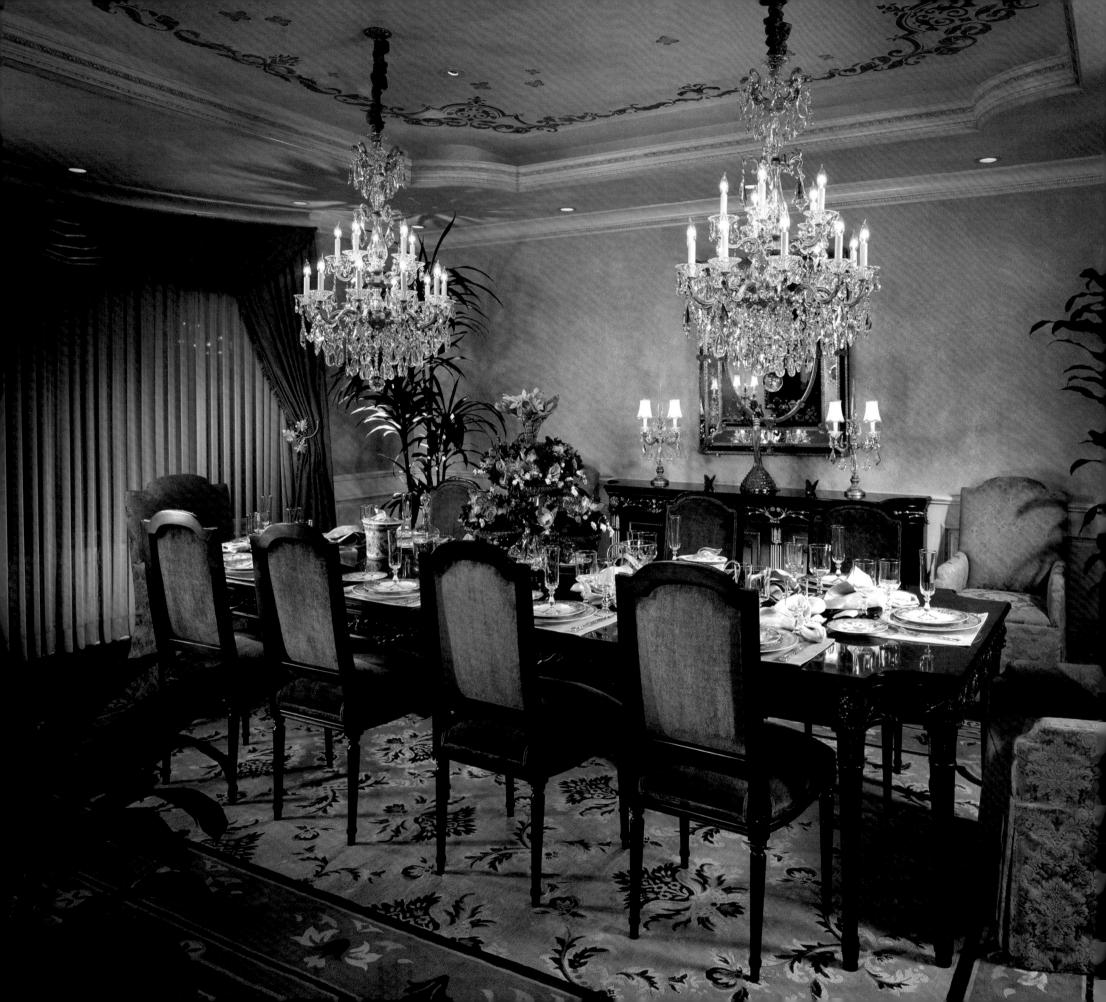

Deanna Robinson,
Allied Member ASID
Deanna Robinson Interiors, Inc.

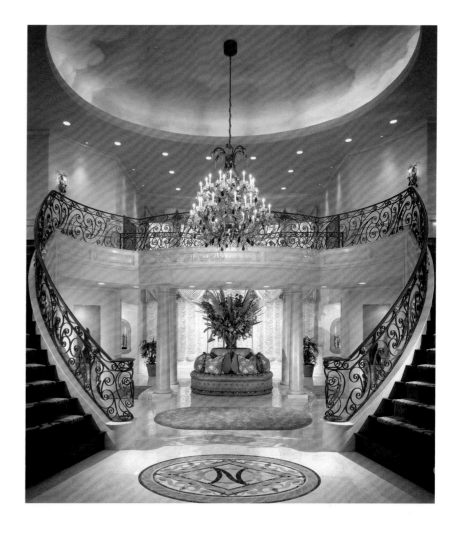

LEFT The formal Dining Room evokes a rich, subtle palette of sage, peach, lavender and gold. E.J. Victor furnishings, Schonbek lighting, a custom hand woven rug and specialty finishes and mural complete this award winning design.

RIGHT Dramatic usage of lighting, murals, custom designed stone inlays, custom designed rugs and railings add warmth to this classical design.

"Deanna Robinson Interiors, Inc. is "the design firm with a difference." From its talented staff to its innovative design process, DRI, Inc. offers their clientele service and design that is unique to the profession. The company prides itself on creating custom interiors that surround clients with luxury and taste that reflect their lifestyle.

Deanna Robinson Interiors, Inc. has a staff of seasoned interior designers and CAD designers, as well as an experienced project administration team. The firm's hallmark is its turnkey project work – from conceptualizing a home's design to completing the details with lighting and accessories. "Our design styles include Contemporary, Transitional, Cape Cod, Traditional, French Country, California Ranch, Tuscan, Mediterranean, and Craftsman," says Deanna Robinson. "But it is always a style interpretation that is unique to each homeowner." Whether it's creating a stunning Tuscan-inspired Villa in the Los Angeles hills or a sleekly contemporary home on the Newport Coast, Deanna Robinson Interiors, Inc. knows that the secret to a good design partnership is listening closely to their clients and understanding their lifestyles.

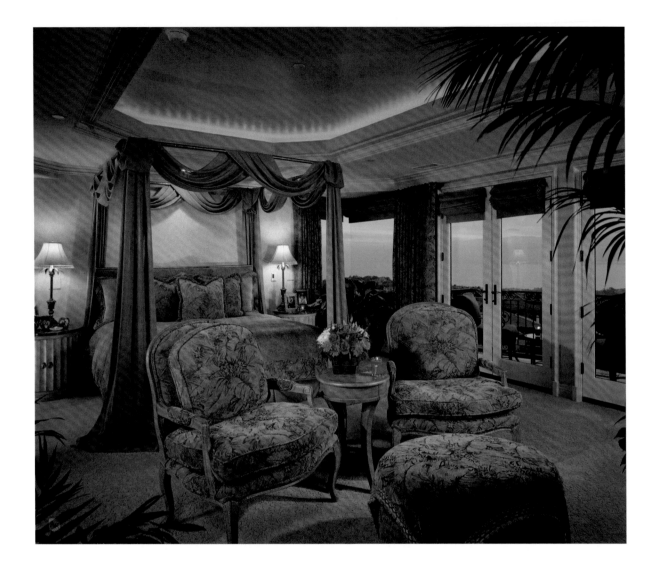

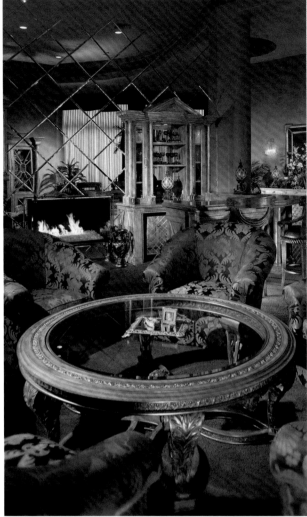

This philosophy is particularly important in custom home and remodel projects where misinterpretations can be time consuming and costly. The company collaborates with architects, builders and clients to develop a comprehensive Specifications Book. "This is a unique service in the design industry that we offer as a part of our regular service," notes Ms. Robinson.

Once Deanna Robinson Interiors, Inc. receives an architect's plans, the firm archives in the details to ensure perfection and smooth project flow – from selecting finishes to detailing every piece of hardware, millwork and flooring. "The Specifications Book is a living entity that starts on day one while we're talking with the client and is updated each and every time a decision is made. The result is an invaluable resource that helps the builder create a bid with less surprise to the client."

The firm stands apart in its ability to enter the design process at any phase of the project cycle. The company utilizes state of the art technology, as well as highly trained virtual design specialists to produce a three-dimensional visualization of a client's dream home before it is completed.

ABOVE LEFT Ocean and city lights are showcased with this dramatic blend of silks, chenille, architecturally proportioned bed treatment, window treatments and key lighting.

ABOVE Luxurious gold tones designed by Custom Phyllis Morris Furniture, fabrics, mirrors, stone work, artwork, crystal and wall finishes create rich formality of magnificent elegance.

FACING PAGE Understated comfort of rich textures and Mediterranean colors of sage, burgundy and gold complete this Tuscan guest house / game room.

Deanna Robinson Interiors, Inc.'s award-winning projects have been featured in numerous publications, including *Coast Magazine, Orange Coast Magazine*, and *Options* magazine, and have been showcased in the Orange County Philharmonic Society, the Spyglass Hill and Big Canyon Philharmonic Societies, and the Corona Del Mar High School and Newport Harbor High Schools Home Tours. Their custom residential projects ranging in size from 4,800-square-foot lofts to 38,000-square-foot estates, include exclusive Los Angeles and Orange County neighborhoods; various resort communities, such as Rancho Mirage and La Quinta; and projects in Las Vegas and Lake Tahoe, Nevada, New York, Hawaii and Saudi Arabia. ■

DEANNA ROBINSON INTERIORS, INC.

151 Kalmus Drive, Suite F-5

Costa Mesa, CA 92626-5965

714-957-5725

FAX 714-957-0347

www.deannarobinson.com

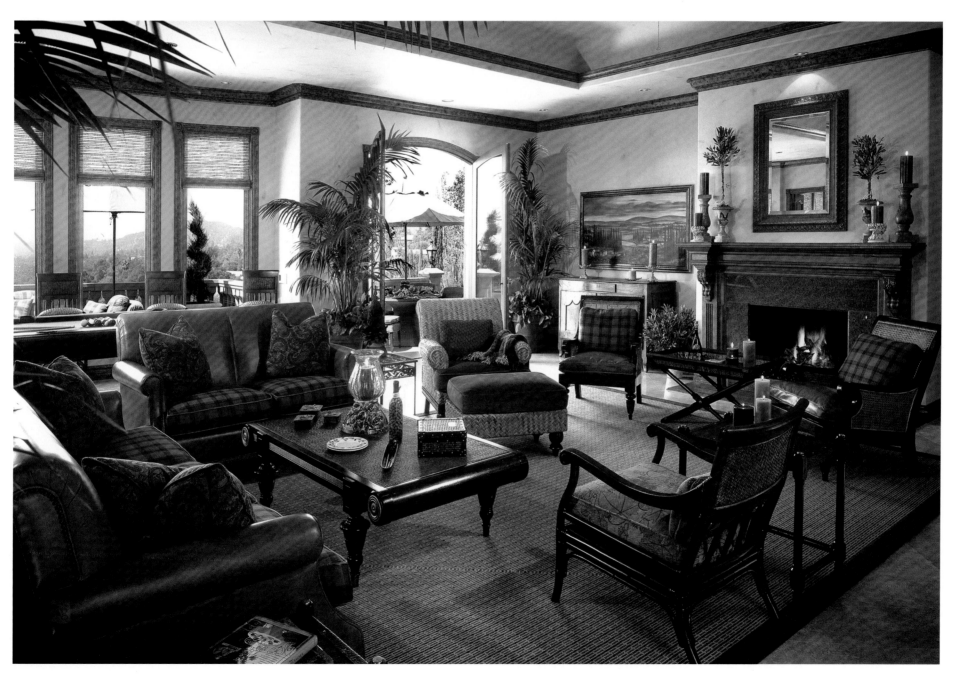

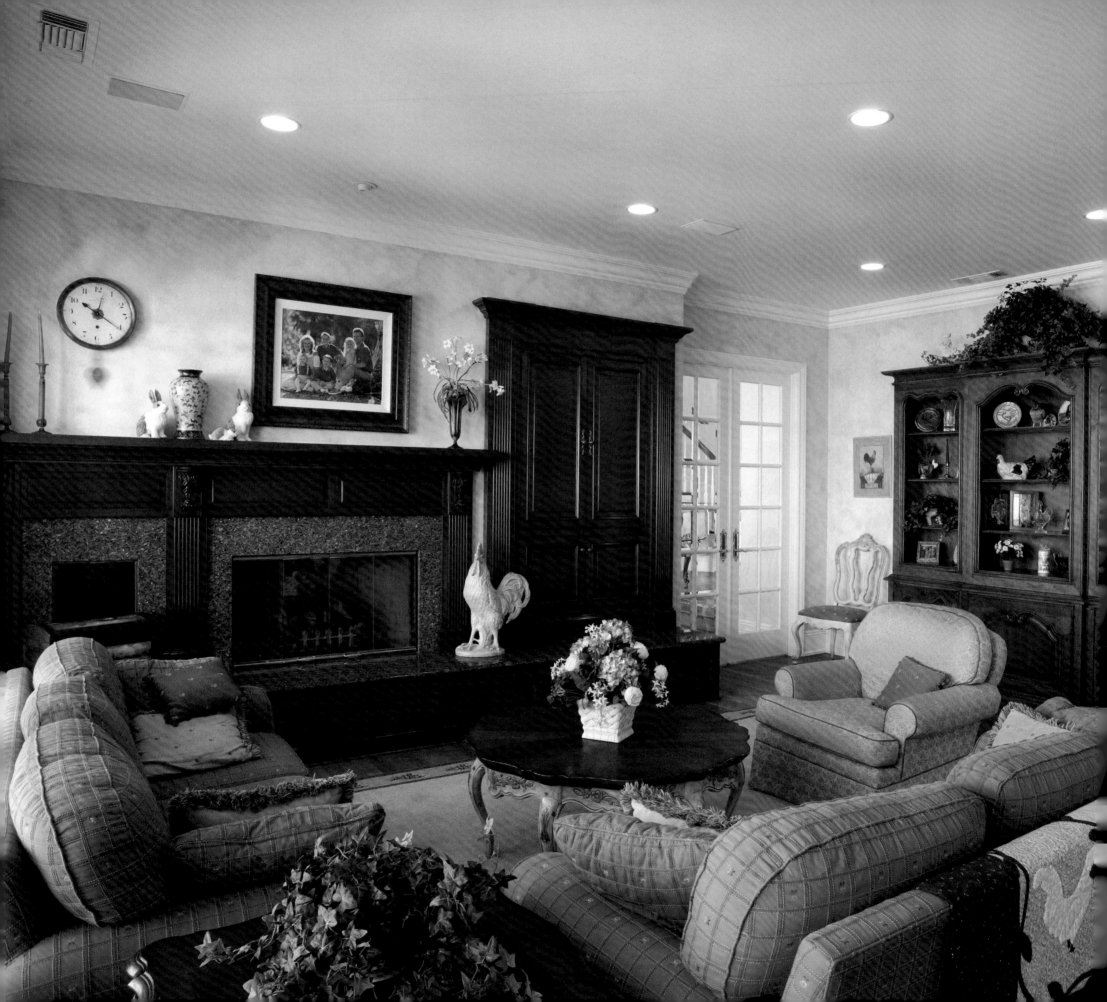

Teresa Scotti, ASID, CID
Design Possibilities

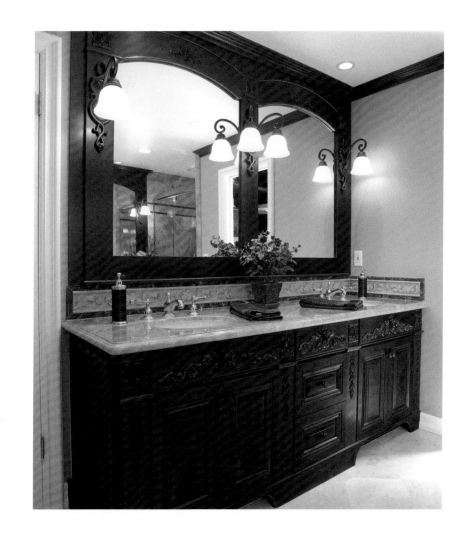

LEFT This family room in a custom home in Fullerton features Country French-inspired faux finish walls, cherry woodwork, blue peral granite, and a custom area rug with tapestry border.

RIGHT This master bath remodel features Furniture-style custom cabinetry and built-in framed mirrors with appliqués, a Karnis slab marble countertop with Emporer Dark marble accents and polished nickel faucets.

To say Teresa Scotti adores interior design would be an understatement. The self-described workaholic lives to uncover just the right accessory, the perfect finish or the exact color combination that not only brings the whole project together, but also makes it shine. "My philosophy is 'Explore the Possibilities,'" she explains. "In design, there are endless options. When I'm presenting to clients, I have some that ask me which design is the right one. The answer is: There is no right choice. You'll have a preference, of course, but there are many possibilities to explore within those preferences. This is why I named my firm Design Possibilities."

An interior designer with more than 25 years of experience, Teresa founded her own firm in 1997. After receiving her degree in environmental design from California State University, Fullerton, Teresa learned the ins and outs of the business from a seasoned interior design mentor.

And this hard work has paid off: Teresa's clients come back to her repeatedly – and refer their friends to the flexible, knowledgeable designer. "My work is primarily residential," she says. "My favorite

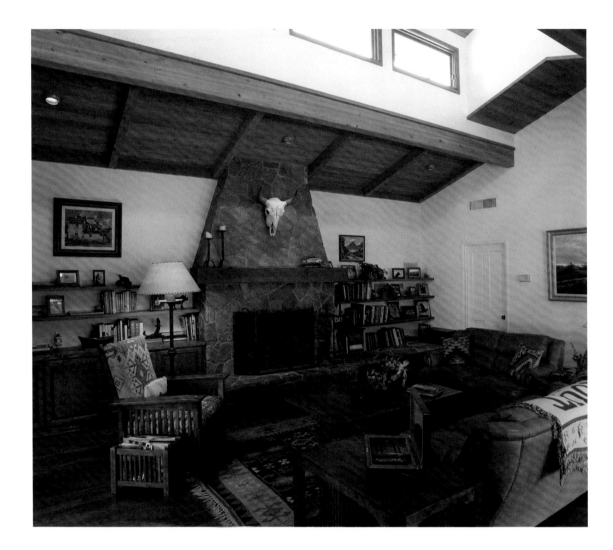

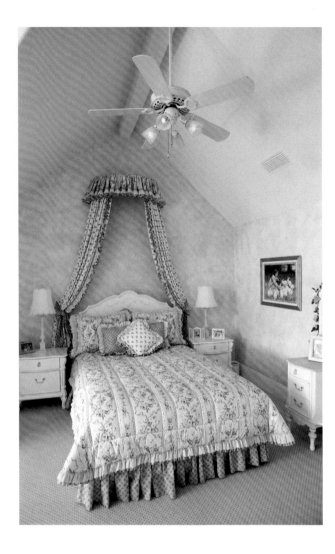

projects are new construction or remodels, so if we have to move any walls we can do it on paper before it's actually been framed. I also love to specify materials. Before you even start adding the furniture and accessories, I like to work with the initial elements that go into making a room."

An example of this top-to-bottom design is a Montana second home that Teresa is currently designing for a long-time client. "It's different from any other house that I've worked on," she says. The vast property includes a main house, a guest house and a bunk house where, working with the rough-and-tumble environment and the client's taste, much of the materials specified by Teresa are rustic and well-worn. "One of the buildings is a homesteader's log cabin where they took the building apart and reassembled it log by log on a new foundation," she recalls. "It's a great experience to collaborate with the Montana contractors – they are such craftsmen and do phenomenal work."

Whether it's modern, classical, retro, rustic – or anything else in between – Teresa prides herself in not imposing a particular style on her work. "I create what the client wants, and so many people have

TOP LEFT This gentleman's den addition in Lemon Heights showcases a natural materials stone fireplace, solid oak plank flooring, wood ceilings, leather sofas and a custom Morris chair and end-table made of mesquite.

TOP RIGHT A young girl's bedroom in a custom home in Fullerton features young, fresh, feminine doll-house inspired faux finish walls, wool carpet, painted furniture and lots of pink roses and ruffles.

FACING PAGE In this kitchen remodel in Santa Ana, the final design was achieved by including clean lines, stained alder cabinetry with custom doors and drawer fronts, Juparana Viara slab granite countertops and splashes and natural wood plank flooring.

an eclectic mix of styles and objects in their homes," she notes. "I do more traditional than contemporary, but that encompasses Arts & Crafts, French, Spanish and even some Scandinavian."

It's this matchless quality of getting into the hearts and souls of her clients that allows Teresa to connect on a higher level. "My clients have told me that I'm easy to work with, and that they love their homes. In my work, I feel that I'm doing something more than making things attractive and functional – I'm helping people emotionally." ■

DESIGN POSSIBILITIES

7851 E. Viewmount Court

Anaheim Hills, CA 92808

714-280-8770

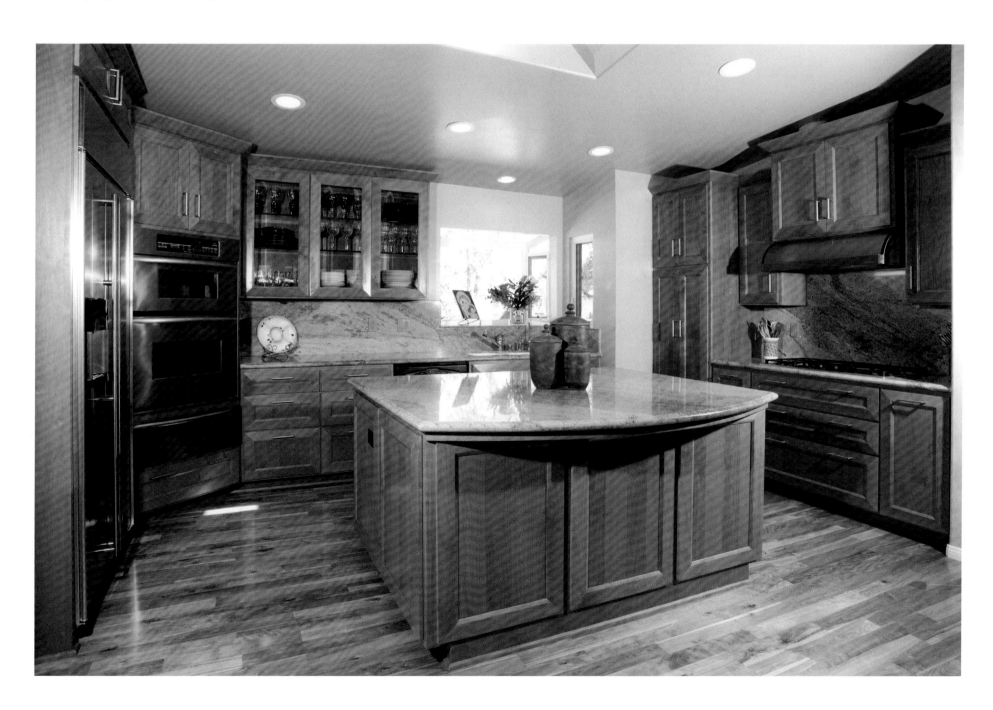

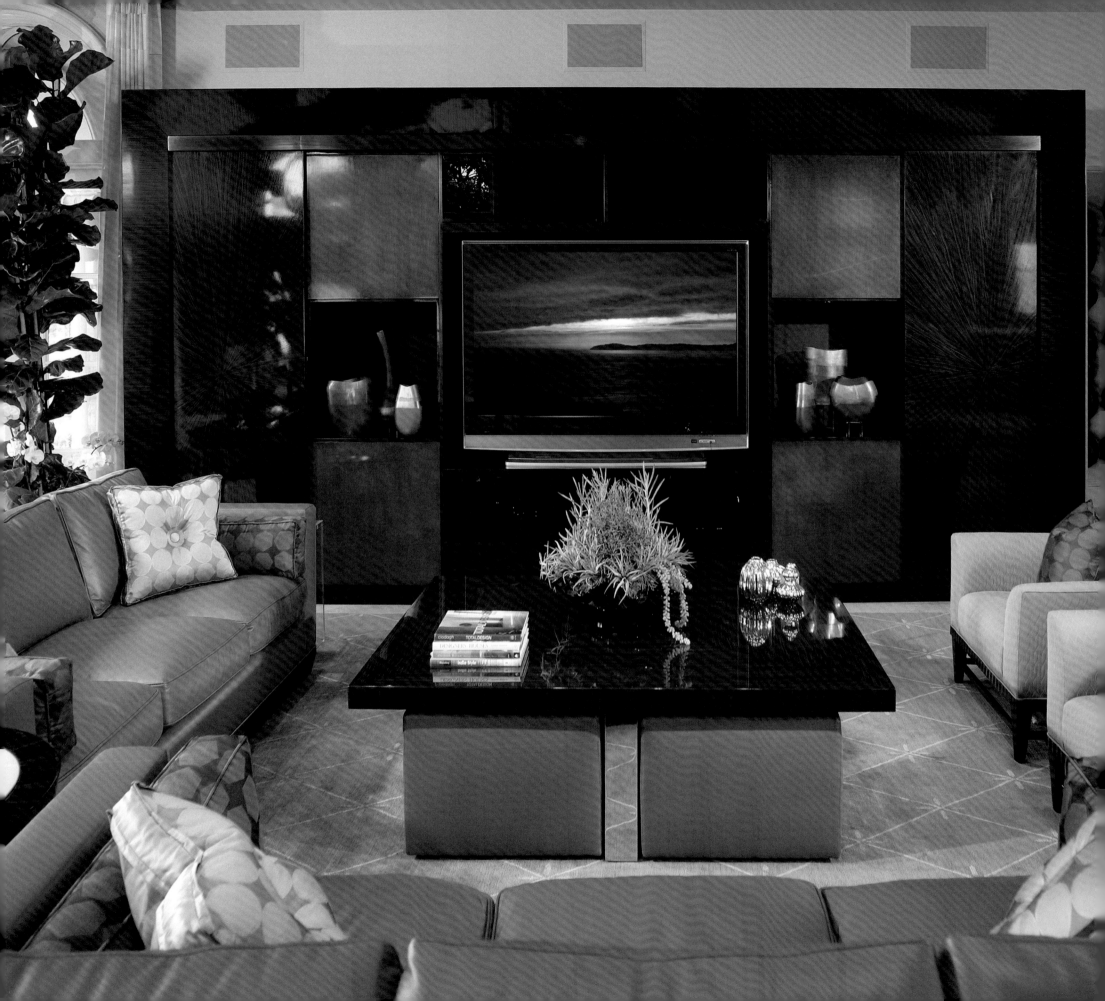

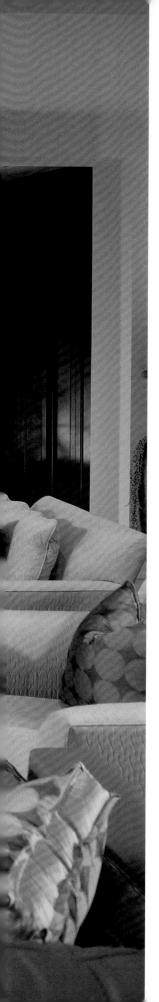

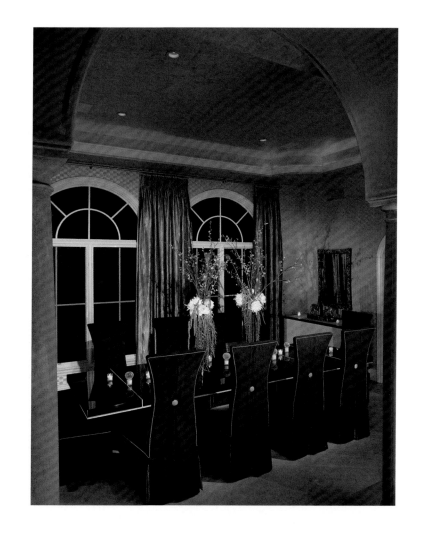

Anna Shay, ASID, CID,CKD
Solanna Design, LLC

LEFT This award-winning project employs rich, exotic maccassar ebony veneers, supple leathers and hand-tufted silk and wool area rugs to draw one into this strongly symmetrical family room. State-of-the-art media equipment make it ideal for quality family time. An extremely warm, contemporary space with dramatic scale.

RIGHT Decidedly Art Deco with its clean lines and rich finishes. Magnificent attention to detail; pleated metallic wall coverings in a pale shell hue impart a soft shimmer; beaded drapery with smock top details. Furnished at the highest level of quality with limited edition furnishings, Dakota Jackson dining table in maccassar ebony with ivory inlays; Lucien Rollin console.

A nna Shay is a master of mood – combining the nearly lost art of fine craftsmanship with exotic materials to create a high-end contemporary style. "My work always incorporates a historical context with a contemporary twist," she says.

Whether its embellishing French Art Deco forms with rich Macassar ebony veneers, or creating hand-blown glass finials and furniture accessories, no two of Anna's jobs are ever the same.

"My inspirations come from my clients and their backgrounds," she notes. "I spend more time than I should trying to absorb another person's aesthetic – finding out how someone sees and feels about color, what level of density he or she is looking for in a room. I'm probably a much cleaner, minimalist designer."

As the principal and founder of Solanna Designs LLC since 1990, Anna specializes in residential interiors. Working with a team including a general contractor, lighting designer, architect and audio/visual specialist, Anna gives clients a cohesive design package complete with one-of-a-kind, tailored pieces.

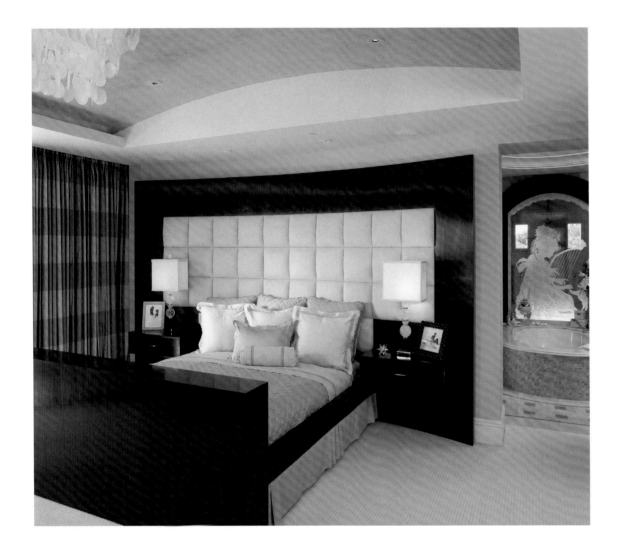

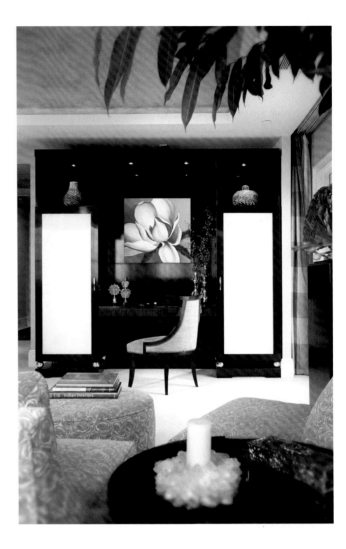

Anna's extensive travels throughout the world – particularly in Asia and Europe – have helped inform her signature design style. And it's this insight into the old traditions, combined with a fresh, contemporary voice, that have won her appreciative clients from a wide range of Southern California's communities.

She describes an art commission from a young Indian couple who wanted to highlight certain elements of their heritage using a distinctly modern flair. "It's a piece that's very Mondrian in style interlaced with subtle references to their Indian background. The clients don't want to turn their backs on their culture, but instead they want to explore a whole new area of design with deference to their unique background. My job is to help them define their culture in their home."

Anna finds that one of the most enjoyable parts of her job is experiencing the inner workings of other cultures. From designing kitchens and learning how clients cook, to learning about the hierarchy in the family, "I find that it makes it more interesting and enjoyable going in to a design project with no preconceived notions," she says. "I really enjoy uncovering how the rhythms of my clients' days go."

TOP LEFT Winner of the ASID Platinum award for best bedroom. Dramatic master suite with sweeping clean lines, suede headboard and exotic wood finishes beckons as an exquisite retreat. Replete with a slim line TV which rises from within the footboard of the bed.

TOP RIGHT This dual function furnishing simultaneously houses the A/V components while providing an elegant work area for a bedroom office space. Rich woods, parchment finishes, and white gold details embellish this custom furnishing.

FACING PAGE Winner of the ASID Platinum award for best bathroom. This bath was described as "total perfection in every detail" by the judges. A peaceful sanctuary in hues of soft blue and beige. Glass mosaic tile and illuminated glass sinks. Intricately carved glass panel lit with fiber optics makes for a magical evening bath.

While Anna has been the recipient of several *Orange County Home Magazine*/ASID platinum awards for her work, and has participated in a range of showcase houses and home tours, she describes her dream job as one with total design freedom. "And I do have jobs like that," she says. In particular, one repeat client who has a home in Hawaii, has given Anna complete creative control of the project. "It's the best reward and confirmation of your work when a client hands over a healthy budget and says, 'Wow me,'" she says. "That kind of confidence really sends my creativity flying." ∎

SOLANNA DESIGN, LLC

1715 Newport Hills Drive West

Newport Beach, CA 92660

949-644-8890

www.solannadesign.com

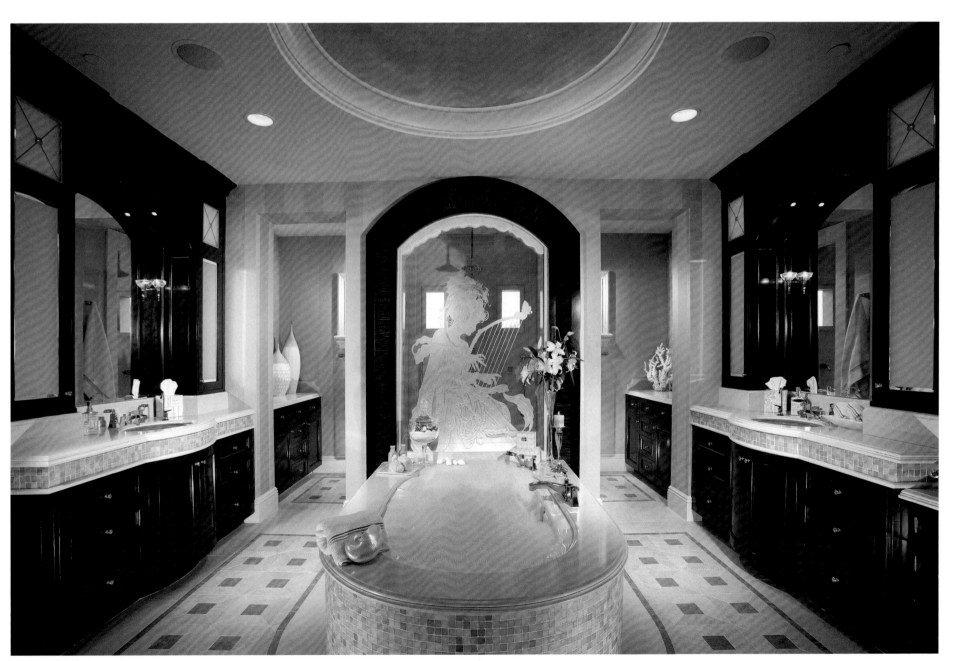

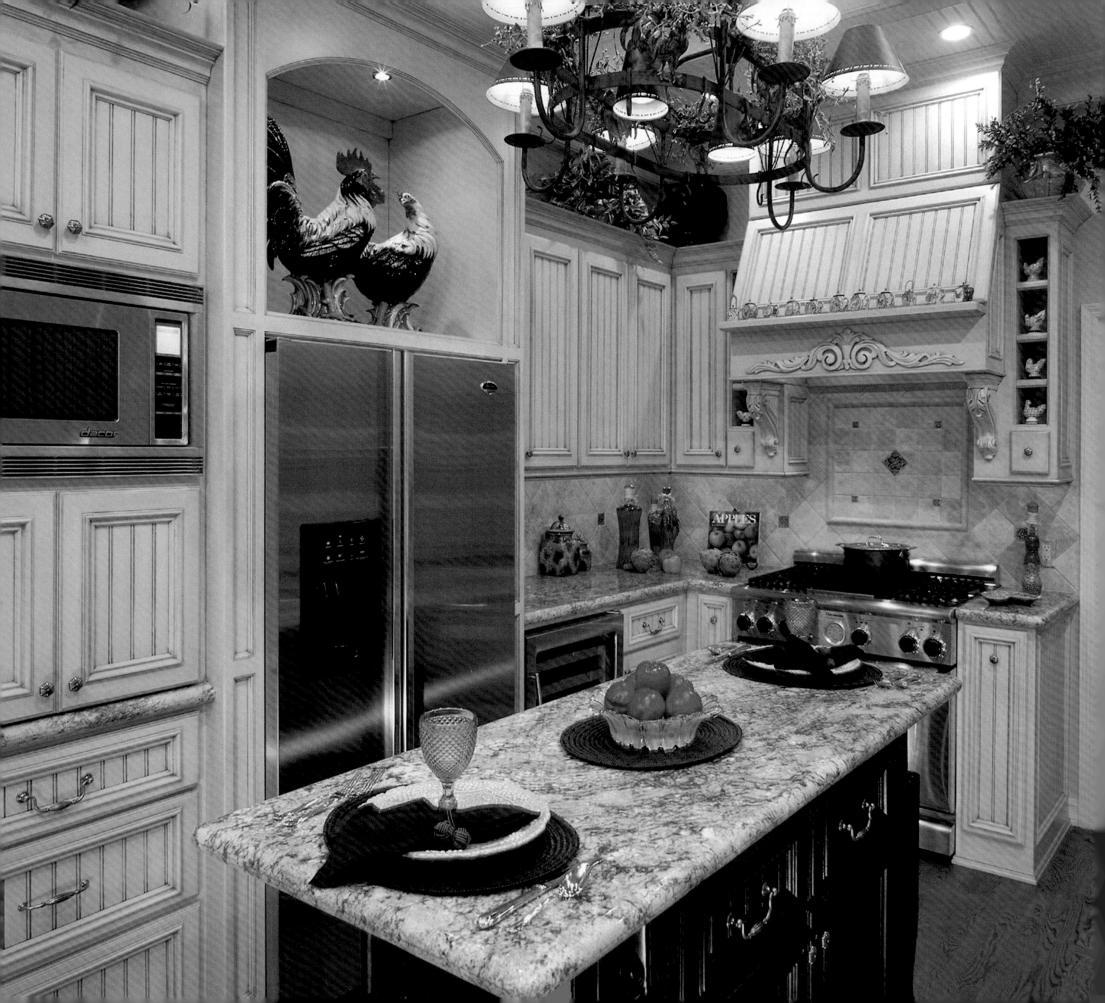

Diane Sparacino
Allied Member ASID, CID
Bay Design Group

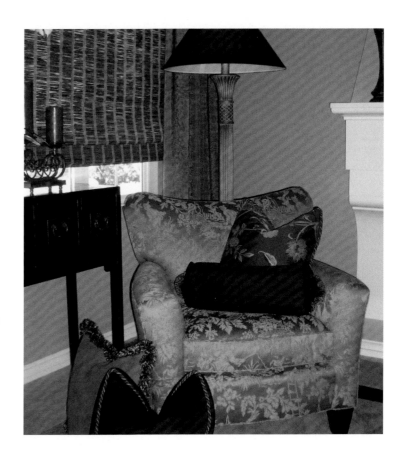

BAY DESIGN GROUP

2915 Redhill Avenue, Suite F205

Costa Mesa, CA 92626

714-540-5370

LEFT The designer was able to make her client's dream of a big, dramatic and professional-style kitchen come true despite the small space.

TOP RIGHT This custom chair with an Asian flair positioned in a sunny corner provides the perfect setting for a cozy retreat.

Diane Sparacino's love for design began some 15 years ago when she was inspired by family and friends to take her creative talents to a new level. Her natural creativity was further honed while attending Interior Designer's Institute in Newport Beach, California, earning her degree in interior design.

Gracious and inviting, Diane's interiors result from carefully considering scale, balance, color, texture, lighting and rhythm to bring harmony to her designs. She loves lots of color and employs it in most interiors – from a causal cottage to the most formal sitting. "The initial planning of a space is the most important aspect of any design," says Diane. She works very closely with her clients to learn their lifestyle, tastes in style and color. She then goes to work to create a pleasing and functional environment in which her clients can enjoy for years to come. Diane will also work with her clients to create their space in phases to accommodate their budget.

Coupled with her interior design degree and California Contractors license, Diane can design and coordinate small or large projects ranging from a remodel to simply accessorizing a space. "I believe in the quote from the crystal and china designer, William Yeoward, 'An item does not need to be expensive to make a design work.' I take traditional elements and tailor them to the individual tastes and lifestyles of my clients," says Diane. ■

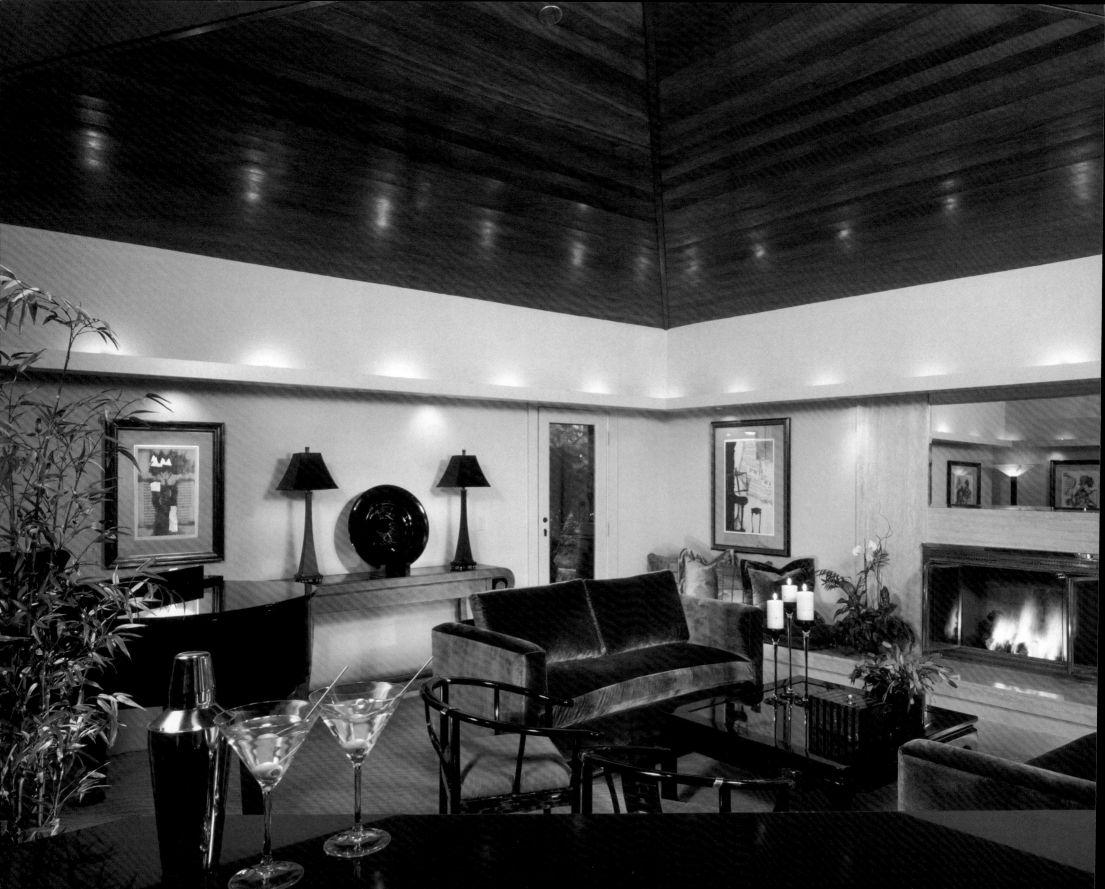

Beverly Stadler, ASID, CID
Design Focus

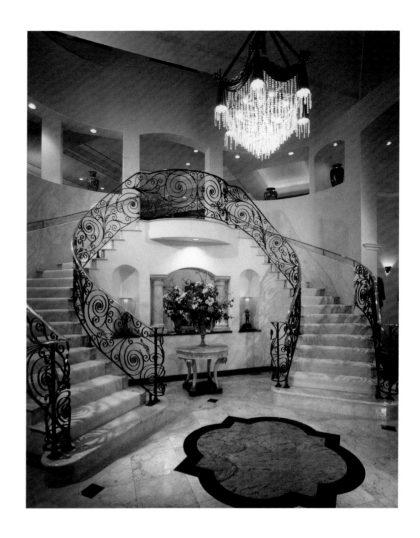

LEFT As cosmopolitan as the martinis being served, this room offers a current and sophisticated design, yet retains a warm ambiance rarely encountered with this design style due to the mahogany ceiling treatment.

RIGHT The curvilinear form of the trefoil stone inlay flooring, in conjunction with the custom designed iron railing and chandelier create a show-stopper entry in this Laguna Niguel Estate home.

People have always come first for Beverly Stadler. Her desire to help led her to pursue a degree in nursing before she decided to make a career change to interior design. "Though the two professions may seem very different, I've found that the focus, attention to detail, organization and communication necessary in the nursing profession are the same skills that make a great designer," she explains.

Armed with a degree from the California Institute of Applied Design, Beverly founded Design Focus in 1983. Eager to remain current with design specifications and requirements, Beverly was among the first to become a certified interior designer in the state, and recently passed the rigorous National Council for Interior Design Qualification two-day design exam. Keeping current with all the newest codes as well as products helps Design Focus, now located in San Clemente, tackle projects from décor and remodel to from-the-ground-up architectural design projects. While Beverly works primarily with residential design and new home construction, she also designs medical offices, commercial spaces and hospital spaces.

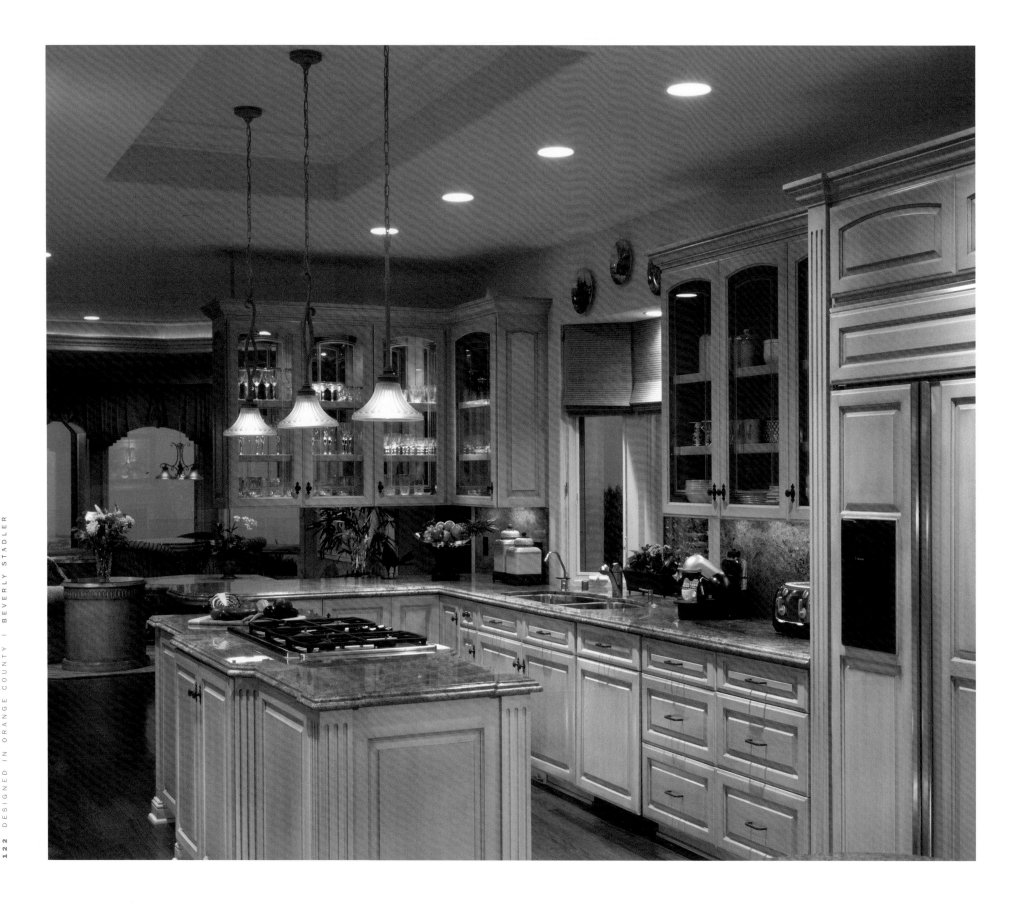

The people and management skills she picked up in her nursing career have helped her manage even the most complex job projects and personnel. Beverly is an expert at finding ways to reach a middle ground. "I can help people see the commonalities rather than focus on the areas where they have disparity," she says. This same talent helped her when she spent the 2003-2004 term as president of the Orange County ASID. "It's the same ability; it's assisting people who are at two ends of the spectrum to try and come together to work effectively."

Her hard work has earned her numerous awards and features in many publications. Beverly received national recognition as the Window Fashions National "Award of Excellence" winner in 2000. In the 2002-2003 *Orange County Home* book, she was honored with the gold award for window fashion design, stone and tile design, and ceramic tile design. In the 2002 Orange *County Home Magazine*/ASID competition, she received the gold award for both bathroom and bedroom design. Beverly's innovative designs have also been featured in *Orange County Home Magazine, Window Fashions Magazine, Orange Coast Magazine, Costa D' Oro, Coast Magazine, Laguna Magazine, Home by Design* and the *Los Angeles Times* Orange County Edition.

Along with her experience and qualifications, Beverly brings a sense of fun to every one of her projects. One of her favorite design techniques is to have clients conjure up their fantasy of a perfect day in the room, encouraging them to pull out

LEFT Traditional takes on a whole new meaning with this fresh new glazed cabinet finish against mahogany flooring. Views of Dana Point are maintained by utilization of dual sided glass cabinetry, creating expansive areas for great room entertaining in the open adjacent family room.

RIGHT This ultra contemporary Marbella Estates custom bath uses combinations of bejeweled silver and plain Caesar stone, in conjunction with blue and white Matisse porcelain tiles to create a vision in crisp contrast and unending reflection.

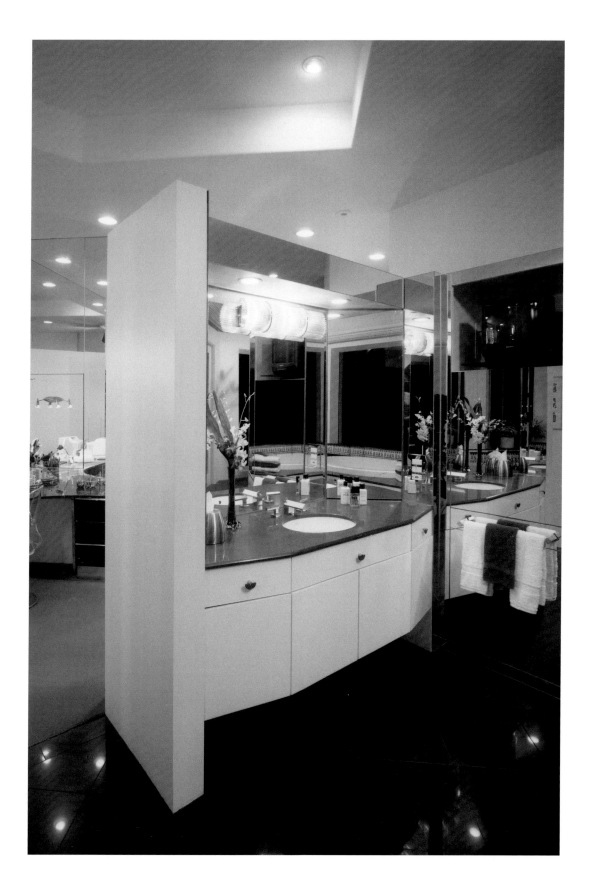

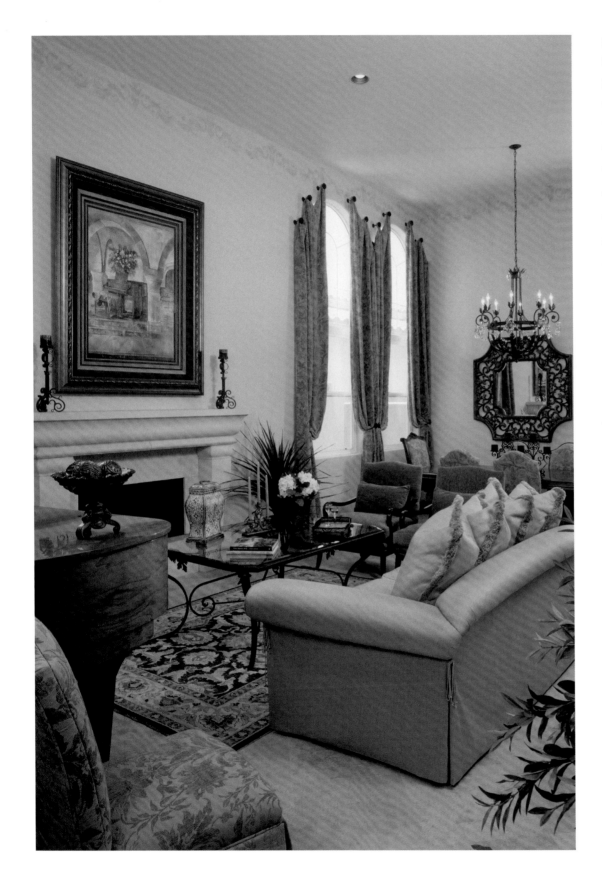

pictures of elements they like. "Just describing a look and a feel is too nebulous for some people," she says. "Creating inspiration boards and idea files gives clients an understanding of how all the elements come together. It also allows me to 'get inside' their heads to begin to create their ultimate dream vision, as my design talent really lies in being able to articulate what the client dreams of, rather than a style preference of my own."

This persistence motivates her until the job is completely finished to the client's satisfaction. Beverly prides herself on her ethical standards practices and promises that clients never have to settle for anything less than the best. "Our agreement represents exactly what their costs will be," she says. "And at the end of the day, if there's a problem, it will be taken care of and it will be right."

Beverly's effort always pays off when clients come back to her for their third or fourth remodel, and even recommend her expertise to their own children. "It's good to know you've done such a great job that you're a part of the family." ■

DESIGN FOCUS

1231 Puerta Del Sol, Suite 200

San Clemente, CA 92673

949-366-3328

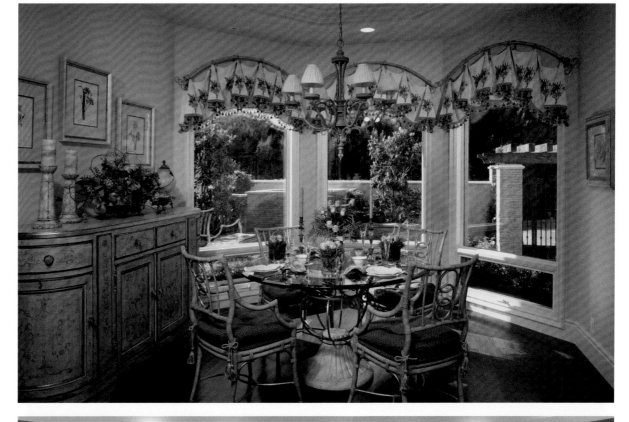

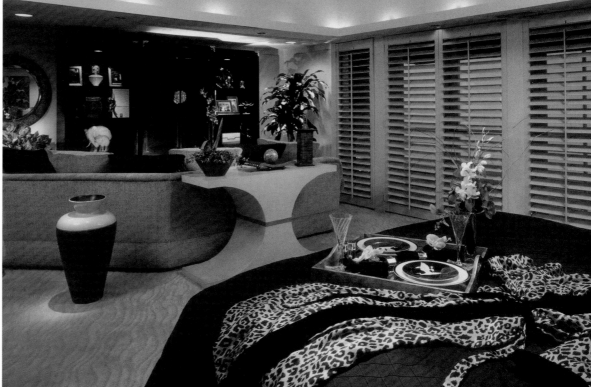

LEFT LaQuinta is the perfect getaway, and this luxurious, un-stuffy design is the epitome of the casual sophistication the desert lifestyle is known for.

TOP RIGHT The attention is in the details in this warm and inviting morning room, from the custom arched drapery rods that mirror the table and chandelier design details, to the design of the unique drapery treatment, to the details on the lovely hand-painted storage buffet.

RIGHT This contemporary master suite is elegant, dramatic and timeless thanks to the classic colors and Oriental influence.

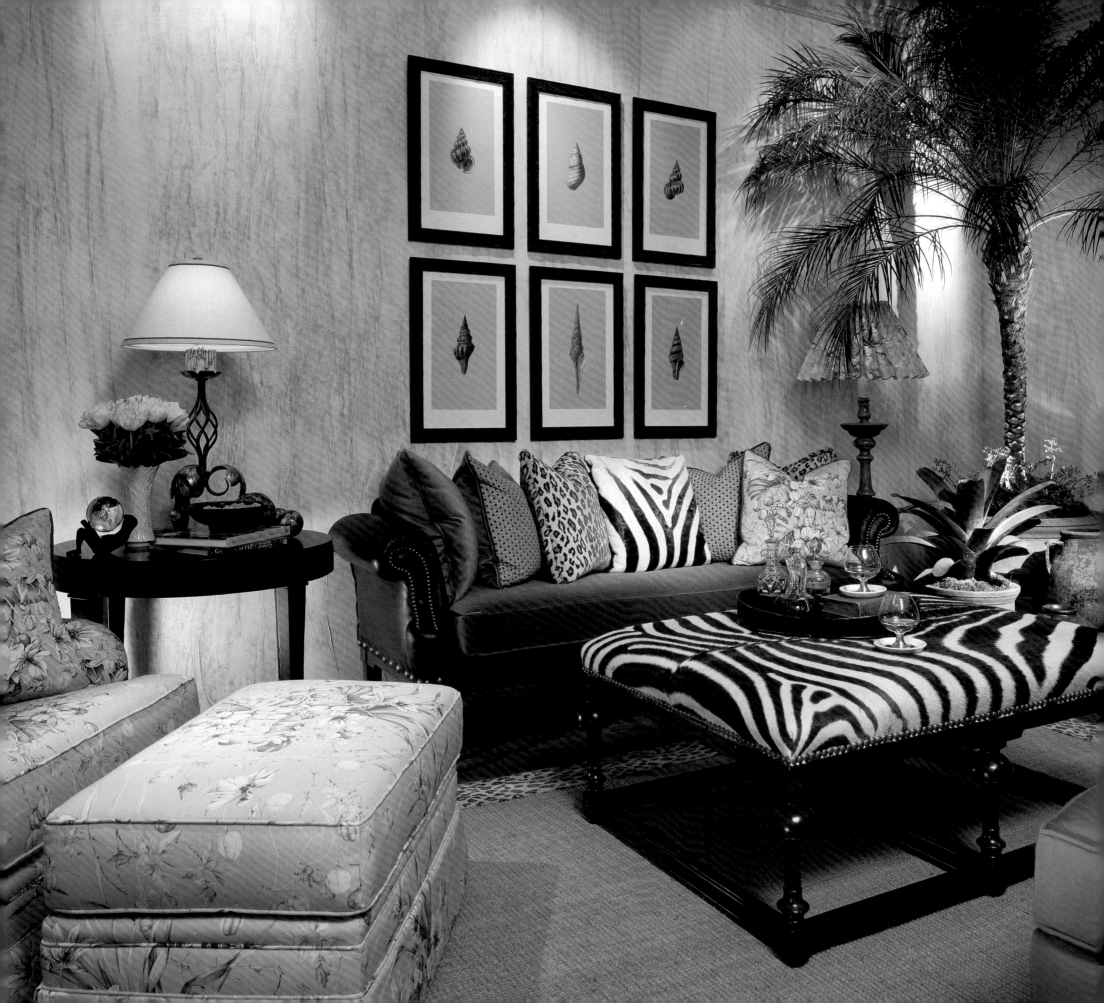

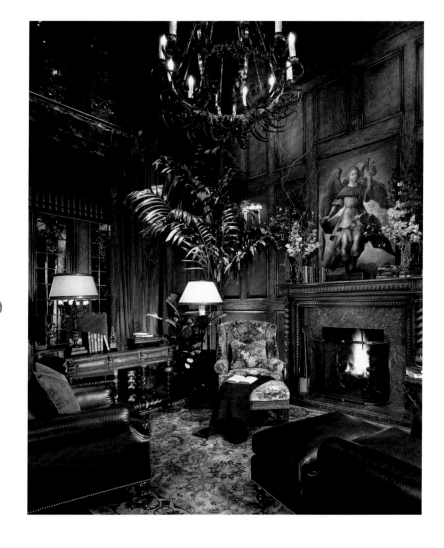

Steve Stein,
Allied Member ASID, IIDA, CID
SLS Designs, Inc.

LEFT Philharmonic House of Design, 2003

RIGHT Philharmonic House of Design, 2004

With care and nurturing, even the modest seed can blossom into an exquisite flower. Award-winning designer and plant aficionado Steve Stein, brings this valuable knowledge to his clients' homes. From concept to completion, he treats every project as its own distinctive entity, always dedicating the time and energy needed to truly make a room shine.

As a high school student, Steve was encouraged to pursue design by his parents' own interior designer. "I've always been creative and it sounded like a good opportunity," he says. He immediately started working in the design business after receiving his fine arts degree from Woodbury University. After more than 25 years, he is still full of fresh ideas and boundless zest.

It's easy when every home inspires a unique design, whether it be the architecture or existing pieces owned by the client. "Sometimes it is a picture a client has cut from a magazine, a piece of fabric or an embroidered pillow with the colors that a client likes," explains Steve. "I'll take those inspirations and bring preliminary fabrics and create a concept." Often, he brings clients to the Design Center to look at the fabrics and furnishings in order to better understand the client's likes and dislikes.

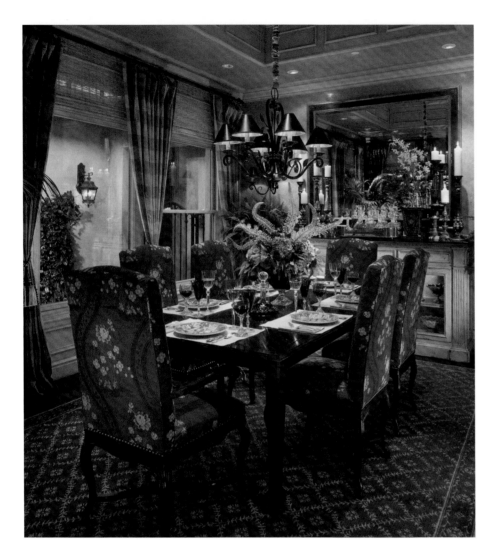
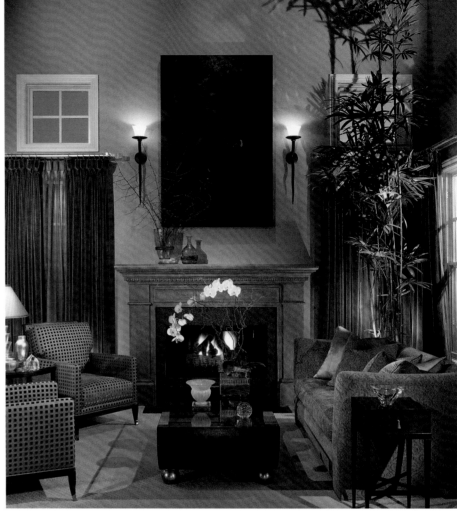

Outside of interior design, Steve likes to travel and take in the museums and theatres of San Francisco, Chicago, New York, Paris and London. On the weekends, he can be found in his yard working on his landscaping or caring for his cycads and other rare tropical plants. His affection for greenery often makes its way into his design; he can regularly be found at the growers searching for the perfect plant to complement his latest interior.

Whether it's a California traditional home or formal English library, Steve's designs stand the test of time. "There's an element of surprise in my design that's non-aging. Five to 10 years down the road, it still looks fresh," he says. He attributes much of this success to keeping the client involved in creating the interior. "I've had clients call me back 10 to 12 years later and some of the things still look good. We might do some reupholstering or a new wall color, but it's a timeless look – sophisticated and classic."

Steve isn't afraid to add a little excitement to his designs. "One client asked me what color I would paint the pantry doors in the breakfast area and I suggested that they be painted red to give it a spark. That got me the job." Steve then continued to create a French Country farmhouse look throughout the 8,000-square-foot home. "The colors are rich golds, reds, blues and yellows. It's striking, inviting and casual – fitting in with their lifestyle full of family and entertaining."

Though he enjoys watching the progression of each project, Steve finds the most satisfaction in seeing the fruits of his labor. "I enjoy finishing a project more than anything else – the final installation when the client walks in and sees everything. It makes you feel good." ■

SLS DESIGNS, INC.

P.O. Box 4470

Laguna Beach, CA 92652

949-376-8886

FAR LEFT Private residence in Coto de Caza, California

NEAR LEFT Private residence in Newport Beach, California

BELOW Philharmonic House of Design, 2002

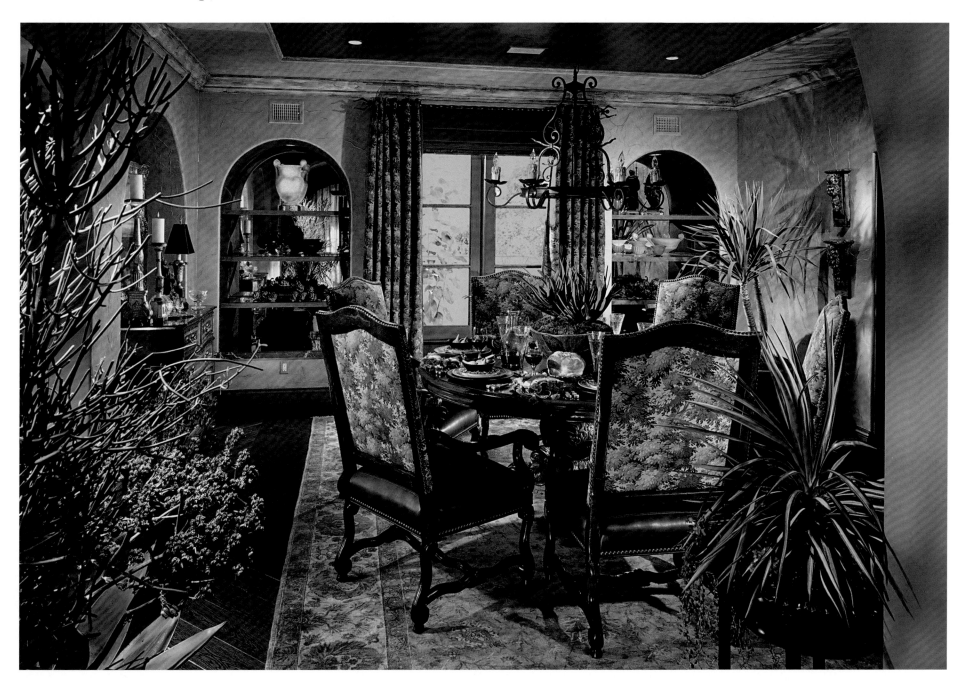

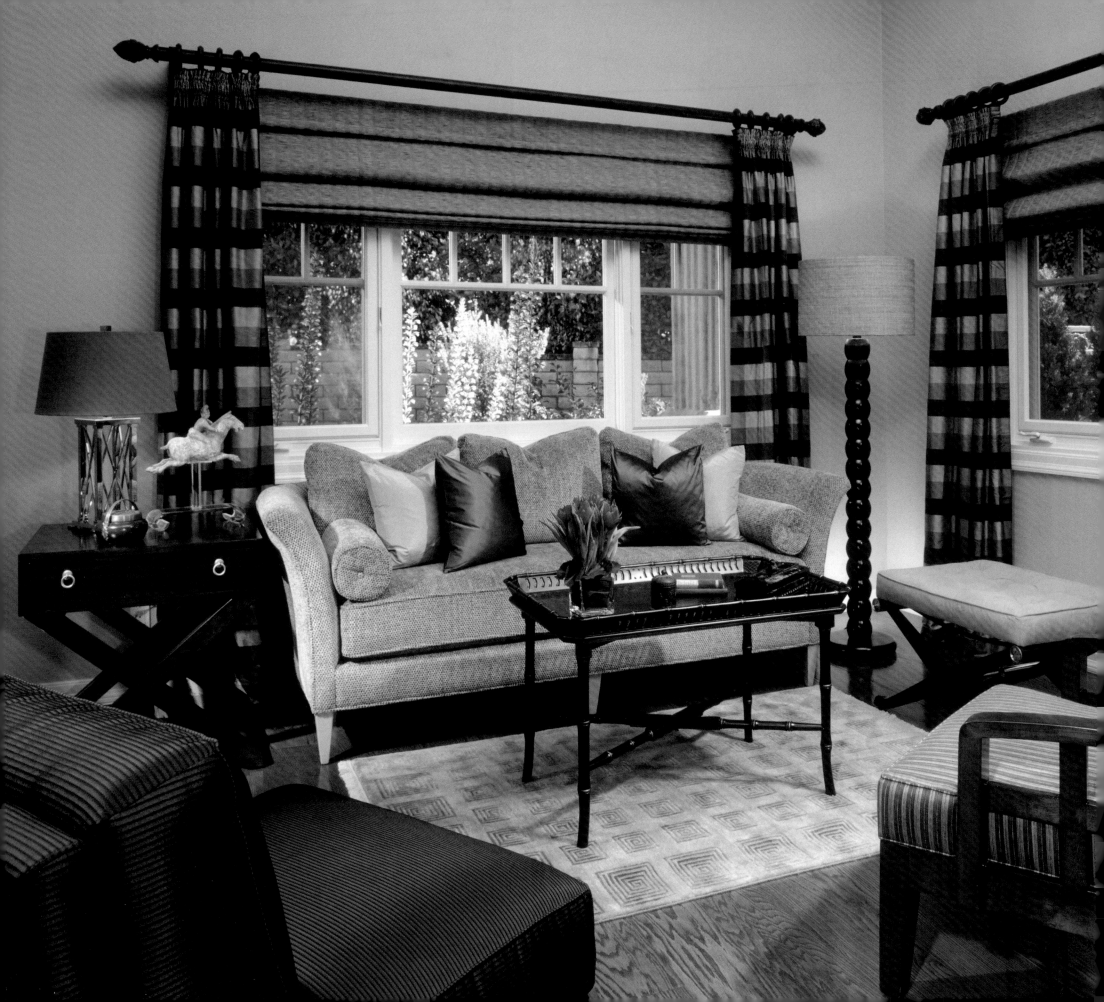

Bunny Sutherland
Allied Member ASID, CID, IDS
Sutherland Interior Design, Inc.

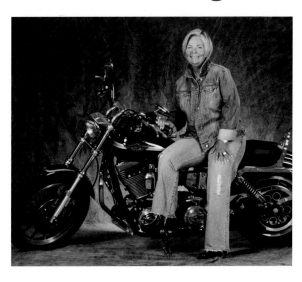

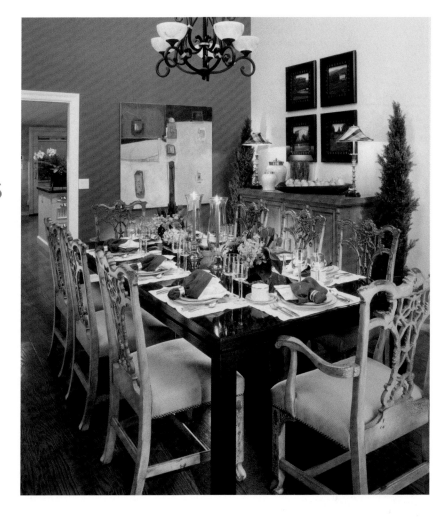

LEFT This room has a great uptown New York feel. Just what the clients wanted. This is a sitting area adjacent to their dining room that gives them the ability to have two great entertaining spaces. It was a fun space to design.

RIGHT A warm sophisticated and friendly space in which to dine. It works great for dinner parties and holiday dinners with family. This is a mix of traditional and contemporary design which satisfied the different design styles of the client.

Whether it's making a career change from the aerospace industry to interior design, throwing in a Louis XIV chair in an otherwise contemporary room, or studying design on the back of a Harley Davidson, Bunny Sutherland, lives for the unexpected.

Though she has been interested in design since she was 16 years old, Bunny worked for McDonnell Douglas in the 1980s until she was able to return to school to earn her degree in interior design. In 1993, she founded Sutherland Interior Design, Inc. and has since grown her business. Although Bunny works primarily with residential design, including new and remodel construction, she also designs medical and commercial spaces and yachts. She has served on the board of ASID Orange County for the past two years, chaired the Orange County Design House project, and has also been featured on HGTV three times.

In addition to designing through her own firm, Bunny has taught interior design at the Interior Design Institute at Brooks College. "My five-year plan would be to work with a few clients a year and teach the rest of the time," she explains. "I want the students to know that they will always be judged on the

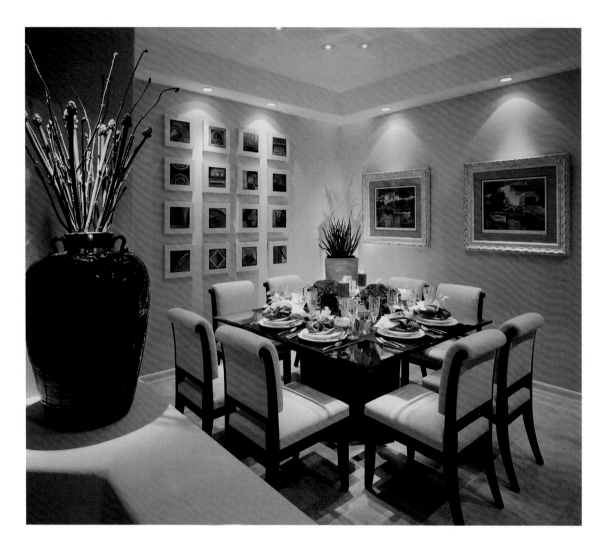

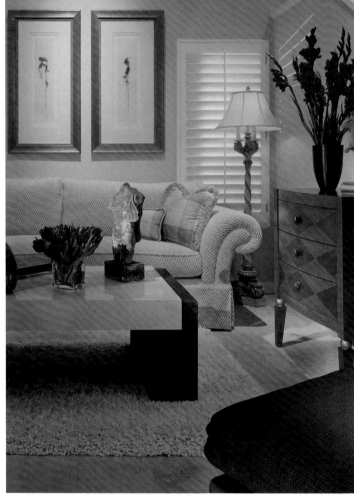

body of their work and that they will always feel a sense of accomplishment when they have completed a project for their clients." During her classes, she discusses the mechanics of working with clients, working with color, choosing furniture and fabrics that will best work for the client and bringing a job to fruition – all things that Bunny is intimately familiar with.

Of the projects that she has completed, the Moran home in Long Beach has been one of her favorite assignments. "The client bought the house and we did some remodeling," she recalls. "Whenever we went to choose materials and finishes, they liked almost everything we looked at it. We were able to nail down almost everything on our first try. The whole job just clicked."

Occasionally, Bunny takes some time to absorb the great outdoors and find inspiration in the most unexpected places: Her weekends are often spent riding her Harley Davidson with her husband and stepson, touring the country on various bike runs.

Her own design style reflects a "less is more" philosophy. "It's a transitional to contemporary style. I'd love to have my house reflect the designer Mies van der Rohe – the Barcelona chair, the daybed,

TOP LEFT This is the Moran's dining room. The one request from them was that everyone would be involved in the dinner conversation. I accomplished this by using a 60-inch square table that seats eight. A great space for dinner conversation. This is a contemporary warm space.

TOP RIGHT A sophisticated, warm living room, I used a mainly monochromatic color scheme in whites and beige with a touch of red. It works well with the dining room and is a great place for that after-dinner cognac.

FACING PAGE I love designing yachts, mainly because my husband also has a boat and we enjoy being out on the water. Designing yachts is a little different than residences; one because of the small space and two, the careful choice of fabrics that need to be used. This is a master stateroom on a 60-foot yacht that was showcased in a prestigious boat show.

straight lines, a little curve, great art, great color," says Bunny. "And always throwing in that juxtaposition of an antique Louis XIV chair or chest. That's probably my favorite look."

When it comes to these kinds of design choices, Bunny stresses the importance of finding a professional designer. "Clients often misjudge space and have a hard time determining what will look good," she says. "They're often afraid to use color. Space, design and color is where a professional designer is able to guide the client to make the right choices for their project."

For Bunny, design is knowing what works when trying to achieve a specific style. "Designers are able to pull all of those things together into something that works for the client – their design style, their lifestyle, their color preferences, and their house. My talent is interpreting what my clients want." ■

SUTHERLAND INTERIOR DESIGN, INC.

5622 East 2nd Street

Long Beach, CA 90803

562-438-6260

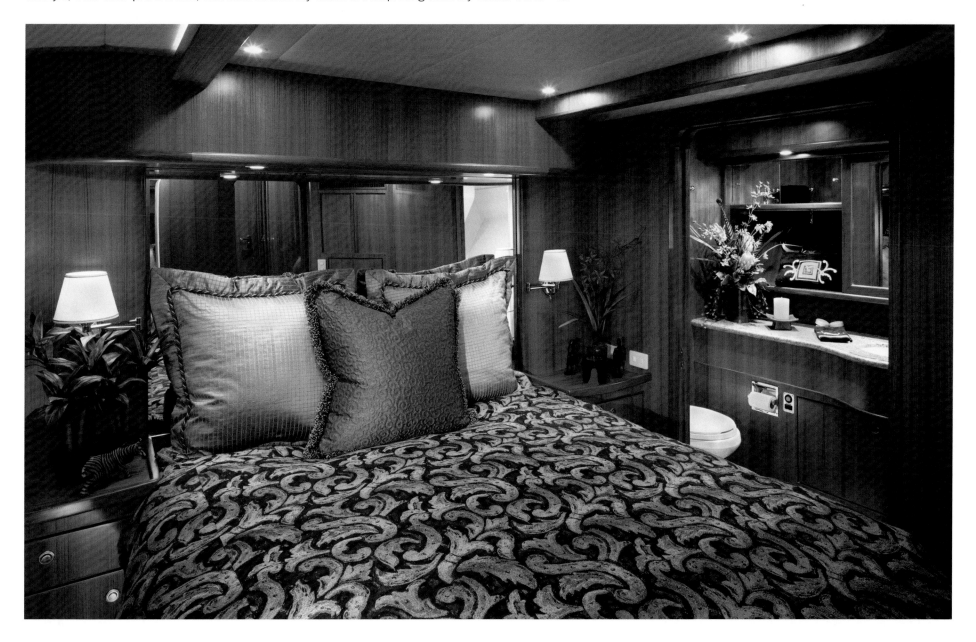

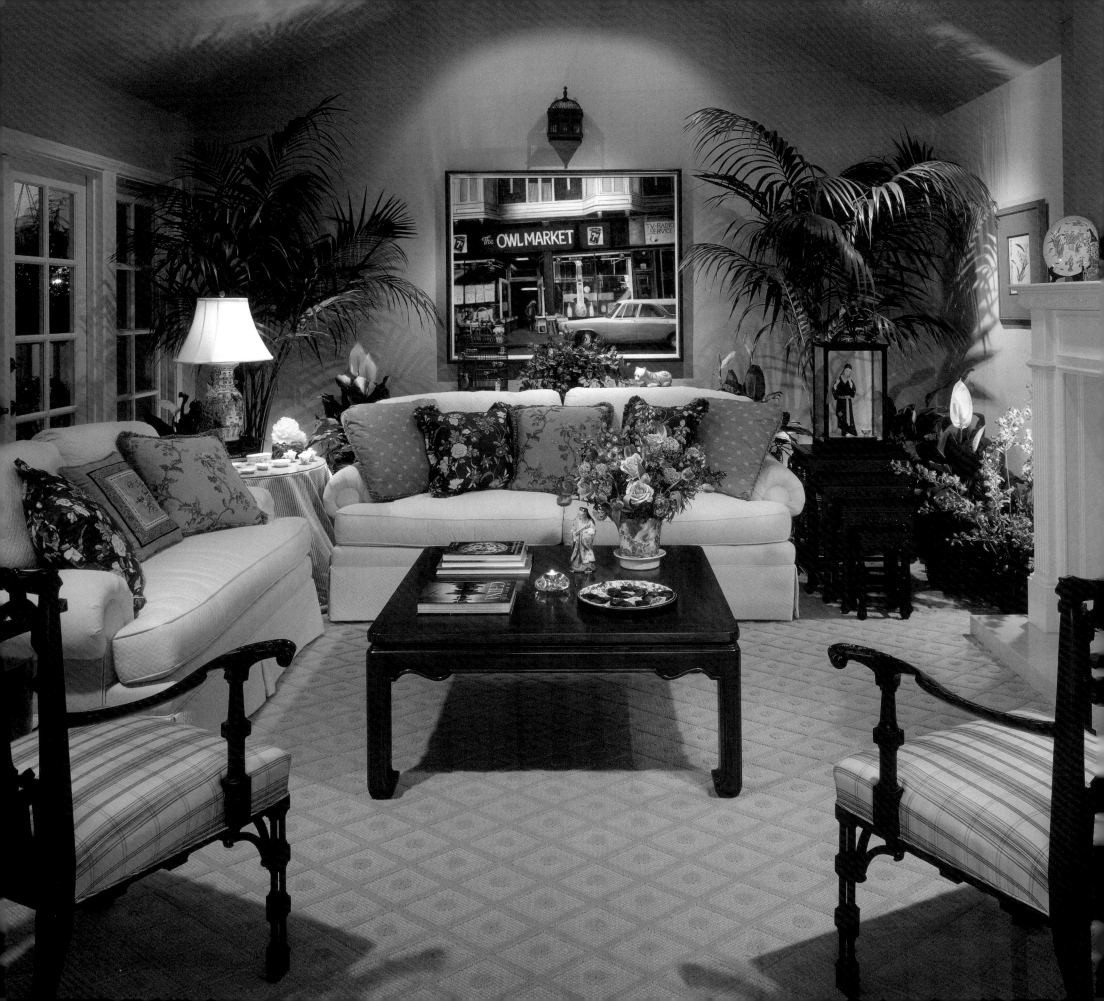

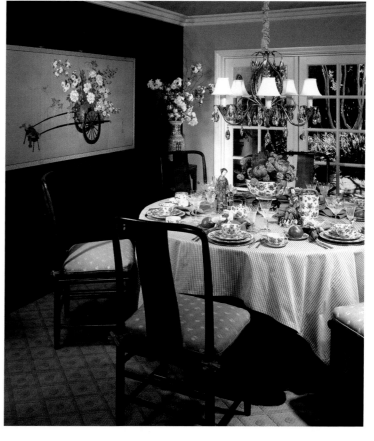

LeAnne Tamaribuchi, ASID, CID
LeAnne Tamaribuchi Interior Design

LEANNE TAMARIBUCHI

INTERIOR DESIGN

One Sunlight

Irvine, CA 92603

949-854-7061

FACING PAGE The contemporary scene painting harmonizes with a pair of Chinese Chippendale armchairs, traditional style furnishings and a collection of Asian art and antiques.

TOP Wickers are moved indoors to give the interior a garden mood. Fabric on the chairs is a red Chinese toile.

TOP RIGHT The Chinese believe the peony flower symbolizes prosperity. A superb Japanes folding screen of a flower cart filled with peonies and flowers graces the wall.

For the last 25 years, LeAnne Tamaribuchi, principal and founder of LeAnne Tamaribuchi Interior Design, has been infusing her traditional interior designs with a touch of Feng Shui. The ancient Chinese art focuses on manipulating and arranging one's surroundings to attract positive life energy. "From an interior design perspective, Feng Shui is about livability and comfort," she says. "It ensures that living spaces are pleasing to the eye and comfortable for your inner self."

It's this combination of interest in her family's roots in China and Japan, as well as in spirituality, that imparts a refreshing, eclectic note to LeAnne's work. "I'll use English or French provincial furniture in a design, but may add an Asian piece or other antiques as appropriate for the client," she explains. Her extensive travels around the world, including trips to China and Russia, continue to enrich her knowledge of design, antiques and materials.

Although LeAnne was a biochemist, she has always had an eye for design and aesthetics. She received her environmental and interior design degree from the University of California, Irvine – one of the two first graduates of the program. Her projects have ranged from small homes to overseeing the comprehensive design and construction of a 9,000-square-foot custom home.

A past president of ASID/Orange County, Certified Interior Designer and NCIDQ juror, LeAnne is an active ASID member, particularly with the Orange County Philharmonic House of Design. She received the ASID Chapter Presidential Citation Award in 1999, and her design work was displayed in the book, *Showhouses Signature Designer Styles*. ■

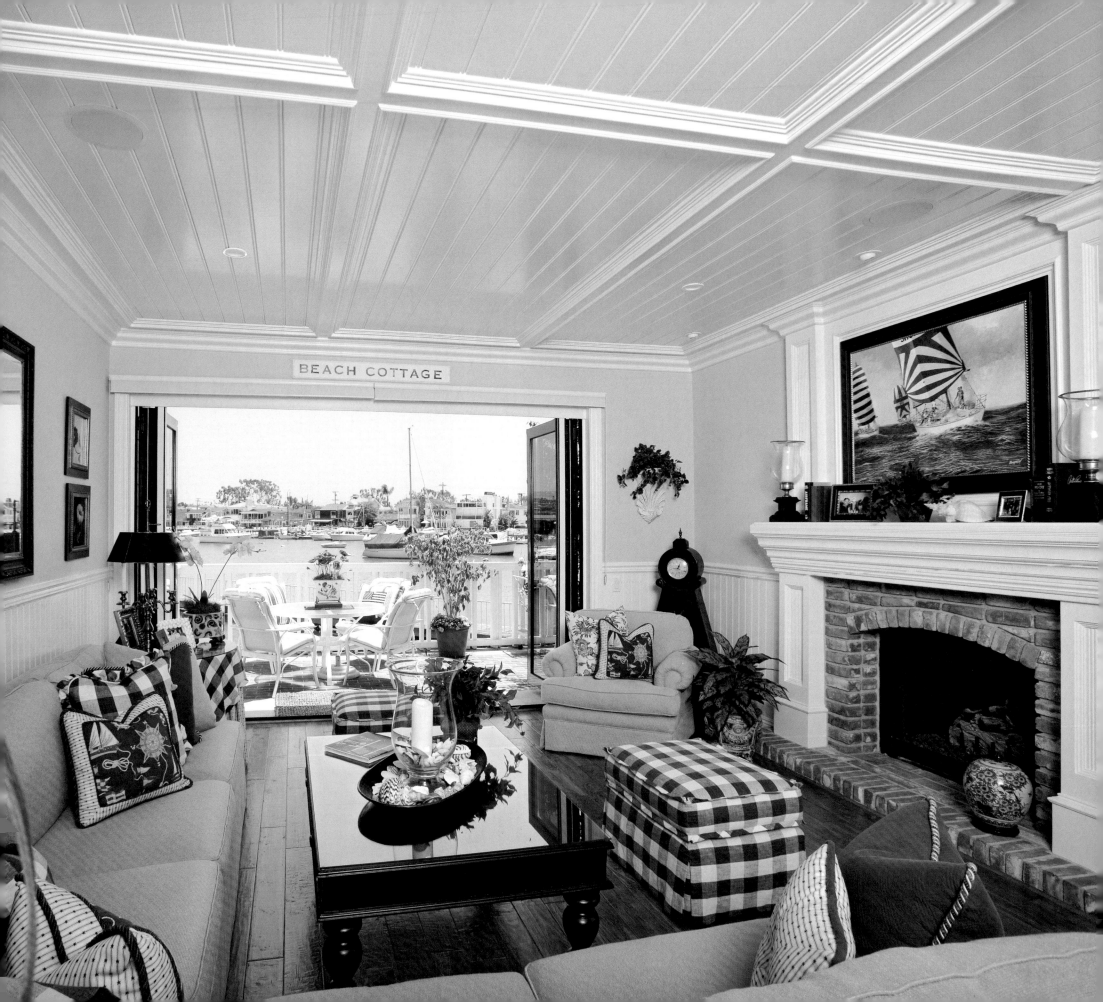

BEACH COTTAGE

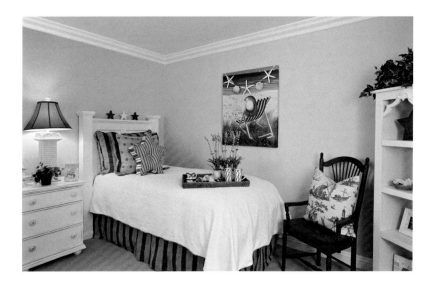

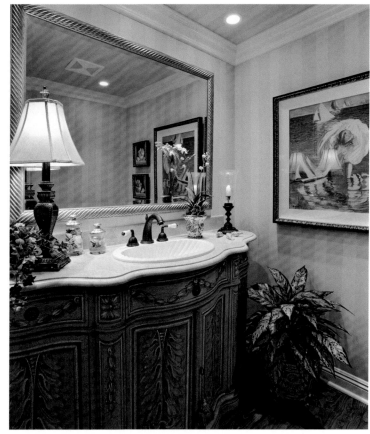

Georgia Walling,
Allied Member ASID
Wallingford Designs

WALLINGFORD DESIGNS

61 Sea Pine Lane

Newport Beach, CA 92660

949-721-8884

FACING PAGE The crisp air and the blue of the ocean were my inspirations for this cozy cottage by the sea! The Nantucket styling of the living area is repeated throughout this Bayshore home in Newport Beach. The great room with bead board and ship lap ceiling enhanced with coffered beams provides the drama and warmth of a seaside cottage. The rustic pine floors compliment fold away Nana doors opening to panoramic bay views.

TOP Our Guests are stars! Whimsical stars on headboards set the mood for the guest bedroom with the primary colors of red and blue complementing the Cottage Chic white furnishings. A Seashore painting repeating the color theme along with comfy red ladder back chair completes the drama.

TOP RIGHT Pampered Powder Room. Luxury at the shore! Resplendent in tone on tone camel stripe wallcovering and designer painted chest turned into a sink and vanity with Platinum finished mirror and accent lamp for the finished touch in a Nantucket styled cottage by the sea.

Georgia Walling's eye for decorating detail was apparent long before she made interior design her career. As a teenager, she accessorized her friends' parties, bringing her own things to the designated house, setting everything up and taking it back home when the party was over.

Her teenaged eye turned into an adult passion, one that has marked Georgia's 20 years in the design business and helped to build her company, Wallingford Designs, into the success it is today. From vacation homes to yachts, corporate and educational buildings to family residences and retirement facilities, each Wallingford Designs project bears the distinct stamp of that passion.

"I love lamps and like to incorporate black lampshades into my work," Georgia explains. "I'm also partial to using beautiful oriental pieces, area rugs, cabinets and books, all put together in the right balance, the proper scale." Achieving balance between over- and under- accessorizing is the key to a successful design, she believes. "I don't feel that every surface has to be covered."

Wallingford Designs was a two-woman team for nine years, with now-retired associate Karen Vint making an invaluable contribution to the firm's reputation. As the sole proprietor for the past decade, Georgia haunts antique stores in Los Angeles and beyond, looking for the perfect accessories for the project at hand. Those pieces are orchestrated to create a composition that best complements the particular space's architectural elements.

"A successful design is the result of teamwork and a strong relationship with each client," Georgia believes. "I'm helping make their dreams come true by giving them something they couldn't have achieved otherwise. That's what makes my work so rewarding." ■

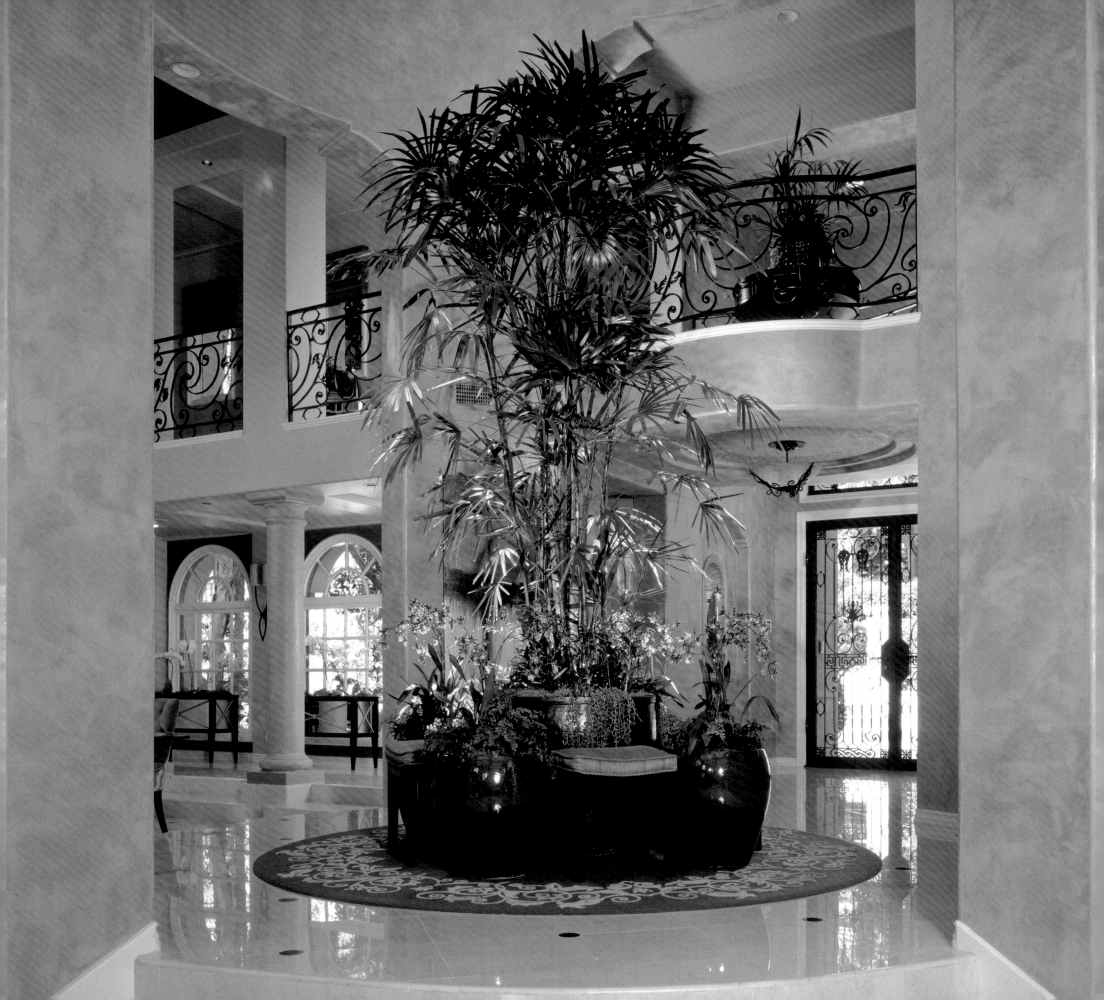

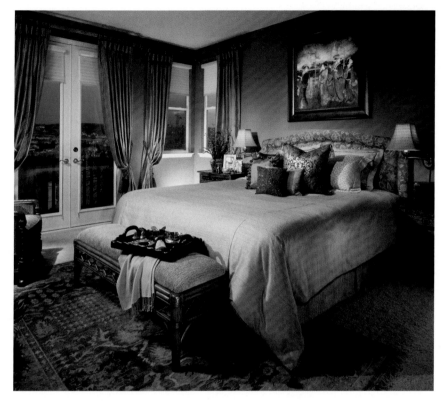

Susan Wesley,
Allied Member ASID, CID, Associate IIDA
Wesley Design, Inc.

WESLEY DESIGN, INC.

2 Sagitta Way

Coto de Caza, CA 92679

949-374-0194

www.wesleydesigninc.com

FACING PAGE The Grand Entry Rotunda, Philharmonic House of Design, 2005. A shimmering iridescent faux finish adorns the rotunda walls and dome. The focal point is a splendid 15-foot palm surrounded by orchids and ferns-filled pots and small benches upon a custom-designed rug. This space demands the unexpected.

RIGHT Rich, sensuous color and texture adorn this master bedroom. Captivating views up the canyons add to the intrigue.

The daughter of an architect, it seems only natural that Susan Wesley would continue in the "family business" of buildings and interiors – adding her own spin to create a successful merger of creative conceptual styles.

As a young woman, Susan's artistic and compositional flair earned her a spot at the prestigious Otis Art Institute of Parsons School of Design in Los Angeles, where one of her teachers was famed architect Frank Gehry. After graduation, she was quick to land a position at a local design/architectural firm. Five years later, she opened her own interior design firm in 1987.

Stylistically, Susan is equally adept at conceptualizing the interiors for a Gold's Gym as she is at customizing a client's master suite. Take her design of the foyer for the 2005 Orange County Philharmonic House of Design showcase home. The large, open space consisted of an entryway leading to a giant 30-foot high domed rotunda. For maximum impact, Susan chose to cover the walls in a unique mica-tinged, lusterstone faux finish. This labor-intensive process involved applying four separate layers of material with scaffolding and a trowel – one layer at a time. The result: a breathtaking, subtly shimmering entry that people are still talking about. "Since it was the first room you entered in the house, it needed to dazzle the senses," she says.

In her client's residential spaces, she also shows her élan for design – making any room a unique showcase. "Interior designers have to be creative problem solvers," she says. "It's the client's style mixed with my taste and design sensibility that pulls together what's going to work for the client." ■

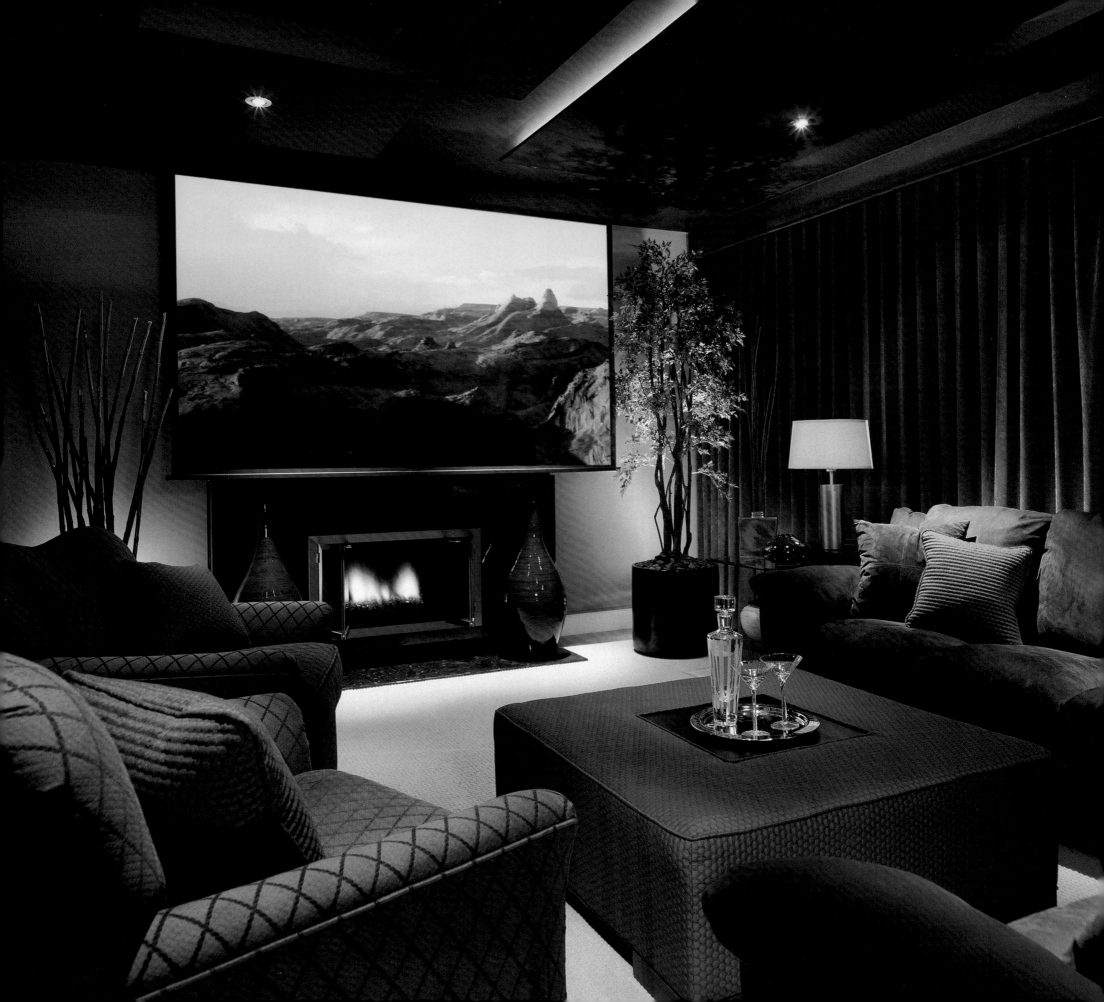

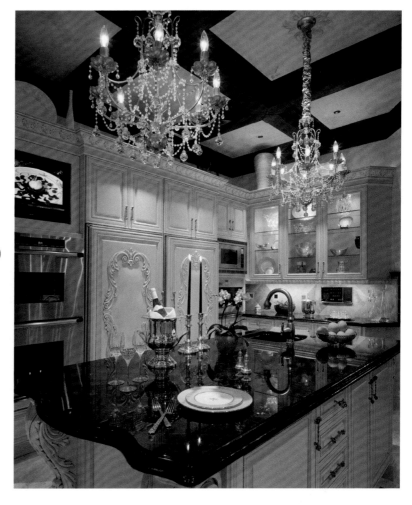

Beth Whitlinger, ASID, IIDA, CID
Beth Whitlinger Interior Design

LEFT This ordinary family room was transformed into a hi-tech, contemporary-styled media room with automated draperies, television screen and lighting.

RIGHT A graceful French chateau kitchen with every modern amenity for the serious cook works perfectly with the castle-like exterior of the home. *2004 Philharmonic House of Design.*

"I don't like decoration for decoration's sake," says Beth Whitlinger. "I like to take a simplified approach toward any style that a client has. I have an architectural viewpoint. Anything we add has to enhance a form, a line or a texture."

Beth's passion for structure means that no two projects look alike; but each one has a timeless elegance that enhances the space. To accomplish this, the owner and principal of Beth Whitlinger Interior Design and her staff, Nikki Maeda, Sharnico Dochtermann and Julie Rosales, pay close attention to what clients say and what they own. "Virtually everyone has treasures in their house, things they can't do without," she notes. "I make it a point to ask if a client wants to incorporate a cherished item into the design and if so, we'll focus around that piece. And because those valuables are so different for everyone, it's easy to start with a fresh concept."

Beth received her bachelor of science in decorative arts and design from Arizona State University in 1982. Starting off in the residential market, Beth worked on numerous model homes projects in the

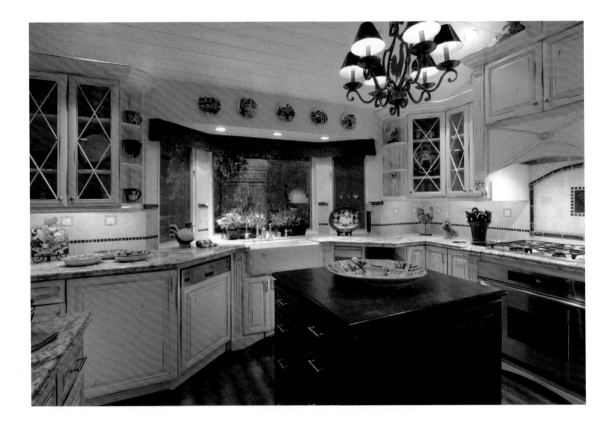

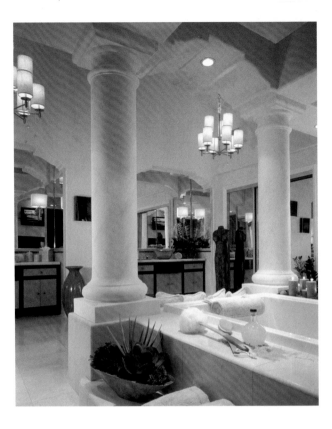

Phoenix area. Her entrepreneurial spirit then took her to Hawaii at the age of 23, where her focus changed to commercial spaces on the islands of Oahu, Maui, Hawaii and Kauai. "I worked with architect/designer Dian Cleve, and she was instrumental in teaching me to look at design from an architectural perspective," Beth says.

In 1990, Beth relocated to Southern California to focus on office space planning. Since starting her own design practice in 1994, Beth has earned a solid reputation for sound design, practical project management and client satisfaction in Southern California's commercial and residential markets.

Her talents have been recognized by a wide range of industry professionals, clients and publications. In 2002, Beth received the platinum award for best small space in the *Orange County Home Magazine*/ASID competition. Additionally, Beth's design work has been featured in the *Orange County Register, Space Magazine, Coast Magazine, Orange County Home Magazine, Orange Coast Magazine, Windows, Walls & Floors Magazine, Home by Design Magazine,* "One Room Three Ways" by *Better Homes and Gardens Books*, as well as several episodes of "Designer's Challenge" on HGTV.

In addition to running a successful interior design practice, Beth has taught color theory and business communications to interior design students at Brooks College in Long Beach; has been a guest speaker at several design programs in Arizona and California; and has served as a co-advisor for the student members of the Brooks College chapter of ASID.

TOP LEFT Upper cabinets were removed over the passthru in this small, closed-in kitchen to create a feeling of spaciousness.

TOP RIGHT Texture and solid blocks of color were used to create the calming atmosphere in this spa-like master bath in the Philharmonic House of Design, 2005.

RIGHT This HGTV "Designer's Challenge" living room mirrored the famiy's love for the islands while still keeping a sense of formality and elegance.

While Beth's creativity is unlimited, she knows that an important key to her success lies in her solid organizational skills. "What's nice is that my clients respect my ability as a professional and if I suggest a design direction that they didn't originally think they wanted to go, they trust me enough to explore that direction. It's really satisfying when you hear from clients at the end of a project that they had no idea that their home could look so wonderful!" ■

BETH WHITLINGER INTERIOR DESIGN

23246 Arroyo Vista

Rancho Santa Margarita, CA 92688

949-766-1093

www.bwid.com

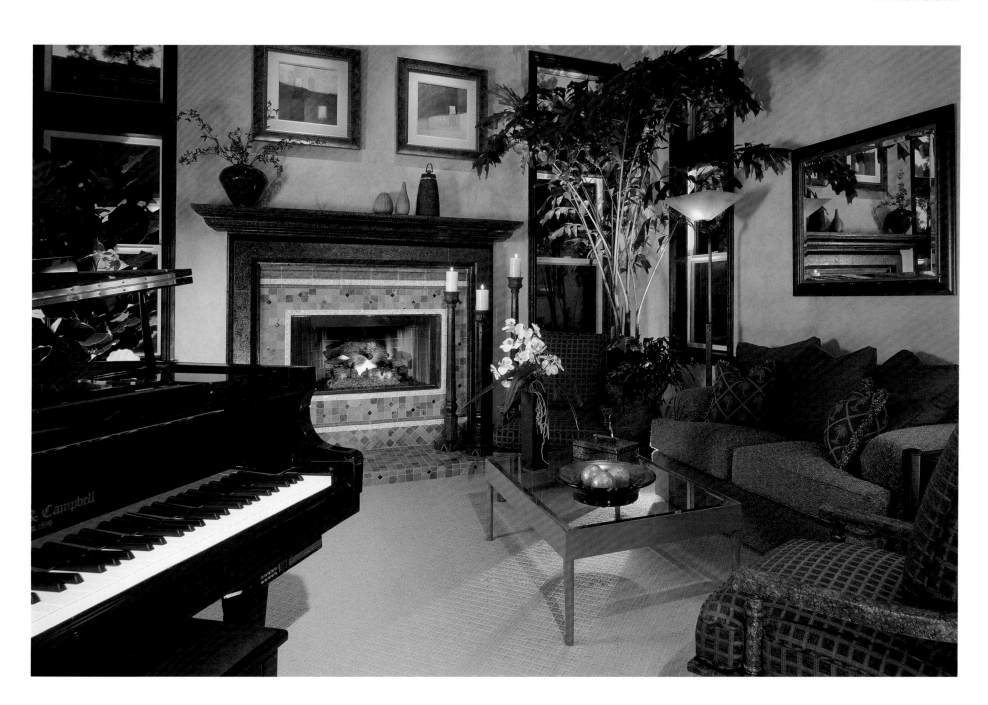

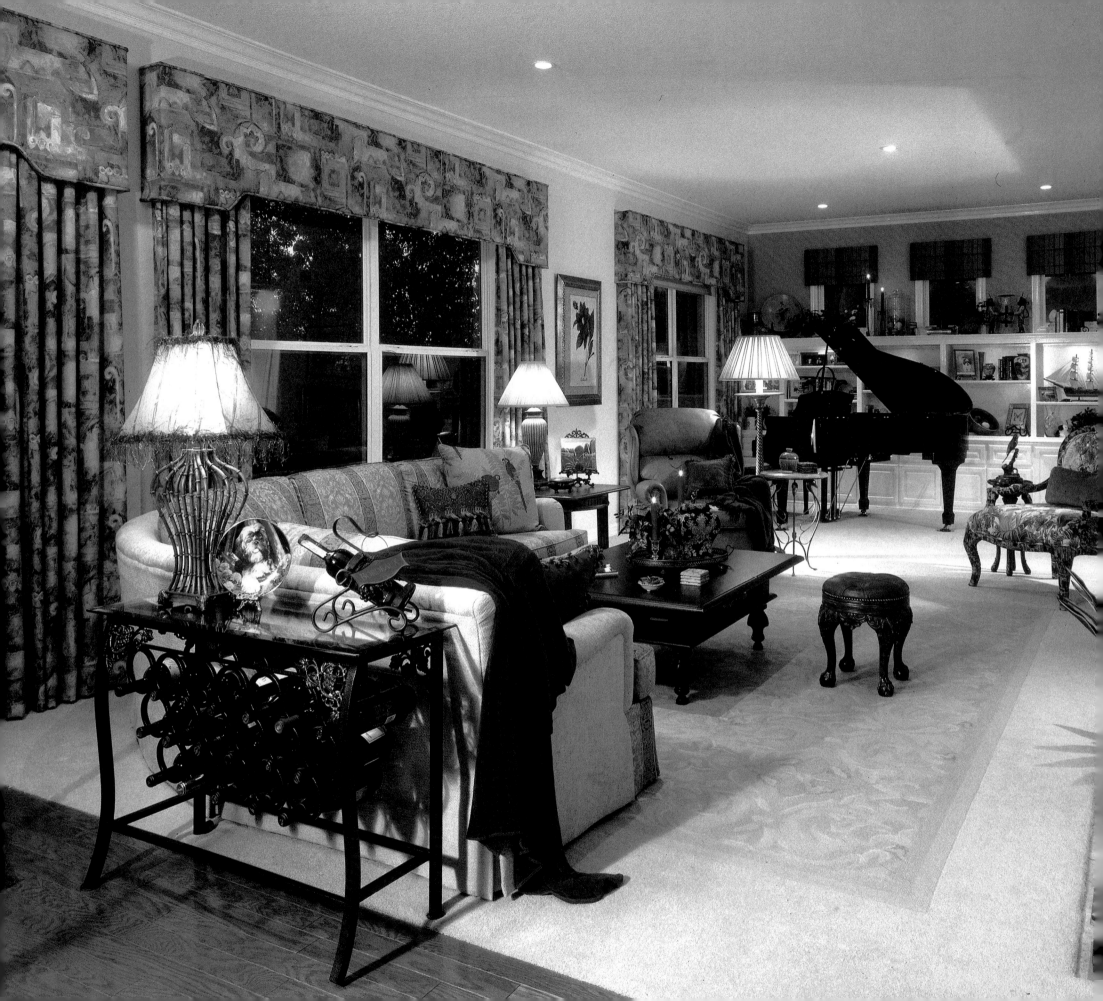

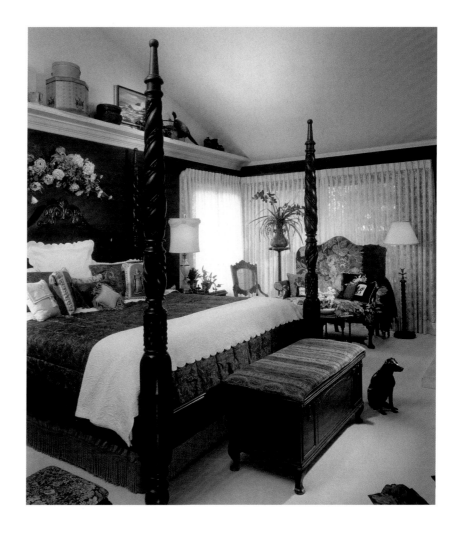

Joy Wood, ASID, IIDA, CID
Mirage Interiors, Inc.

LEFT With a sweep of soft chromatics, this family room accommodates her client's musical interests. Sound and lighting titillate while the decor focuses on comfort and company.

RIGHT Joy's own boudoir: A little bronze canine guards her great-grandmother's chest companioned with a Victorian settee and carved poster bed. Norwegian "Bunde Rot" wall color enhances the sleeping room. Pearl lace suggests a fresh bright "morrow."

Joy Wood can make the best out of any situation. At age 21, she was working on getting her master's degree studying to become a museum curator. But after traveling to Europe to study art in Scandinavia, the money for her master's degree quickly evaporated. Instead of becoming discouraged, Joy finished her bachelor's degree and took a job as an apprentice designer. Lucky for her clients, she has never looked back, honing her skills with frequent trips to Europe, Asia and Africa, studying and absorbing new and old art and design forms.

Joy has applied this very same adaptability to her design pursuits today. With her company, Mirage Interiors, she's helped many different people develop design solutions that fit their needs, finding creative compromises when necessary. "Many times the husband and wife don't agree," she explains. "He likes one style, she prefers a completely different scheme and they can't get anything accomplished. My job is to find a commonality between the two of them. I work with the positive and involve both partners' needs. Besides," she continues, "if the designer decides, then they don't have to."

Clients' differences often work to Joy's advantage. "I don't run out of ideas," she says, "Each client inspires a unique composition. All kinds of different artistic elements go into the recipe for design,

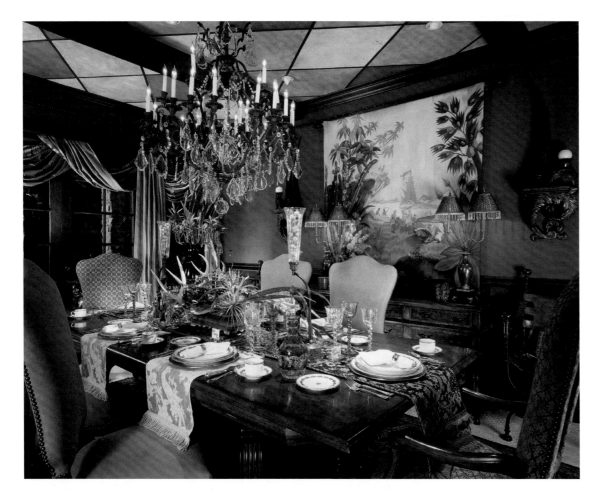

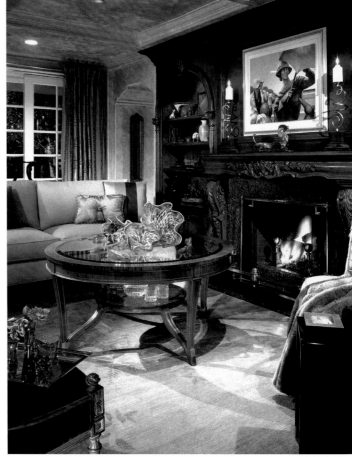

so it comes out differently." To every job, Joy brings her mix of technical ability and artistic inspiration. No matter how unique the final design may turn out to be, clients can be sure they will end up with a fashionable and practical living space with personal style and panache.

In every case, Joy makes sure that she produces the best product for the dollar. Her company Mirage Interiors specializes in home furnishings, including floor coverings, window covering and wall coverings, furniture, and custom-designed pieces. "We try to find pieces that fulfill the need in terms of scale, color and function," she says.

After 41 years of practicing design, Joy is now working on homes for the children of clients. "We are privy to people's experiences, backgrounds and relationships," she says. Knowing how personal design can be, Joy has developed a sense of trust with her clients. "As a designer, you're dealing with people's feelings as well as their taste," she explains. "It takes patience and empathy, as well as skill and experience."

Design projects have taken Joy far and wide; she has done jobs in Colorado, Las Vegas, Hawaii, and Canada. She was even able to design a house in the Santa Ynez Valley without seeing it until after it was built. She created the design using just the architectural plans and a topography study. When she

TOP LEFT As seen in the Orange County Philharmonic House of Design, 2003. Cozy? Interesting? Masculine? Bold? Comfortable? Unusual? Rich? Beautiful? Practical? Are these some of your goals? Here is a room that has them all.

TOP RIGHT As seen in the Orange County Philharmonic House of Design, 2005. Skill translated into unique specifics that can be appreciated by the masses -- this is a trait needed for success in creating for a design house. Using cutting-edge style and technology, but making it pleasurable for living may seem a dichotomy. This designer has the training, talent and tenure to pull it off! Adventure juxtaposes safety.

FACING PAGE Formal, understated elegance in neutrals. Great quality always equals timeless good taste in any language or style. Trendy makes a poor bedfellow with this classic influence.

finally saw the finished house, it was exactly as she had envisioned it—completely decorated per her specifications. Her education in Europe and the Midwest, in addition to many trips to the Far East, have given Joy an appreciation of multicultural design, and provided her with an aptitude for designing the unusual and exotic as well as a comfortable respite.

"I have been gifted with a good sense of visualization," she says. "I have a very good imagination. This creative ability has become my professional identity. It's serious business for me. And it's very satisfying to be able to help improve the quality of my clients' lives, designing especially for each of them." ∎

MIRAGE INTERIORS, INC.

5589 Santa Ana Canyon Road

Anaheim, CA 92807-3148

714-998-4439

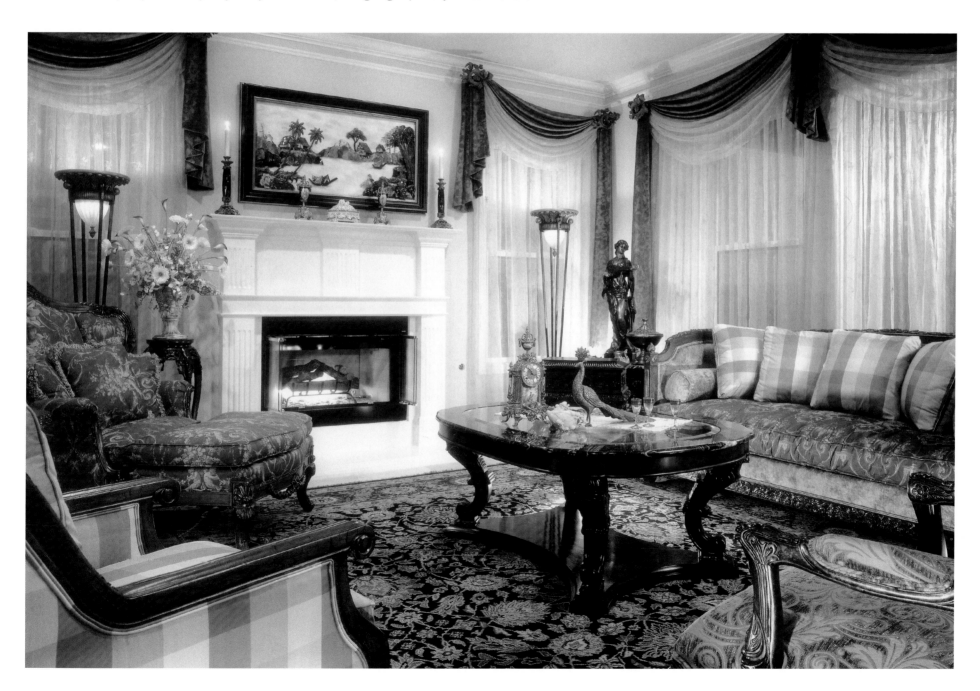

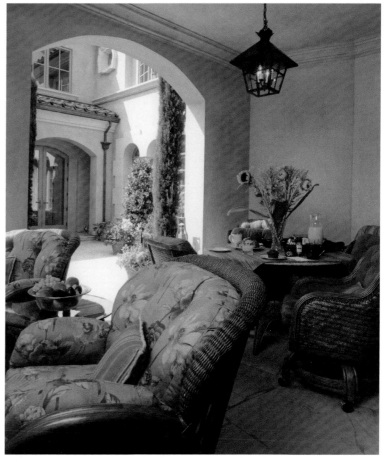

Karen Ziccardi, ASID
Brooke Ziccardi, Allied Member ASID
Ziccardi Designs

ZICCARDI DESIGNS

3188 Airway Avenue, Suite D

Costa Mesa, CA 92626

714-556-8080

FAX 714-557-3927

www.ziccardidesigns.com

FACING PAGE Ziccardi Designs was commissioned from the initial planning stage through construction to provide total turnkey interior design services for this exclusive estate.

TOP Ziccardi Designs incorporated the client's fine art collection into their interior design for this stunning residence.

TOP RIGHT Working closely with client, architect, contractor and landscape architect, Ziccardi Designs became part of the team that transformed the client's vision of an authentic Tuscan Villa into reality.

Mother-daughter interior design team of Karen and Brooke Ziccardi provide clients with not only three decades of experience in the interior-design business, but a fresh, youthful approach to style.

Karen Ziccardi has honed a trademark of understated elegance. Her portfolio of clients across the globe includes entertainment figures, entrepreneurs, hoteliers and royalty. Karen holds both a master's and doctorate degree from UCLA in environmental design.

Brooke's enthusiasm for interior design started early; as a young girl, she'd often sit at her mother's drafting table with crayons in hand. Over the years, she continued to pursue that interest grounded by a solid business background: she graduated from the UCLA Interior Design Program, and obtained a bachelor's degree in business from the University of Southern California.

The Ziccardi Design team specializes in all aspects of design and space planning. From a contemporary-style penthouse in Shanghai and a private Napa Valley winery estate, to a panoramic 22,000-square-foot Italian-style oceanfront manor, Brooke and Karen have helped clients realize their own unique visions.

Their international projects allow the team to gain a more global view of current trends which they then meld with classic design styles to inspire their designs. The Ziccardi Design team continually strives to create elegant and unique interiors that are appropriate for each individual client. ■

Photo Credits

Index of Design Firms